$75.00

At the Edge of the Sky

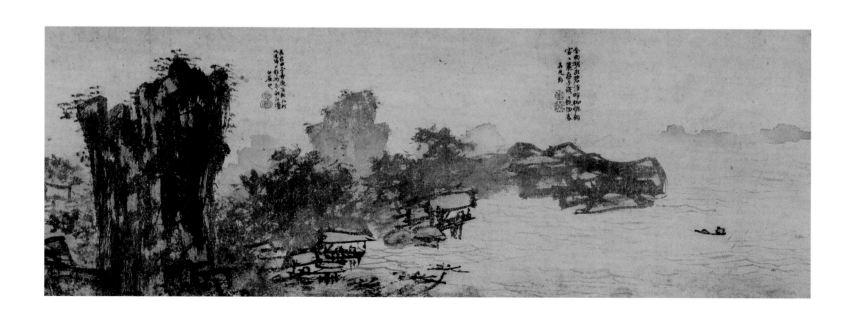

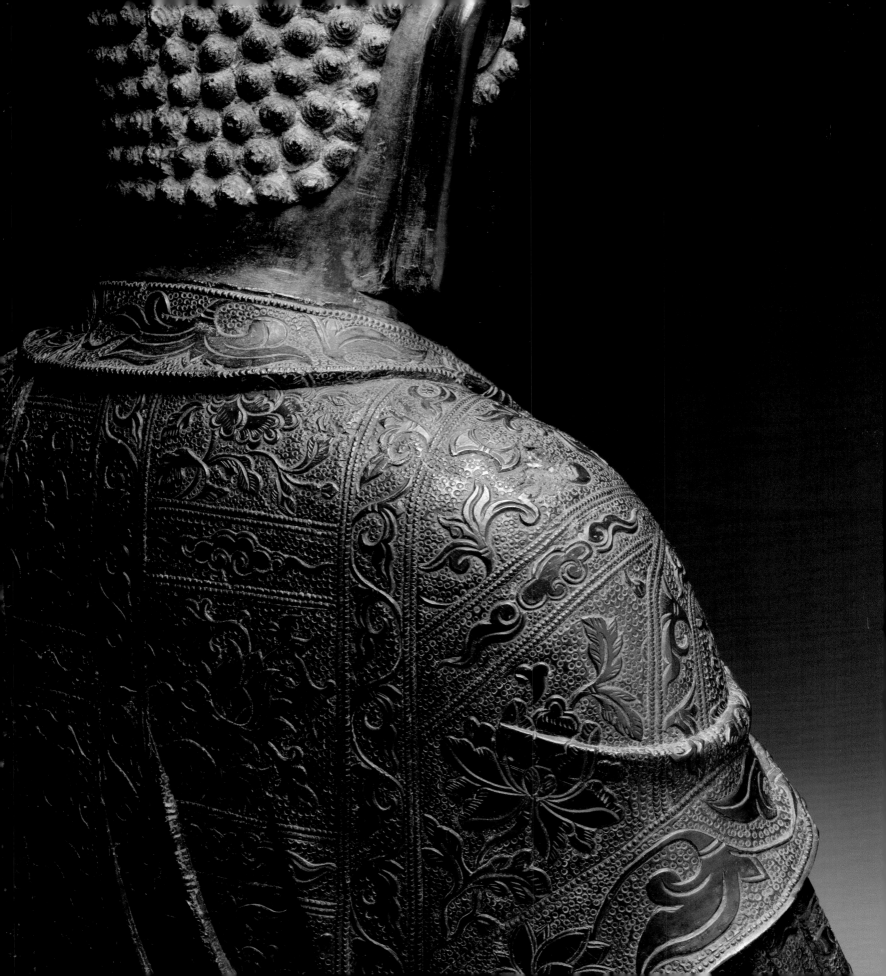

At the Edge of the Sky

ASIAN ART IN THE COLLECTION
OF THE SAN ANTONIO MUSEUM OF ART

Martha Blackwelder
John E. Vollmer

Edited by Retha J. Oliver

SAN ANTONIO MUSEUM OF ART

 This publication celebrates the opening of the Lenora and Walter F. Brown Asian Art Wing at the San Antonio Museum of Art.

This publication is produced through the generous support of the Ewing Halsell Foundation and Trinity University Press.

Library of Congress Catalog Number: 2005930236
ISBN-13: 978-1-883502-13-3
ISBN-10: 1-883502-13-6

Photography by Peggy Tenison
Edited by Retha J. Oliver
Copyedited by Laura Iwasaki
Designed by John Hubbard
Color separations by iocolor, Seattle
Produced by Marquand Books, Inc., Seattle
 www.marquand.com
Printed and bound by CS Graphics Pte., Ltd.,
Singapore

Distributed by Art Media Resources

Frontispiece: *Landscape in Contemplation*. China, Ming dynasty, dated 1382 [see cat. no. 34]

Page 2: A'mita Buddha. Korea, Choson dynasty, 18th century [see cat. no. 59]

Pages 5 and 128: Palanquin, or *norimono*. Japan, Edo period, early 19th century [see cat. no. 61]

Page 14: Horse and rider tomb models. China, Western Han dynasty, 206 BCE–9 CE [see cat. no. 4]

Page 19: Noh theater robe. Japan, Edo period, early 19th century [see cat. no. 60]

Page 20: Jar. China, Yuan dynasty, 1279–1368 [see cat. no. 32]

Page 22: Valance. China, Qing dynasty, dated to 1911 [see cat. no. 52]

Page 133: *Scenes In and Around Kyoto,* or *Rakuchu rakugai-zu.* Japan, Edo period, first half of 17th century [see cat. no. 57]

Page 152: Yogini. India, Uttar Pradesh or Madhya Pradesh, 10th–11th century [see cat. no. 63]

Page 180: Vase in *meiping* shape. China, Ming dynasty, Wanli mark and period, 1573–1620 [see cat. no. 41]

Contents

Acknowledgments

At the Edge of the Sky is the first publication devoted to the Asian art collection at the San Antonio Museum of Art, introducing our large and diverse holdings both to the public and to the academic community. The catalog celebrates the Lenora and Walter F. Brown Asian Art Wing, a permanent gift to our Museum and to the people of San Antonio.

As with any undertaking, this publication would not be possible without the contributions of a wide range of talented individuals. A debt of gratitude is owed to many people, not all of whom can be mentioned here, whose contributions, great and small, assured the success of the Asian Wing and this catalog.

Many scholars and specialists in the field of Asian art have provided invaluable knowledge and assistance with this project. We would like to thank James Godfrey for his expertise and knowledge of the collection; Amy Heller, David Weldon, and Jonathan Chaves for their beautiful translations; Pratapaditya Pal, Vidya Dehejia, Suneet Kapoor, Ramesh Kapoor, and Dan Ehnbom for information on the Indian collection; Ian Alsop, David Weldon, and Edward Wilkenson for research on the Tibetan works; Sebastian Izzard for insights on the Japanese collection; Sharon Takeda for her comments on the Noh theater robe; Julia Curtis for her research on the Chinese blue and white porcelain collection; Richard Pegg and Wen Xing for their insights into the Chinese works of art and early support of this project; and Lark Mason and John Ayers for reviewing the initial selection of objects.

Over the years spent preparing this publication, as well as the building and opening of the Asian Wing, there have been many people whose time and energy helped bring these projects to fruition. The talents of conservator Jane Gilles assured that objects looked their best. Christopher Pawlik and

John Tenison provided unflagging support during exhaustive photo shoots with Peggy Tenison, whose beautiful images fill the book along with those of Steven Tucker. Many thanks are due to the entire Museum staff, especially the offices of the Registrar and Exhibits: Rachel Mauldin, Heather Snow, Tyler Lewis, Tim Foerster, Karen Baker, and Roy Gary.

I would like to thank the curatorial assistants, interns, and volunteers of the Asian art department, who worked countless hours over several years on all aspects of the Asian Wing and this publication. Lauren Ascolese shepherded this project, seeing it through to completion. I am grateful to Emiko Murphy and Heather Eichling, who served as departmental assistants during the excitement and chaos of developing the Asian Wing, and Melanie Meyers, who provided research for this publication in its early stages. The department is blessed by the efforts of our dedicated volunteer, Molly Nunnelly, whose attention to detail and intelligence informs every undertaking on our behalf.

Writing this book has been a collaborative effort with John E. Vollmer, co-author, and our editor, Retha J. Oliver. John Vollmer brought not only scholarly expertise but perspective and support throughout the entire project. Retha Oliver's constant encouragement and professional publication management kept our ship on course even through the rockiest of times. I would like to thank both John Vollmer and Retha Oliver for their dedication and commitment to this project.

I would like to thank Marion Oettinger, Jr., Director of the San Antonio Museum of Art, for his counsel in the process of publication and for encouraging this project toward completion. Marion has shared not only his experience, but his contacts, and I am grateful to him for his introduction to Ed Marquand and Marquand Books. I am indebted to their professional team, especially Managing Editors Marie Weiler and Jennifer Sugden, Laura Iwasaki who edited our copy, and John Hubbard who designed this beautiful book.

Finally, my most sincere thanks go to the many donors who over the past seven decades have shared their collections with the San Antonio Museum of Art. It is through their gifts of generosity and vision that we share this collection with you.

Martha Blackwelder
Coates-Cowden-Brown Curator of Asian Art

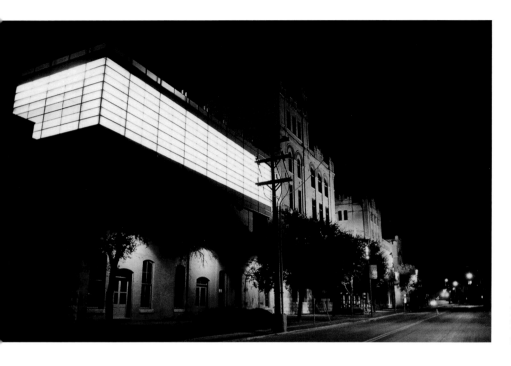

An evening view of the Chinese Ceramics Gallery, part of the 15,000 square foot Lenora and Walter F. Brown Asian Art Wing

Foreword

The opening of the Lenora and Walter F. Brown Asian Art Wing in spring of 2005 marked yet another major milestone in the remarkable evolution of the San Antonio Museum of Art. Twelve new galleries announce its commitment to the extraordinary arts of East and South Asia. This publication celebrates that milestone and the Museum's continuing commitment to the arts of China, India, Japan, Korea, Southeast Asia, and Tibet.

The Museum began informally collecting Asian art during the 1930s. San Antonians who visited Asia as tourists or on military assignment generously donated objects to our young institution, which proudly exhibited them alongside art from other parts of the world. However, the first serious commitment to establishing a major department of Asian art began in 1981 with major gifts of Chinese ceramics and porcelains from the splendid collection of Lenora and Walter F. Brown. The Browns' gifts and unflagging support have continued over the years, and today the San Antonio Museum of Art possesses one of the important collections of Asian art in the United States. James Godfrey, founding curator of the Asian Department, helped build the Museum's fine collection during its first decade, and his positive influence will be felt far into the future.

We would like to thank the many individuals, corporations, and foundations whose generous gifts made the Asian Wing possible. We would especially like to express our deep gratitude to the Ewing Halsell Foundation, which, under the leadership of the late Gilbert M. Denman, Jr., made the very first major gift to the Asian Wing expansion project. The foundation also provided funds for this publication and the photography in it. We would like to express our appreciation to Barbara Ras, Director of Trinity Press, for her early support and encouragement. Robert Washington, Administrator for the Halsell Foundation, has been closely involved with this publication and has also worked tirelessly in support of the Museum's Asian project. We thank him for his valuable time.

Every successful project has its catalyst, and Martha Blackwelder, our Coates-Cowden-Brown Curator of Asian Art, has been so here. Through her serious commitment to and advocacy for Asian art, boundless energy and infectious personality, and tireless outreach to the San Antonio community, Martha has brought the arts of Asia alive for all of us. She is at the very core of the success of this project, and the Museum is fortunate to have her with us.

Finally, I would like to thank the Museum's Board of Directors and our hardworking professional staff for bringing this project to fruition. The Asian Wing and this valuable publication were collaborative efforts from the very beginning and in every respect.

Marion Oettinger, Jr., Director

Map of Asia

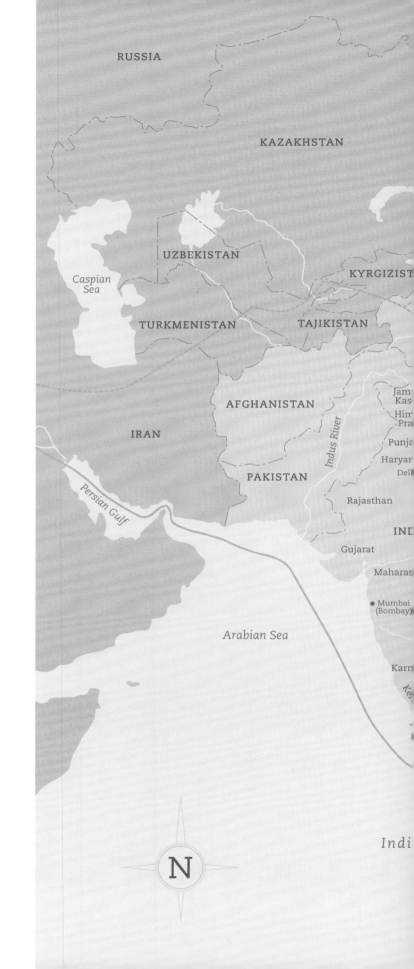

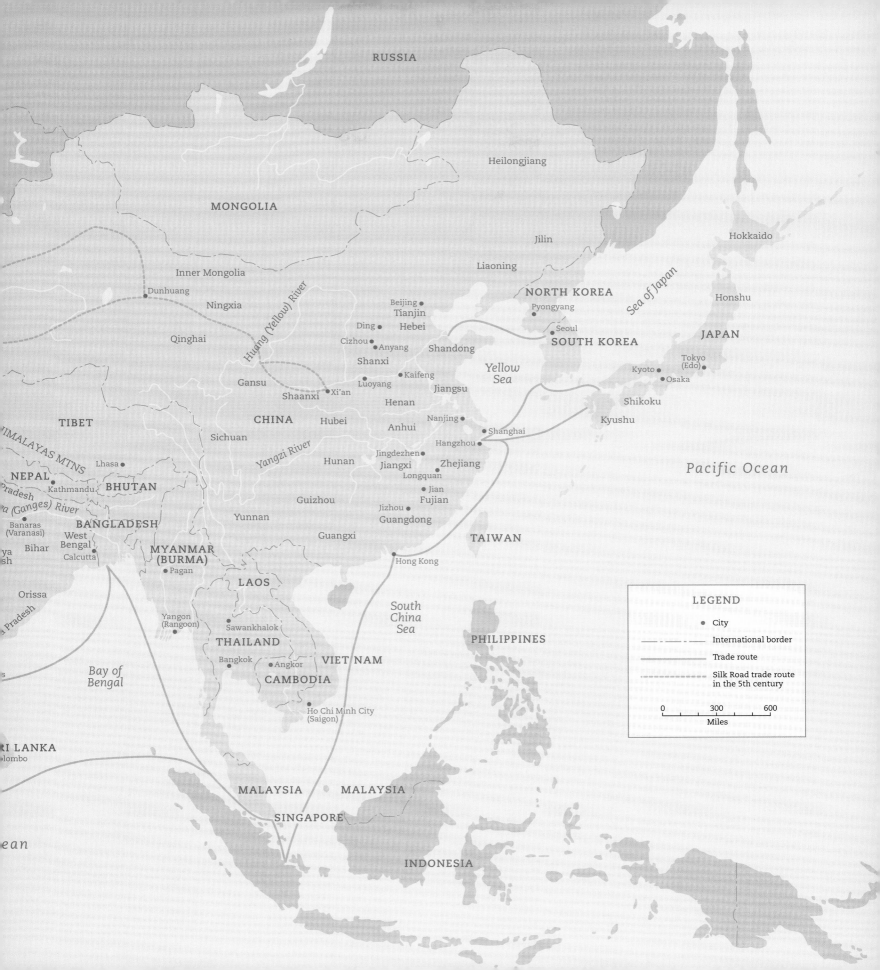

RUSSIA

MONGOLIA

Heilongjiang

Inner Mongolia

Jilin

Liaoning

NORTH KOREA

Sea of Japan

Hokkaido

Honshu

Dunhuang

Ningxia

Pyongyang

JAPAN

Qinghai

Huang (Yellow) River

Beijing ●
Tianjin

Ding ●
Hebei

Cizhou ●
Anyang ●

Shandong

Seoul

SOUTH KOREA

Yellow
Sea

Tokyo
(Edo)

Kyoto ●

Osaka

Gansu

Shanxi

Kaifeng ●

Jiangsu

Shikoku

Shaanxi

Xi'an ●

Luoyang ●

Henan

Kyushu

TIBET

HIMALAYAS MTNS

CHINA

Hubei

Anhui

Nanjing ●

Shanghai ●

Sichuan

Yangzi River

Hangzhou ●

Pacific Ocean

Lhasa ●

NEPAL

Kathmandu ●

BHUTAN

Hunan

Jingdezhen ●

Jiangxi

Longquan ●

Zhejiang

Pradesh

a (Ganges) River

Banaras
(Varanasi) ●

Bihar

sh

BANGLADESH

West
Bengal

Calcutta ●

Guizhou

Yunnan

Jizhou ●

Jian ●

Fujian

Guangdong

Orissa

Pradesh

MYANMAR
(BURMA)

Pagan ●

LAOS

Guangxi

TAIWAN

Hong Kong ●

RI LANKA

lombo

Bay of
Bengal

Yangon
(Rangoon) ●

Sawankhalok ●

THAILAND

Bangkok ●

Angkor ●

CAMBODIA

VIET NAM

South
China
Sea

PHILIPPINES

Ho Chi Minh City
(Saigon) ●

MALAYSIA

MALAYSIA

SINGAPORE

INDONESIA

ean

Timeline

	China	Japan	Korea	West
5000	Neolithic cultures 6500–1700 BCE	Jomon period 10,500–300 BCE	Neolithic period 7000–1000 BCE	Neolithic cultures (Ancient Greece) 7000–3200 BCE
	Shang c. 1600–1050 BCE			Egyptian Kingdoms and Aegean Empire 3150–1100 BCE
1500				
1000	Western Zhou 1050–771 BCE		Bronze age 1000–300 BCE	
				Early Greek art 900–480 BCE
	Eastern Zhou 771–256 BCE			
500				Roman Republic 509–27 BCE
		Yayoi period 300 BCE–300 CE	Iron age 300–0 BCE	Classical period 480–320 BCE
				Hellenistic period 320–30 BCE
	Qin 221–206 BCE			
BCE	Western Han 206 BCE–9 CE			
			Three Kingdoms 57 BCE–668 CE	Roman Empire 27 BCE–395 CE
0				
	Eastern Han 25–220			
CE				
		Kofun period 248–646		Christian and Byzantine era 100–1453
	Six Dynasties 220–589			
500	Sui 589–618	Asuka period 552–645		
	Tang 618–907	Nara period 645–794	Unified Silla 668–935	
	Liao (North) 907–1125	Heian period 794–1185		
	Northern Song 960–1127		Koryo dynasty 918–1392	
1000	Jin (North) 1115–1234			Romanesque art 1050–1200
	Southern Song 1127–1279	Kamakura period 1185–1333		Gothic art 1140–1500
1200	Yuan 1279–1368			
		Nambokucho period 1333–1392		
	Ming 1364–1644			
		Muromachi period 1392–1573	Choson dynasty 1392–1910	Renaissance 1400–1600
1500				
		Momoyama period 1573–1615		Baroque and Rococo 1575–1775
1600		Edo period 1615–1868		
	Qing 1644–1911			
1700				Neoclassicism and Romanticism 1725–1875
1800				Realism and Impressionism 1820–1890
		Meiji period 1868–1912		Modernism 1890–1940
1900				

	Thailand	Cambodia / Burma	Vietnam	India	Nepal	Tibet
5000				Indus valley civilization 2500–1500 BCE		
1500	Ban Chieng culture 1766 BCE–200 CE			Vedic period 1500–322 BCE		
1000						
500		Dongson culture 300 BCE–200 CE	Dongson culture 300 BCE–200 CE	Maurya dynasty 322–185 BCE	Birth of the Buddha in Lumbini, Nepal 563 BCE	
BCE				Shunga period 185–72 BCE		
0				Andhra period c. 70 BCE– 3rd century CE		
CE				Kushan period (Gandharan) late 1st century– 3rd century CE		
500				Gupta period 320–647	Licchavi Kingdom 300–879	
				(South) Pallava period 500–800		Yarlung dynasty 600–850
		Khmer empire 800–1200	Khmer empire 800–1200	(Northeast) Pala period 730–1197	Transitional Kingdoms 879–1200	Period of Second Diffusion 975–1250
1000	Cambodian dominance 1022–c. 1250			(South) Chola period 897–c. 1200		
1200	Sukhothai c. 1250–1378	Thai dominance		(North) Sultanate of Delhi 1206–14th century	Early Malla period 1200–1482	Sakya dynasty 1250–1368
			Vietnam conquers Champa 1400	(South) Vijayanagar period 13th century–1565		Period of Monastic Conflicts 1368–1642
	Ayudhya period 1378–1767	Angkor defeated 1437		(North) Mughal Empire 1526–1756	Late Malla period 1482–1768	
1500						
1600				(South) Madura period 1646–1900		Period of the Dalai Lamas 1642–present
1700				British rule of India 1757–1947		
1800					Unified Nepal 1769–present	
1900						

13

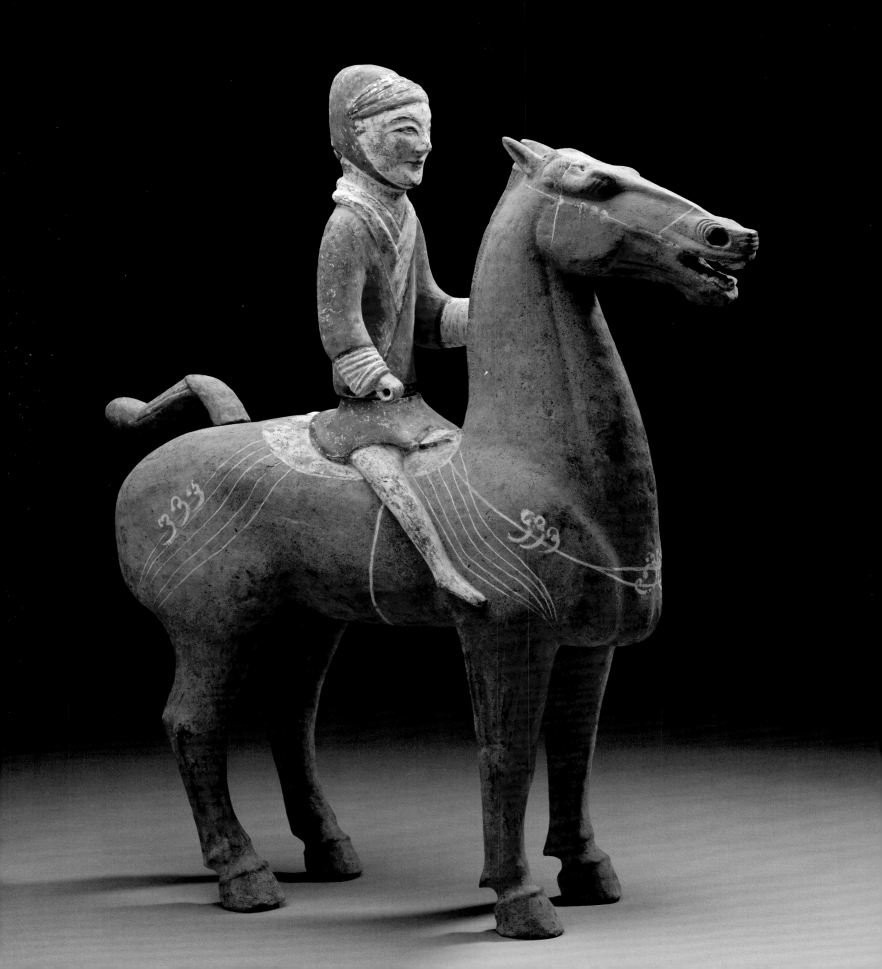

Asia in the Heart of Texas

A History of the Collection

The San Antonio Museum of Art has become a repository of treasures reflecting the three great regions that have defined global society: Western civilization, from its beginnings in ancient Greece and Rome; New World society, from pre-Columbian through the world-redefining Spanish colonial era to the present; and Asia, the towering innovator of the past and the dominant force in the near future.

By late in the 20th century, pundits and soothsayers were already referring to the century to come as "the Asia Century." Yet, as the collections at the San Antonio Museum of Art make clear, Asia has already enjoyed a century of dominance—about thirty centuries, in fact. The Chinese were making fine silks and drinking tea from porcelain while Europeans still dressed in rough cloth and ate from wooden bowls. Global history, when objectively considered, must rank the highly evolved culture and technological developments of Asia as among the earliest, and among those that would most profoundly impact mankind.

San Antonio's Asian collection began before there was a museum, back in the day when ranches and cattle ranges still co-existed with mom-and-pop groceries, feed stores, and new business enterprises near downtown. The city's military served—then as now—as a conduit between San Antonio and the world. In 1898, Teddy Roosevelt recruited his Rough Riders for the Spanish American War here, and forces shipped out to fight that war from Fort Sam Houston. The legendary General John Pershing led his San Antonio enlistees to the Philippines, replacing the Spanish colonies there with a permanent U.S. presence for trade and military operations. A few years later, Pershing brought San Antonio's first permanent Asian population to the city: Sent into northern Mexico on a punitive expedition to capture Pancho Villa, Pershing returned without Villa but brought with him 527 Chinese who had assisted his troops south of the border. "Pershing's Chinese," as they came to be known, would establish the first permanent Chinese community in Texas and remain the state's largest Asian population for decades. San Antonio comes honestly by its claim to be a "crossroads of civilizations."

The city thus enjoys the fruits of early curio collectors, individuals, and families who pursued Asian wares not as experts or formal collectors but often as the boys in uniform bringing home that which intrigued them. One of the oldest major cities in the region, San Antonio also benefited from the savvy of early cultural travelers and statesmen, such as Floyd Whittington, and pioneering donors like Bessie Timon. The early collection reflected the specific interests of a handful of pioneering men and women who represented the spirit and persistence that

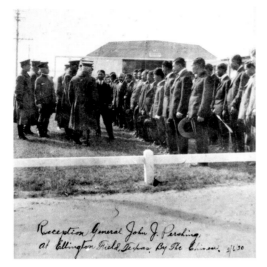

General John J. Pershing at a reception by the Chinese at Ellington Field in Houston, Texas, 1920.

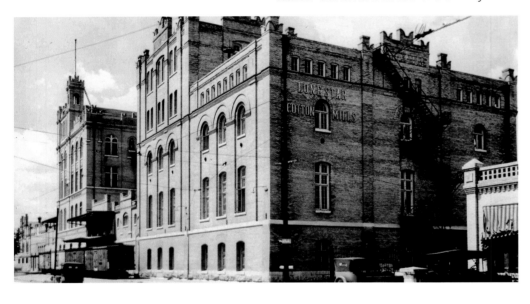

Between 1921 and 1925, in response to Prohibition, the former brewery served as the Lone Star Cotton Mills. This photograph dates from that era.

the whole world has come to think of as uniquely Texan: curious, confident, and often larger than life. Their gifts, collecting sensibilities, and foresight helped establish a base on which more recent visionaries, including Lenora and Walter F. Brown and the late Gilbert M. Denman Jr., would expand to establish an entire wing devoted to the arts of Asia.

The collections were originally housed on Broadway in what is now the Witte Museum. At the time, it served as the city's treasure trove of artifacts and art objects from many cultures. When returning soldiers visited "the mother-in-law of the Army" (as San Antonio was known), the exotic objects they brought with them often came to repose there. The first accessioned group of objects in the Asian collection dates from the 1930s and includes Chinese textiles, jades, and Japanese lacquer. Throughout the first half of the 20th century, the Museum had no collection plan in Asian art, no curator, and no purchasing agent abroad acting on its behalf. Instead, objects trickled in as singular gifts or treasures eventually given to the Museum.

While at the Witte, the Museum's wide-ranging assortment of artifacts and art objects was curated by Cecilia Steinfeldt, who wrote the first pamphlet on the Chinese textile collection in the 1980s. There, too, San Antonio's celebrated potter, Harding Black, performed thousands of glaze experiments, reconstructing the secrets of Chinese glazes, and taught a generation of San Antonians to make and love ceramics. As the collections matured, expertise was sought to guide the collecting process, and the need for a new location became critical. In the late 1970s, Lenora and Walter F. Brown began to shepherd the Museum in collecting, and James Godfrey was engaged as a consultant in Asian acquisitions.

Over time, the collections became too large and diverse to adequately house and display at the Witte Museum. In 1981, the San Antonio Museum Association moved its fine arts collections to a newly renovated site, the historical Lone Star Brewery on West Jones Avenue. Texas historical objects as well as archaeological and natural science collections were left behind on Broadway. Until 1996, the two museums remained bound together under the Board of the San Antonio Museum Association. Lenora Brown became the founding Chairman of the Board of Trustees of the new San Antonio Museum of Art in 1994 and served in that position through 1997. Her concern and vision guided the Museum as it established itself as an independent institution.

The new space allowed for the display of objects that had been buried in storage for years. Additional galleries called out for collections to fill them, and just after the new building opened, the Browns began lending and giving Chinese porcelains.

Walter Brown, a successful oil producer, is a man of many interests and cultural pursuits. He and Lenora enjoy a fascination with art and collecting that encompasses

numerous cultures and centuries. They have collected extensively from all areas of Asia, particularly wares from China for which they are well known. Mr. Brown proved a savvy collector, developing an interest and expertise in Liao ceramics which was then still relatively unknown among Western collectors. As a result of Brown's foresight the Museum displays the largest collection of Liao ceramics in this country and many gifts of Liao ceramics are presented in this catalog [nos. 21, 22, 23, 24, 25].

Prior to the Browns, no single collector or collection dominates the early years, yet there are unique stories associated with Asian acquisitions. Like Texas itself, the history of the collection is filled with strange occurrences and notable characters. Diamond theft must be among the most unusual ways to acquire objects, yet it played a role in the Museum's collection of works from India when the McFarland diamond (given by E. B. and Myrtle McFarland in 1958) was stolen from the Witte. The 49.40-carat canary diamond worth $250,000, originally belonged to the maharaja of the Mahratta Kingdom. When the diamond was taken, acquisitions intended to adorn the Jewel Room were left behind, including six miniature paintings that date from the 16th to 18th centuries. *A Prince on a Hunting Excursion* [no. 69] and *Krishna Meeting with King Kamsa* [no. 72] are among the miniatures that remain in the Museum's possession.

Bessie Timon, too, was a Texas-sized personality, the widow of Judge Walter Timon. A diminutive woman who left a large legacy, Timon was a retired school teacher, active in all types of cultural and community activities throughout much of the 20th century. Although she had diverse interests, including opera and theater, she was best known as a local authority on Chinese culture and customs. She devoted a sizable part of her life and funds to the study and celebration of

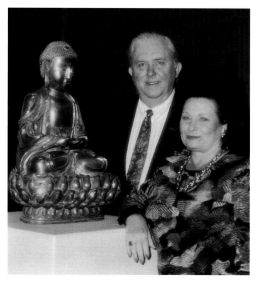

Lenora and Walter F. Brown with a Ming dynasty gilt-bronze sculpture of Amitayus Buddha.
PHOTOGRAPH BY PAUL OVERSTREET

China's culture. Newspapers of the day depict her decked out in traditional Chinese garb, giving lectures in San Antonio and Corpus Christi. In 1969, she bequeathed her entire estate to the San Antonio Museum Association. The forward-thinking Timon also set aside an acquisition fund for the Museum, which is still in use.

Timon's collection consists primarily of Chinese textiles and decorative objects. Among the noteworthy donations is a Chinese *huanghuali* six-post canopy bed [no. 46], given to the Museum in 1965. The bed was rediscovered in storage in the 1980s, disassembled and stored as dozens of small wooden parts. Chinese furniture expert Lark Mason divined its substance from these small pieces, and the bed was reassembled by a team from Sotheby's. The reassembly took place in full view of the public.

In the 1990s, another major gift augmented the Museum's growing collection when Floyd Whittington bequeathed his collection. Whittington had lived in Bangkok, Thailand, for many years and actively collected 15th- and 16th-century Southeast Asian wares as well as some Korean ceramics and other works of Korean art. A diplomat

and energy industry executive, he was among the first to recognize the unique nature of works from the region and to collect seriously and diligently. As a result, he developed what may be the world's first significant collection—so notable, in fact, that he was once asked to lend works back to the king of Thailand.

Faye Cowden and Elizabeth Huth Coates made an essential contribution to the Asian collection, not only through wares, but through vision. Cowden had accompanied longtime friends Lenora and Walter Brown to Asia and returned an Asian arts enthusiast; Coates was one of the city's most celebrated benefactors, always eager to meet cultural challenges. Together, they initiated an endowment completed by the Browns in 2005 for the curatorial position, which bears their names: the Coates-Cowden-Brown Curator of Asian Art.

With the opening of the new museum in 1981, Gilbert M. Denman, Jr., made a gift of three Indian miniature paintings, expressing his lifelong interest in the arts of Asia. Denman, one of San Antonio's most enduring cultural donors, had helped retired Oklahoma rancher Ewing Halsell set up his eponymous foundation, which still underpins much of San Antonio's cultural life decades after Halsell's death in 1965. Denman was a world traveler and aficionado of the arts whose interest in Asia was sealed as a young child in his aunt's New York apartment. There, he was entertained by a friend of the 13th Dalai Lama, who filled him with tales of life in Lhasa. In 1995, Denman realized his dream tour of Tibet, and he remained devoted to the culture of the region until his death in 2004. Under Denman, the Halsell Foundation played a powerful role in the Museum's evolution. Beginning in 1996, the Foundation became a catalyst for the development of an Asian art wing when it made the initial donation

for construction. Denman knew that the success of the endeavor would rely on the continued generosity of Lenora and Walter Brown, and he outlined the new wing's purpose in a letter to them: To express gratitude and to commemorate the Browns' ongoing contributions to San Antonio's Asian art legacy.

James Godfrey, the Museum's first curator of Asian art, initiated an acquisition plan to build a premier Chinese ceramics collection. Godfrey also expanded the exhibits to include the extraordinary collections of Kay and Tom Edson, whose Japanese lacquer and Edo period (1615–1868) paintings provide a formidable introduction to the works of Japan. With the Browns' Chinese collection and the Edsons' Japanese works as anchors, the Museum established the goal of a more comprehensive collection. A long-term loan of objects from the Asian Art Museum of San Francisco added works from India and Southeast Asia.

Godfrey guided the Museum's Asian collecting for more than a decade, bringing his comprehensive knowledge of Chinese ceramics, his savvy about the markets, and a network of collectors into the Museum's orbit. In 1996, he relocated to New York to head Sotheby's Chinese arts department. Godfrey has continued to guide aspects of the Museum's collection to the present day.

For a number of years following Godfrey's departure, the curatorial position remained unfilled. The Museum continued to expand and excel in other arenas, establishing core specialties that moved areas of the collections to prominence. The exceptional antiquities collection found a home in the Ewing Halsell Wing, and the Latin American collection came to reside in a towering new wing, constructed under the curatorial auspices of Marion Oettinger, Jr., who now serves as the Museum's director. These two outstanding

collections provide resources for scholars as well as casual visitors and have contributed to the stature of our young institution. The Museum's Asian exhibits and galleries were maintained by the graces of Gerry Scott, then the Museum's antiquities curator, who oversaw the department as a temporary guardian.

By 2000, the Museum was ready to turn its attention to the Asian art collection. Then-director George Neubert was given the charge to select a curator whose previous experiences would strengthen the Japanese collection and expand other aspects of the collections. In choosing Martha Blackwelder, Neubert found curatorial leadership that would concentrate on funds and building concerns as well as focus on advancing pan-Asian collections.

Since 2000, new sources and donors have enhanced the South Asian collections. Drs. Ann and Robert Walzer saw the opportunity to make an impact through lending and purchasing works personally and through the Nathan Rubin–Ida Ladd Foundation. The Walzers have enriched the collections in China, India, Japan, Nepal, Sri Lanka, and Tibet. Their exceptional contributions in Indian art now enables the Museum to tell that nation's story from prehistory through the 19th century. The Walzers offer a keen eye and discriminating aesthetic: Among the many noteworthy gifts from the Rubin-Ladd Foundation is the Pala period Vishnu sculpture [no. 64].

By placing confidence in this collection, with its unexpected geography, Robert Walzer has helped bring the focus of national collectors to our Texas treasure and encouraged local and regional givers to value the exceptional opportunity that exists in San Antonio. Among those new local donors are Rose Marie and John L. Hendry III, who share the Walzers' South Asian interests. These extensive new

collections allow the Museum to span regions ranging from China through South and East Asia.

With Martha Blackwelder, the Museum also reenergized efforts to secure funds for construction of the wing. Support of board members Peggy Mays and Emory Hamilton kept energy focused on the goal, and more than $9 million poured into the Museum's coffers, signaling local, regional, and national support. The architects at Overland Partners designed the glittering jewel box of glass and steel that now provides a contemporary syncopation to the Museum's weathered façade.

In part, the outflow of support reflects the city's growing Asian population in the city. From "Pershing's Chinese," San Antonio's Asian community has grown as diverse and as dramatically as the city itself. Constructing the wing has united these elements of San Antonio and spurred broad interest. Immigration, military experiences, and urbanization continue to have an impact on the city, and the annual Asian Festival (begun at the Museum) has become a fixture of the city's cultural calendar, with attendance 10,000 strong. Interest in things Asian is well established—as is the role of the Museum as a primary conduit to Asian cultures.

San Antonio now boasts organizations and schools for Chinese Americans as well as the India Association of San Antonio, the Japan-America Society of San Antonio, and numerous other Asian organizations, all of which have been galvanized by the Museum's mission. With the arrival of Toyota in San Antonio, the city's relationship with Asia will strengthen yet again, as new faces and populations continue to expand on a base of interest that has long been part of San Antonio's diverse heritage.

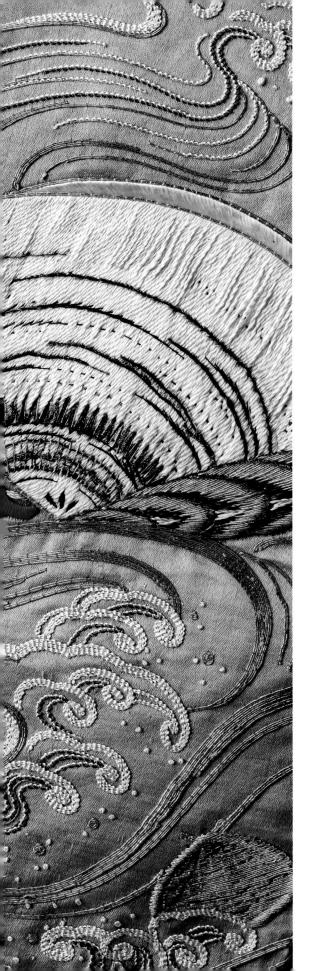

At the Edge of the Sky

The title of this volume is taken from a line of poetry incised on a 12th-century pillow [no. 26] in the Museum's collection.

> *I lean from the tall tower,*
> *Concealed behind the blind.*
> *In an ice-cold jar, wine is served;*
> *Soaked plums float in this gourd!*
> *Small "gall-bladder vase":*
> *Pomegranate blossoms arranged.*
> *Porcelain pillow, gauze curtain*
> > *just right beside the window:*
> *Green mountains, pale, pale,*
> *Dots at the edge of the sky.*
> *A fisherman, creaking his oar,*
> *Fragrant on the breeze, budding flowers:*
> *Ten miles of lotus bloom!*

In this poem, the poet observes the world from his hiding place and notes first the objects closest to him. They are functional, yet aesthetic objects, like many of those in this catalog—a vase, a jar for wine, and a porcelain pillow. The poet's perspective is constrained by his hiding place, as human perspectives often are, due to geography or imagination. Yet, beyond, through an open window, the world waits in the distance, "at the edge of the sky."

On the opposite side of the globe, we share the poet's ability to appreciate domestic touches and natural forces alike. Wherever humans dwell, we make objects of beauty and function. The skies, too, have fascinated and inspired us throughout time and across cultures, whether as home to gods or for the uncharted regions of space. We are united under one vast limitless sky.

The objects selected for this publication reflect the scope and range of the Asian art collections at the San Antonio Museum of Art. They run from the monumental to the intimate; for public worship and for private contemplation. Some are functional; others were intended for display, imbued with authority and significance. This diversity is grouped into three geographical sections that reflect the principle collecting areas of the Museum: China; Japan and Korea; and South Asia, the Himalayas and the Tibetan Plateau. Within these sections, objects are arranged chronologically, regardless of medium.

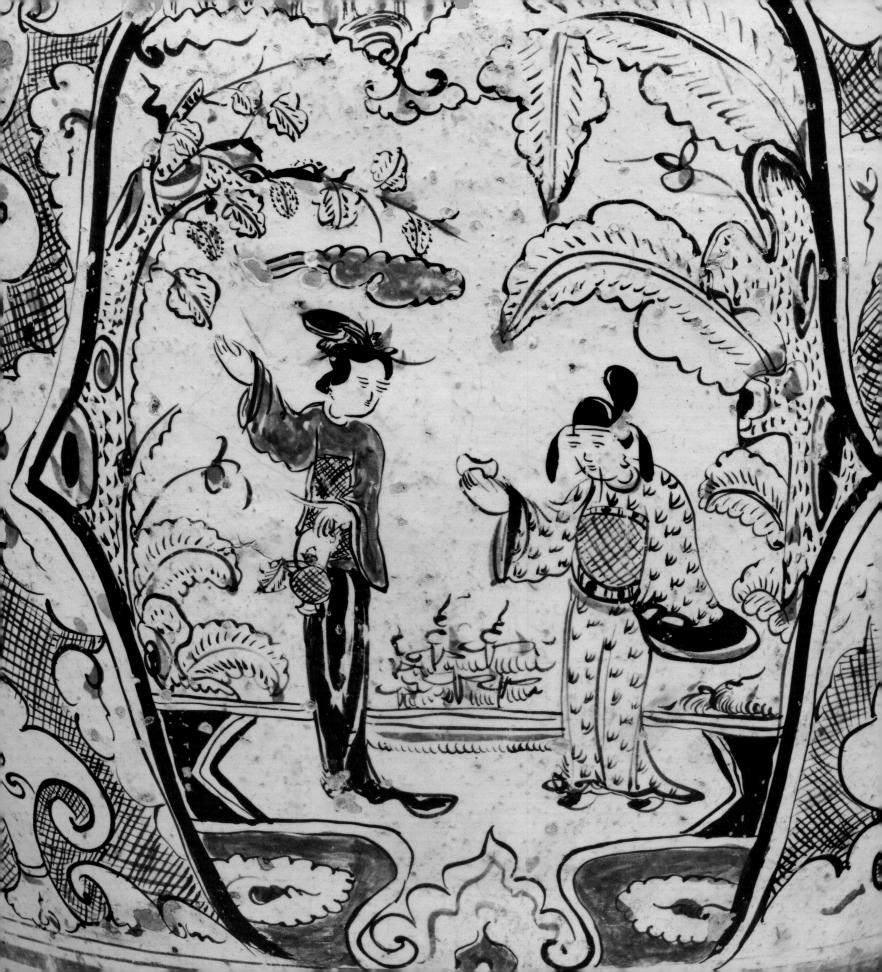

China

While the rise of secular society in the West can be traced to the Renaissance five or six centuries ago, society in China has been shaped by secular values since the founding of an empire in 221 BCE. Law and historical precedent both resulted from its strong central government and defined society for more than 2,000 years. Decrees emanated from the emperor; those appointed to administer or enforce them attained social recognition and enjoyed the privileges of their position. From the earliest periods of Chinese civilization, court rank was the key determinant of social status, economic stability, and prestige.

So pervasive was the belief in a central authority that the court also served as model for both domestic and religious life. At family gatherings such as weddings, birthdays, or New Year celebrations, the patriarch and his wife sat on throne-like chairs to receive homage from family members ranked like courtiers: by generation, birth order, and gender. Similarly, pantheons of gods and goddesses were thought to hold court when they received the adoration of the faithful, as in the painted scene decorating one side of the embroidered, silk satin valance from the last year of the Qing dynasty [see no. 52].

Attitudes about politics, society, and religion were shaped by the teachings of the fifth-century BCE philosopher Confucius. His Five Classics describe and celebrate an idealized period of social stability and peace under the Western Zhou kings (c. 1050–771 BCE), considered China's golden age. According to Confucius, the unrest that characterized his own time arose because people no longer understood their assigned roles and place in society. Those roles required them to defer to superiors while acknowledging the needs of inferiors. Confucius proposed a code of social conduct based on the family, with its precisely defined relationships. By extension, he argued that the family was the basis for an ordered political life. Just as the authority of the patriarch was assumed, the right of rulers to rule was unquestioned. Nevertheless, the ruler—like a father—was morally obligated to rule for the benefit of society.

In the Confucian plan for moral government, the ruler was aided by a class of educated scholar-officials who were ranked according to their education and performance on three sets of rigorous examinations based on the Five Classics. Those attaining the highest, or *jinshi*, degree were guaranteed a position in the imperial civil service. Rank and position were clearly marked: Objects, which served in many contexts, declared status. Entitlement to specific kinds of goods and materials in the public sphere raised awareness of the value of art and encouraged connoisseurship and the discipline of collecting and displaying decorative arts privately. Rank, privilege, and the arts were inextricably connected. Decorative objects

signified and perpetuated the class system, and those associations remain strongly embedded in Chinese society. This factor contributed to Mao Zedong's decision to unleash the Cultural Revolution in October 1966, during which so many historical artifacts and structures were destroyed.

The emphasis on education reflected the Chinese preoccupation with written language. Writing developed on the North China Plains during the second millennium BCE, and accorded dominance in East Asia to the culture that became China. Writing allowed the culture to keep records and to store its collective knowledge. Through writing, the superiority of Chinese civilization was lauded and communicated widely.

The standardization of official language and writing was one of the great achievements of the unification of China into an empire in the 3rd century BCE. Nevertheless, the written language remained complex and difficult to learn. The state examination system also perpetuated the use of complex, rather than simplified, forms of writing, which made it difficult to expand the language to include new ideas and new vocabulary. These challenges encouraged educated people to distinguish themselves by showing off their skills with particularly demanding literary styles.

Early 18th-century dictionaries list more than 50,000 separate characters, the vast majority of which were rare or obscure variants that had been accumulated over the millennia. Historically, an educated person would probably have recognized about 6,000 characters. Under Mao, characters were simplified to facilitate writing them mechanically and make them easier to learn; since his character reforms of the 1950s, a person needs to recognize only 3,000–4,000 words to read a newspaper. Despite these efforts at

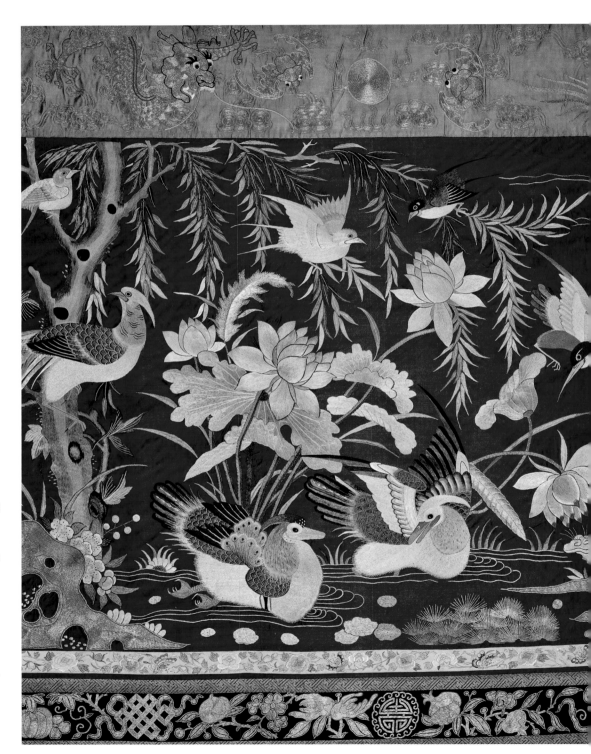

modernization, there is a certain irony in the fact that Mao's own calligraphy, which was steeped in historical tradition, was much praised and served as a model for school-children.

Like the lyric poem inscribed on the glazed earthenware pillow [no. 26] or Wang Bo's 7th-century preface and poem, which occupies an entire side of the massive under-glaze cobalt blue vase [no. 44], such writing demands a highly educated audience. Even the woman's canopy bed [no. 46], with its finely detailed words carved into the rail-ings, is meant to be read. The carving, which includes the words "good luck," "long life," and "prosperity," hints at the conception of sons who will succeed in passing the civil service examinations, thus securing status and rank for the next generation.

Writing is also at the heart of the sophis-ticated symbolism that characterizes Chi-nese decorative arts. All Chinese characters have only a single syllable. Therefore, many words are homophones, sharing the same or similar pronunciations. In oral communica-tion, meanings rely on context, intonation, and placement within a phrase. Despite this, a certain ambiguity exists, and verbal puns are a common feature of spoken Chinese. Written language, however, is extremely pre-cise. The symbolic language seen in decora-tive motifs plays with this dichotomy using images to evoke phrases wishing for happi-ness, long life, or wealth. The ram-shaped jar seen in number 10 conveys such a sentiment through the word for "ram," *yang,* which sounds like the word for "auspicious."

The decoration on the embroidered valance in number 52 transmits auspicious wishes through symbols and rebus (see detail on opposite page). For example, the pair of ducks with lotus in a poolside setting symbolizes a happy marriage, as mandarin

ducks were thought to mate for life. The lotus was particularly valued because it blossoms and bears fruit simultaneously. The word for lotus, *lian,* is pronounced the same as the word for "to repeat" and "continuous." Lotus seeds, called *lianzi,* express a potent message for continual birth of children, because *zi* means both "seed" and "child." The bats in the upper border, among dragons chasing pearls, are a common rebus for wishes of happiness. The word for bat, *fu,* is pronounced the same as the word "happiness" and "con-tentment." The lower border includes *Citrus medica* (Buddha-hand citron), peach, and pomegranate. Together, these motifs can be arranged to read "May you have an abun-dance of luck, long life, and children."

Confucian society valued the efforts of individuals on behalf of the group. In the family, all contributions were directed toward the benefit of the clan. In government, mas-sive public-works projects, such as the build-ing and maintenance of the Great Wall, were organized with conscripted labor. This trend toward subdivision of labor and centralized control is reflected in the earliest production models for the manufacture of luxury goods. The consistently high quality of these goods over time is remarkable, but not surprising given the social significance of objects.

The sheer number of art objects pro-duced in this period in China is unparalleled. The volume of production encouraged the development of extensive marketing and distribution systems. High aesthetic stan-dards made these luxury goods desirable both within and outside China. Traditionally, Chinese diplomacy was centered on the per-son of its ruler. Securing the loyalty of sub-ordinates and the support of foreign allies involved distributing lavish gifts. Sanctioned trade, the corollary of gift-based diplomacy, spread Chinese luxury goods and ideas far

beyond the borders of the empire. Through gifts and trade, Chinese rulers attempted to develop tributary relationships that kept the empire at the center of the civilized universe.

Trade also opened China to foreign goods such as the heavenly steeds, or *tianma,* of Central Asia, represented in numbers 4 and 16, that were prized by the ruling elite of the Han and Tang dynasties. The artists and artisans who created these works were also inspired by foreign influences: materials, such as cobalt ore from the Middle East, used to produce the intense blue on underglaze-painted porcelains that have come to define "chinaware" [nos. 35, 39, 41, 43, 44, 50]; tech-nologies, such as pink overglaze enamels [no. 48]; and religions, such as Buddhism, which introduced new customs and forms [nos. 25, 68].

The artifacts that follow offer a sampling of the San Antonio Museum of Art's collec-tion. They include goods made for burial, dishes for the emperor's table, objects of devotion, items for export, art for collectors, and furnishings for the home. Together, they span more than 4,000 years of history. Dem-onstrations of consummate skill and artistry, these works also embody cultural values, celebrate status, and proudly proclaim the tangible benefits of rank.

1 *Tripod ewer, or* he

China, Shaanxi province
Longshan culture, Kexingzhuang II phase,
Neolithic period, c. 3000 BCE
Earthenware
H. 8⅞ in. (23 cm)
Gift of the Nathan Rubin–Ida Ladd Foundation
Ester R. Portnow Collection of Asian Art
on the occasion of the opening of the
Lenora and Walter F. Brown Asian Art Wing
2005.9.1

The three-legged vessel is one of the most distinctive shapes to evolve in East Asia. This tripod ewer, known as a *he,* is used for heating and pouring liquids. The legs offer stability and save fuel by raising the body above the fire, exposing the maximum surface to heat.

In this example the potter transformed a functional ewer into an elegant, sophisticated vessel by rubbing the surface with a smooth stone before firing, creating a metal-like sheen. This contrasts with the unburnished areas on the underside of the handle and the interior of the spout. An applied strip of clay with pinched crenellations joins the two legs under the spout, complementing the notches that ornament the strap handle where it attaches to the back leg.

Tripods were used in the preparation and serving of both food and drink. By the Shang dynasty, three-legged food and beverage vessels were prominently displayed in sets of ritual dishes. By the Zhou dynasty, the *he* had fallen out of fashion.

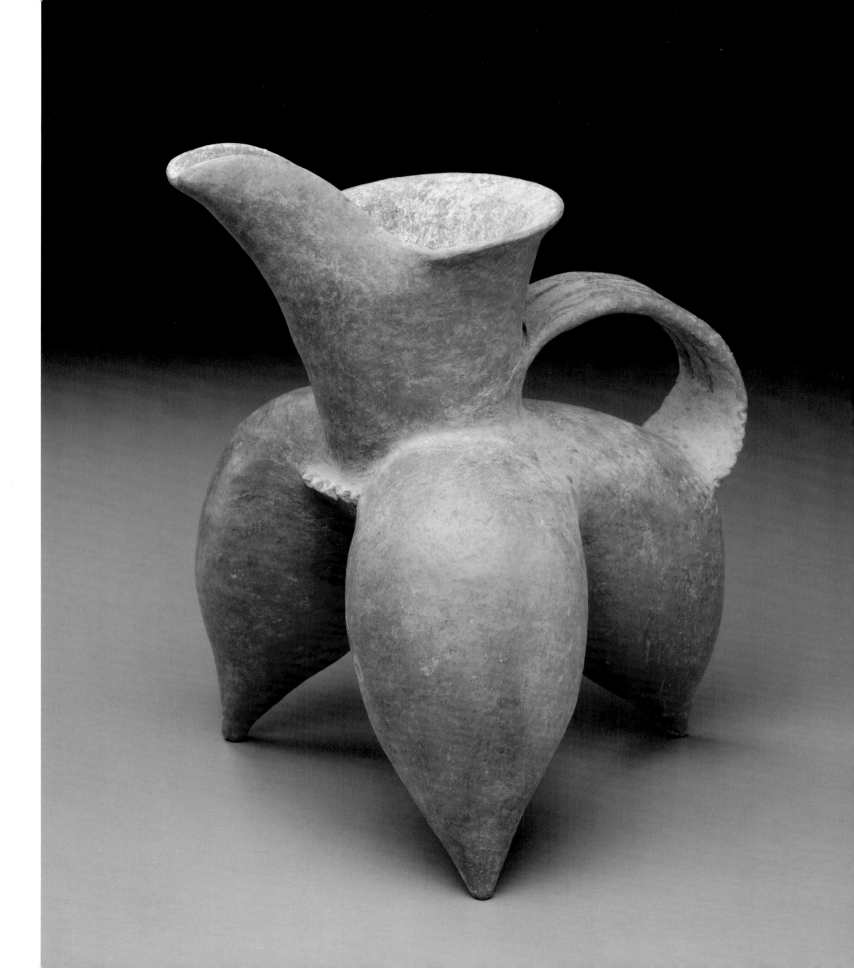

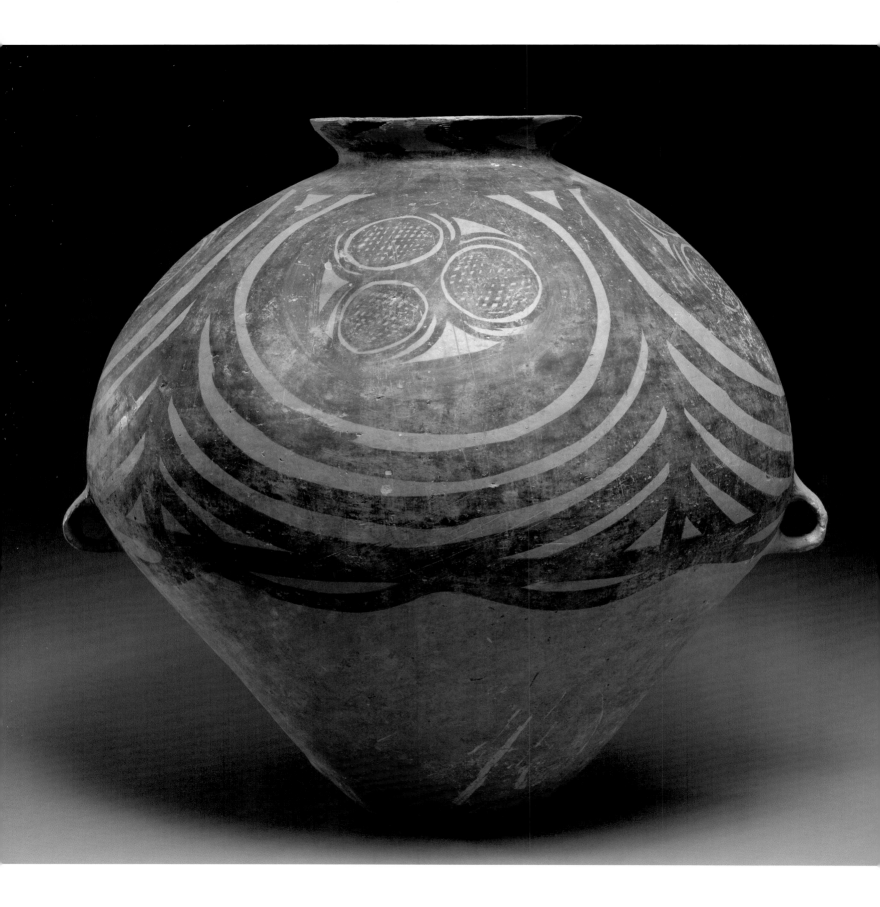

2 *Granary jar*

The jar with a swelling shoulder tapering to a narrow foot remained a characteristic vessel shape throughout Chinese history. This large, rounded jar was hand-built of clay coils in two pieces and joined at the midpoint. After smoothing the surface with a beater and anvil, the potter used an animal-hair brush to create the abstract lines and swirls that decorate the upper part of the vessel. This same tool would later determine painting and writing styles in Chinese art.

Scholars have speculated that these vessels were half buried in the ground for stability; therefore, only the upper portions of the vessel were decorated. In excavated burials, usually seven to twelve granaries were used to store millet.

China, Gansu or Qinghai province
Majiayao culture, Banshan phase,
Neolithic period, 2500–2000 BCE
Earthenware with pigments
H. 17½ in. (44.4 cm)
Gift of Mr. and Mrs. S. Roger Horchow
87.59

3 Jar

China
Western Han dynasty, 206 BCE–9 CE
Earthenware with slip and pigment
H. 12⅛ in. (30.5 cm)
Purchased with funds provided by
Faye Langley Cowden
92.14.18

Western Han dynasty ceramics made for burial were typically low-fired earthenwares decorated with pigments. This robust, ovoid jar, called *yadanhu,* or "duck-egg flask" was popular during the late Zhou and Western Han dynasties.

The vessel's decoration imitates the much more costly painted lacquerwares of the period that accompanied princely burials. The decoration features bands of swirling clouds in white, pink, red, and a dull blue, separated by solid stripes against a gray body. Echoing deluxe goods of other media is one of the recurring themes in Chinese ceramic production.

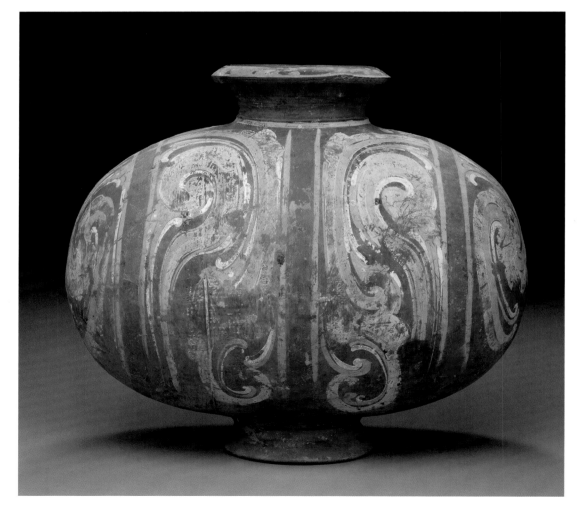

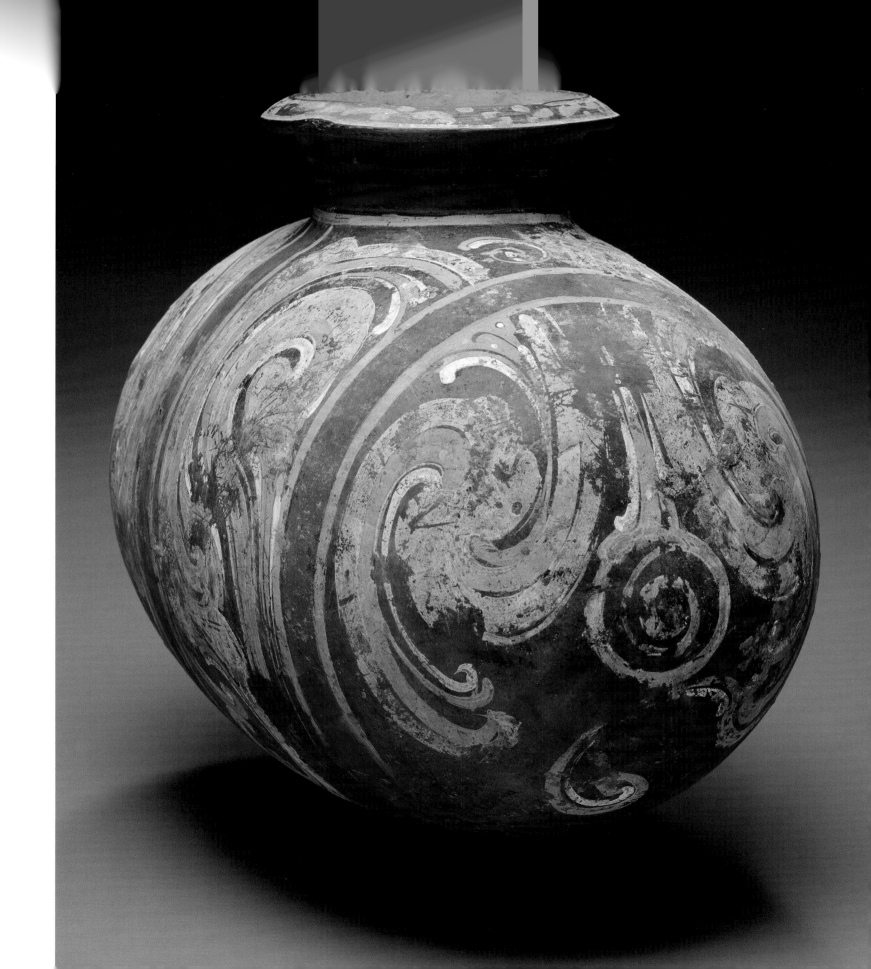

4 Horse and rider tomb models

China
Western Han dynasty, 206 BCE–9 CE
Earthenware with pigment
H. 22 in. (55.8 cm); W. 19½ in. (49.5 cm)
H. 29½ in. (74.9 cm); W. 21¼ in. (53.9 cm)
Gift of Lenora and Walter F. Brown
98.15.1.a–c
2004.20.12

Qin Shihuangdi established the first Chinese empire in 221 BCE. By then, models of retainers, rather than human sacrifices, were being entombed with the dead. Like their human counterparts in previous eras, tomb models reflected the status of the deceased in life.

These two horse and rider tomb models were part of a larger mounted escort. They marked rank and entitlement. The Chinese called their horses "heavenly steeds," or *tianma*. They were believed capable of running a thousand *li* (310 miles) a day. These tall, noble horses were of Arabian stock from Central Asia. They are very different from the smaller Mongolian horses of the Bronze Age, which pulled the chariots of early warrior princes for highly ritualized, person-to-person warfare. During the Qin and Han dynasties, cavalry replaced chariots as the elite fighting corps in the Chinese army.

This pair is similar to those excavated in 1965 at Yangjiawan in Xianyang, the site of the Qin dynasty capital, near Xian, Shaanxi province.

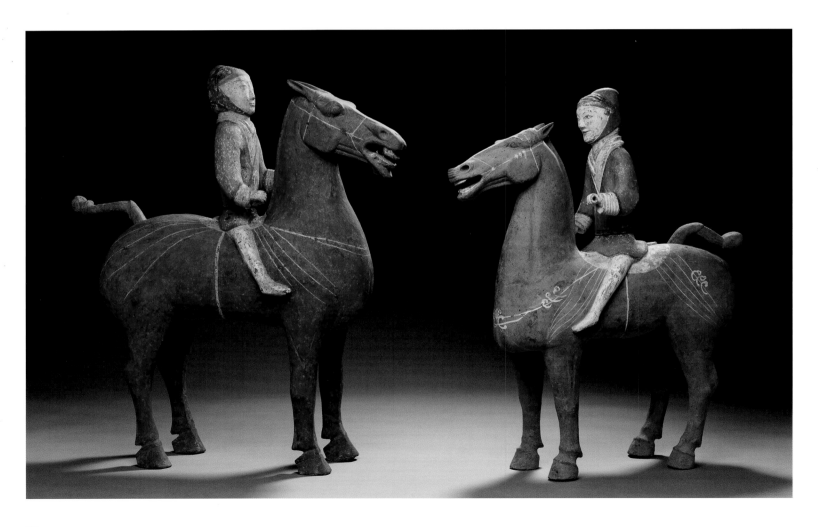

5 *Dog tomb model*

This stocky mastiff with distinctive, cropped ears (cut in triple points) once protected grave goods. Since trained dogs guarded property in life, it was logical to include them among the tomb models that represented necessities for the afterlife.

Heightened realism is typical of artistic styles from Sichuan province in western China. As recent excavations have revealed, Sichuan was the center of a highly refined Bronze Age culture that was largely independent but which paralleled developments along the Yellow River. During the Han dynasty, the western and southern parts of East Asia came under Chinese control. In turn, Chinese culture was enriched by Sichuan naturalism and the complex cosmology that marked Daoist philosophy.

China, Sichuan province
Han dynasty, 206 BCE–220 CE
Earthenware with slip and pigment
H. 21 in. (53 cm)
Purchased with funds provided by
Faye Langley Cowden
92.14.8

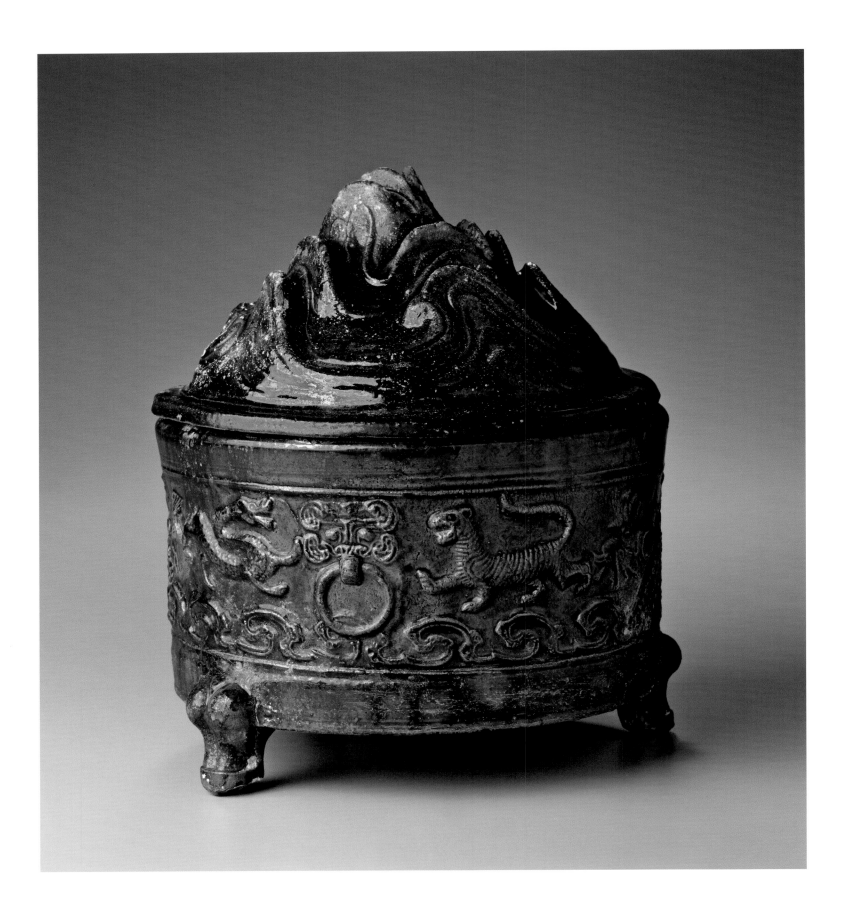

Incense burners were often depicted in the form of sacred mountains. This jar with its mountain form lid is known as a *boshanlu,* or "universal mountain censer." Mountains have captured the imagination of the Chinese since early times. In the fourth century BCE Daoism and its quest for immortality became popular: Elixirs and sites where immortals resided were introduced. The mythical island of Penglai, supposedly floating in the Eastern ocean, and Mount Kunlun, located in the far Western reaches of China, were both believed to be paradises of the immortals. Later, these became destinations for departed souls.

This incense burner is made in two parts, a cylinder-shaped container supported by three feet and a separate lid resting on top. The base is decorated with a band of landscape impressed into the clay. The landscape features cresting waves interspersed with mountainous peaks. A variety of real and imaginary animals race across the top of waves such as a tiger, a bear, a monkey, a dragon and other creatures. The lid, which is much more sculptural in form, features a three-dimensional cluster of overlapping peaks encircled by mist.

Hill jars such as this one were probably modeled after more expensive bronze models. The *taotie* mask with ring handle, included in the landscape frieze, is similar to the type found on bronze vessels from earlier periods. This incense burner does not have perforations in the lid, hence was not functional, and was probably made for burial.

6 *Censer*

China
Eastern Han dynasty, 25–220
Earthenware with lead glaze
H. 9½ in. (24 cm); DIAM. 8 in. (20 cm)
Gift of Elizabeth Huth Coates
93.93.1.a–b

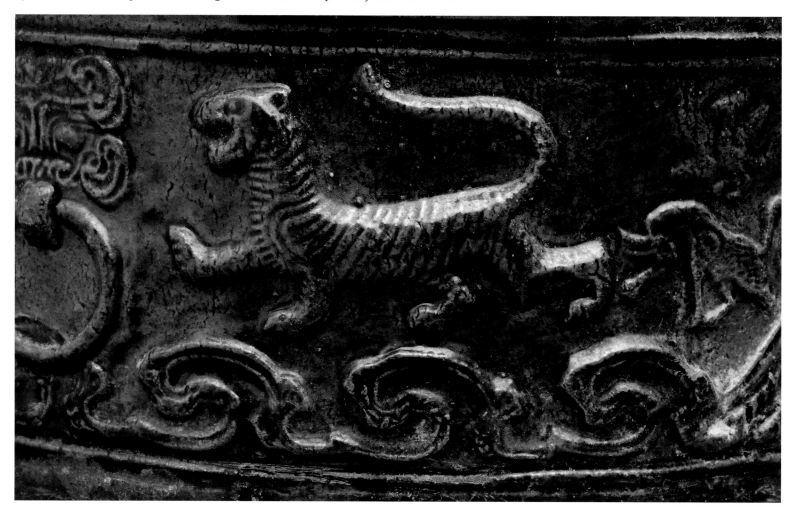

7 Watchtower tomb model

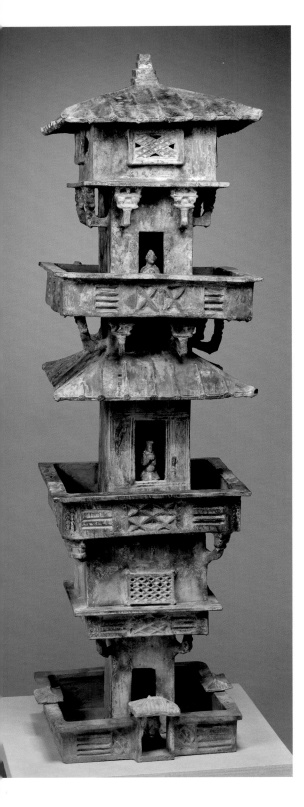

China
Eastern Han dynasty, 25–220
Earthenware with lead glaze
H. 63 in. (161 cm); W. 17½ in. (44.5 cm);
D. 17½ in. (44.5 cm)
Purchased with funds provided by the
Karen and John McFarlin Purchase Fund
89.12.a–e

Watchtowers added prestige to palace complexes during the Han dynasty. They later served as models for Buddhist pagodas throughout East Asia.

Chinese architecture evolved along the Yellow River, a region with very little good building stone but with abundant timber. Constructions utilizing wood allowed movement, hence protection from frequent earthquakes. A rammed-earth platform, faced with brick or stone, raised the floor above the damp ground. Columns of lacquered timber were set on, not into, stone bases. These were arranged in rows to support horizontal beams. Additional tie beams linked horizontal elements. All joints were mortise and tenon with a minimum of nails. Heavy, tiled, overhanging roofs gave the buildings stability in high winds and protected the construction and its platform from rain.

A system of brackets, or *dougong,* is the most visible feature of Chinese architecture, and provides structural support for the roof and decorative effect for the building. Exterior and interior walls were merely screens with no structural function.

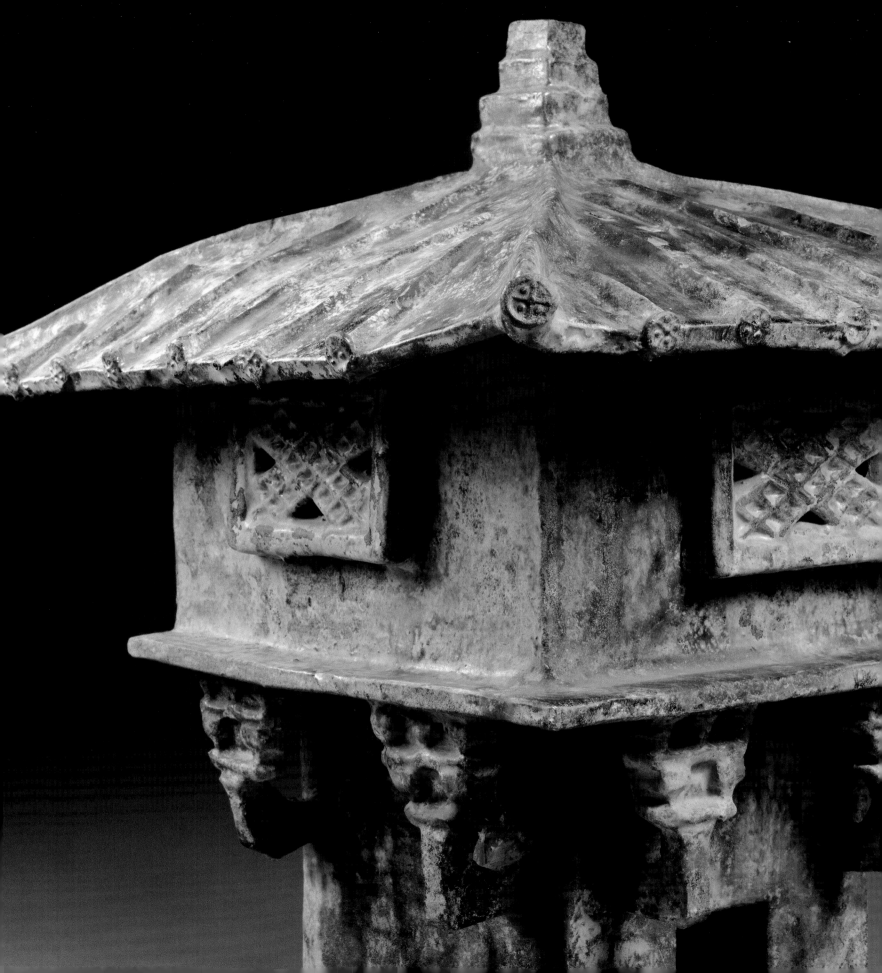

8 Jar

China
Eastern Han dynasty, 25–220
Stoneware with ash glaze
H. 18 in. (45.6 cm); DIAM. 13 in. (33 cm)
Gift of Lenora and Walter F. Brown
2004.20.8

The development of high-fired ceramic technology during the Eastern Han dynasty set the stage for one of China's most important industries. The term "stoneware" describes tough, durable ceramics that fire in kilns at temperatures between 1150 and 1300 degrees Celsius. At these temperatures, when calcium oxide and alumina are present, a glassy glaze is formed. Early glazed wares, like this jar, often have irregular patches of glaze deposited on the mouth and shoulder where wood ash introduced into the kiln during firing settled on the vessel.

This vessel imitates a contemporaneous cast-metal shape. It features details such as mask-and-ring handles and three sets of raised rings that decorate the shoulder. High-fired ceramic technology permitted potters to make thin-walled vessels, capturing the refinements of their prototypes in ways that lower-fired earthenware could only approximate. The simple band of combed wavy lines at the neck—a potter's gesture—contrasts sharply with the jar's otherwise carefully crafted metalwork imitation.

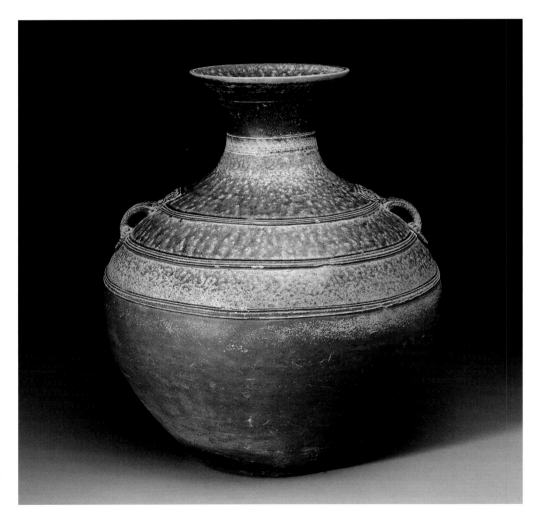

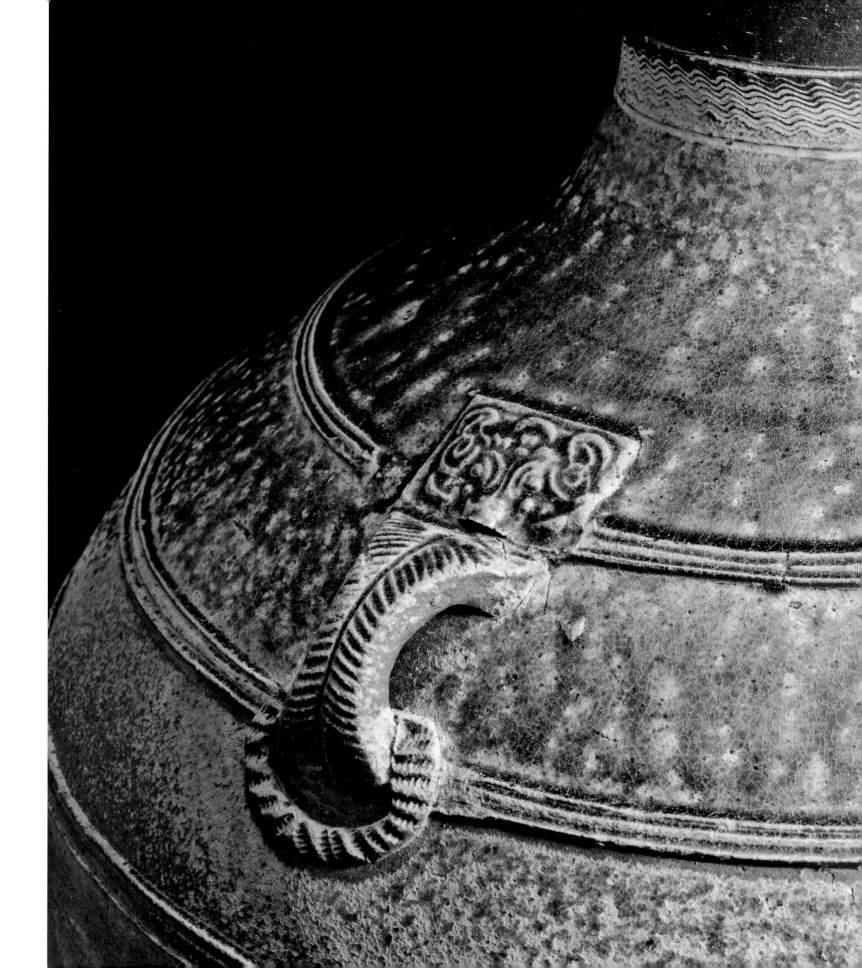

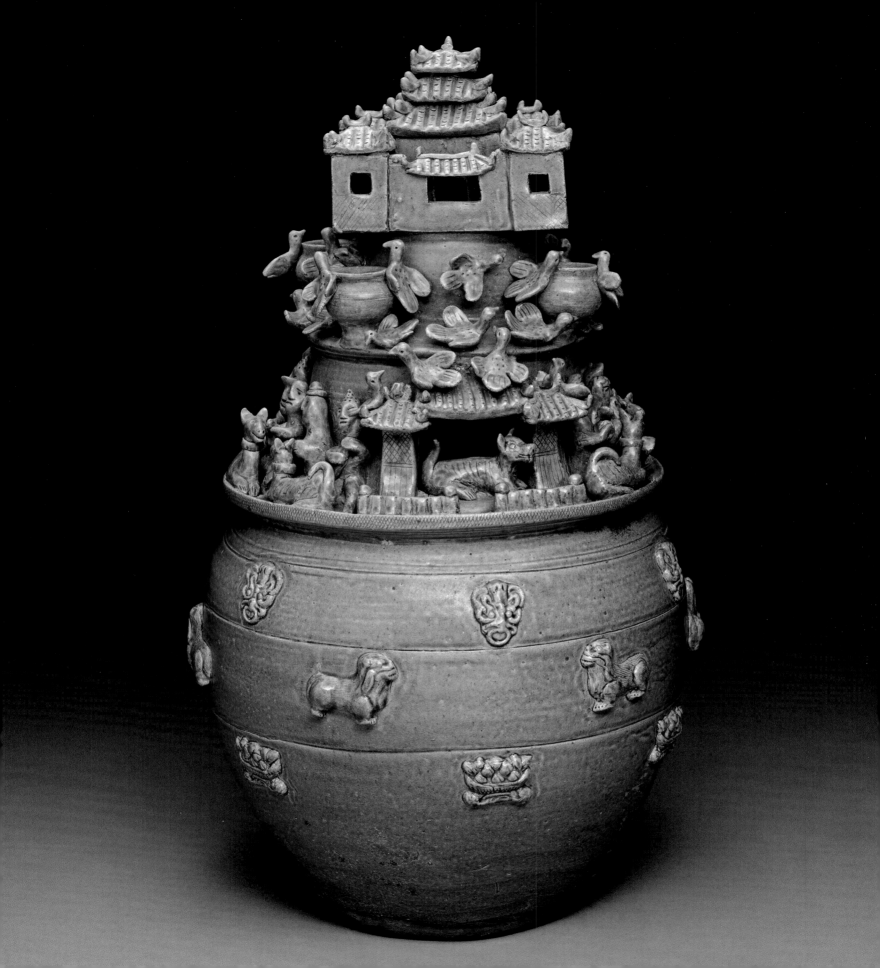

9 Granary jar

This type of elaborate jar came from the eastern central coast of China and held rice. It was interred in burials to supply food for the deceased whose ghosts would then have no reason to haunt the living. In addition to symbolically supplying food, this jar features three tiers of ornament that also address the physical comforts of the departed. Musicians and servants, farm animals, and birds encircle an elaborate four-storied house within a walled compound.

The charming sculptural composition was modeled by hand. The vessel was thrown on a wheel, and decorations of molded masks and animal plaques were subsequently applied.

China
Western Jin dynasty, 265–316
Stoneware, glazed;
Yue ware
H. 20½ in. (52 cm); DIAM. 11½ in. (29.2 cm)
Gift of Lenora and Walter F. Brown
2004.20.10

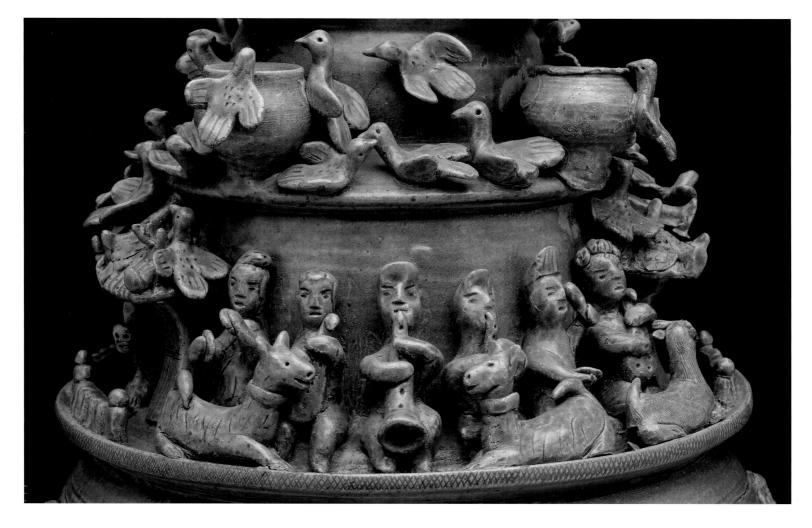

10 *Ram-shaped jar*

China
Western Jin dynasty, 265–316
Stoneware, glazed;
Yue ware
H. 6 in. (15 cm); L. 6¼ in. (16 cm)
Purchased with funds provided by
Faye Langley Cowden
92.14.2

This heavily-potted vessel was created specifically for burial. It has only a single hole at the top of the ram's head, unlike the functional Yue ware ewers, which have an additional hole, an air vent, to facilitate pouring.

In Chinese, the word for "ram" is *yang,* a homonym for "auspicious." The symbolic pouring of wine from such a container conveyed wishes for the well-being and good fortune of the deceased.

High-fired, green-glazed wares were created by adding iron oxides to the glazing solutions. They were fired in a reducing atmosphere in which air inflow was restricted in order to cause a buildup of carbon monoxide and hydrogen. These gases attacked the iron oxide, reducing it to its ferrous, or lower-oxygen-containing, state, resulting in a green rather than a brown color. Green glazes were perfected at the Yue kilns in Zhejiang province during the 3rd and 4th centuries, and green wares continued to dominate production at these kilns until the 11th century.

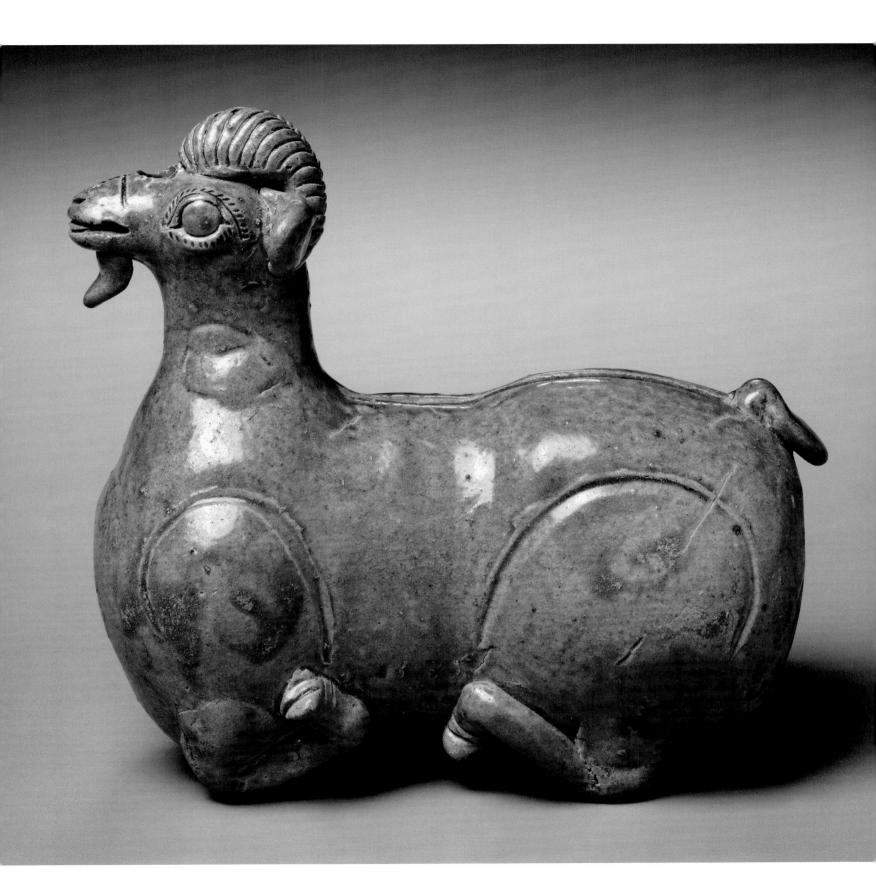

11 *Ox tomb model*

China
Northern Qi dynasty, 550–577
Gray earthenware with white slip
H. 7½ in. (19 cm); L. 14¼ in. (36 cm)
Gift of Lenora and Walter F. Brown
2004.20.6

Throughout the centuries, tombs continued to be subterranean pits that held prestige objects associated with ritual in addition to the body of the deceased. During the Han dynasty, tomb imagery featured different elements of agrarian life such as models of granary and pigsties. By the Northern Qi, however, new images came into use, reflecting changes in agricultural technology. The massive ox, a castrated bull, is a powerful beast of burden whose use transformed agricultural habits.

Ceramic models of oxen and oxen pulling carts appear in large numbers during the Northern Qi dynasty, reflecting the animal's newfound status. This example is unusual because it features the animal in a recumbent pose and unharnessed, with beautifully detailed, even gentle, features.

Ox carts became more widespread by the 6th century and remained in use throughout the Tang dynasty.

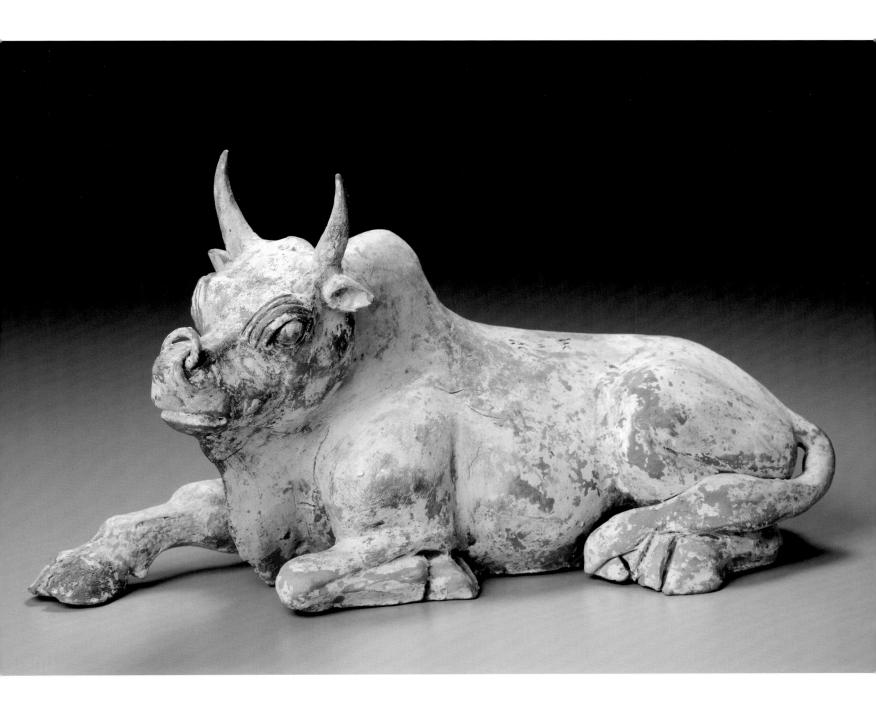

12 *Pair of soldier tomb models*

China
Northern Qi dynasty, 550–577
Gray earthenware with white slip and pigment
H. 18½ in. (47 cm)
Gift of Lenora and Walter F. Brown
2004.20.5

The expressive hands and strong faces on these figures may represent northern, possibly Turkic, peoples. Originally, each soldier would have held a lance or halberd. The large shield resting on the left foot of each figure bears two tiger faces, possibly indicating rank; other related soldier models of the period have lion masks on their shields.

The potter has stressed the details of military dress and armor. Heavy, sleeved tunics, ending at the knee, are worn over leggings and protective chaps. A fitted helmet with earguards and backflaps protects the head. The style of armor known as *mingguangkai,* or "bright-and-shining armor," featured padded shoulder guards, breastplates, and backplates, each with a pair of ovals made of polished metal. Such armor was worn on the battlefield as well as by court officials during the Six Dynasties period (265–589).

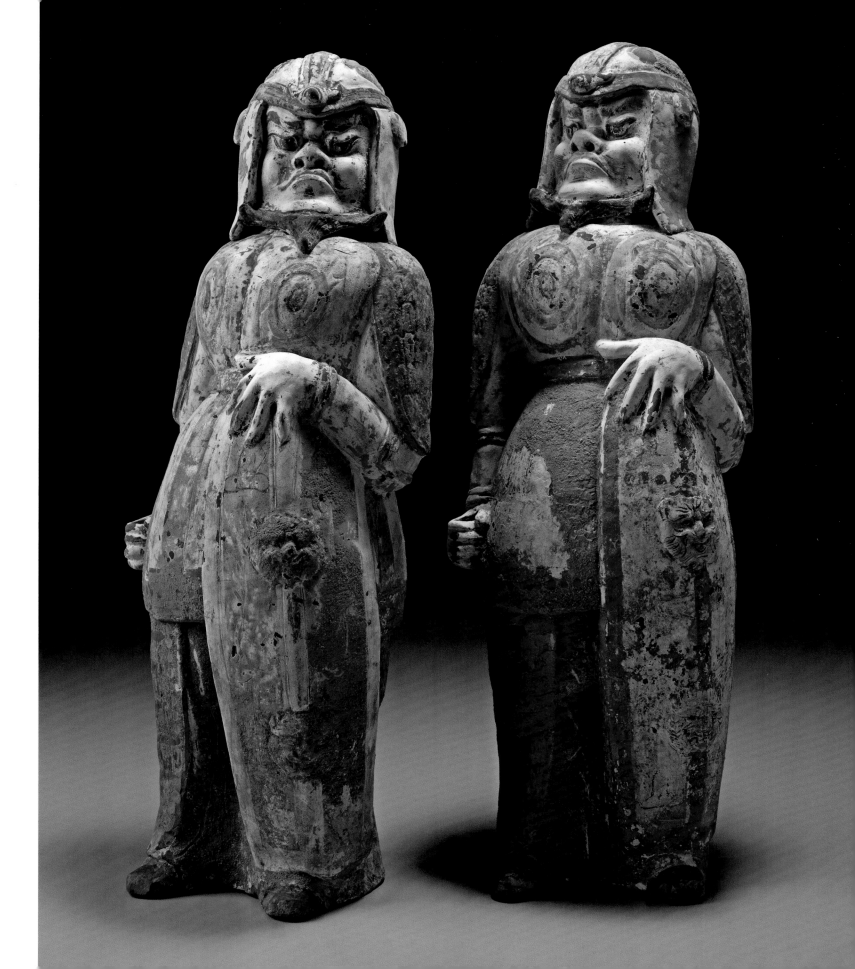

13 Set of musician tomb models

China
Sui dynasty, 589–618
Earthenware with slip and lead glaze
Average H. 12½ in. (31.7 cm); W. 3½ in. (8.8 cm)
Purchased with funds provided by
Faye Langley Cowden
94.17.1.a–h

Music was a significant part of Chinese ritual, a fact confirmed by the variety of drums, bells, and chimes that were included in Bronze Age tombs. During this period, the musicians were entombed with their instruments: In 433 BCE, thirteen young women were buried in the side chamber of the Marquis Yi of Zeng's tomb.

A thousand years later, the prestige of all-women orchestras continued, but models, rather than actual players, accompanied the dead. This eight-member ensemble plays a range of instruments, indicating the impact of international trade. The multi-piped instrument held by the musicians at the left, the *sheng,* has a long history in China, but the small lute held by the third woman and the gongs held by the sixth and seventh were imported from the West. The grouping also includes a transverse flute similar to instruments used in South and Southeast Asia.

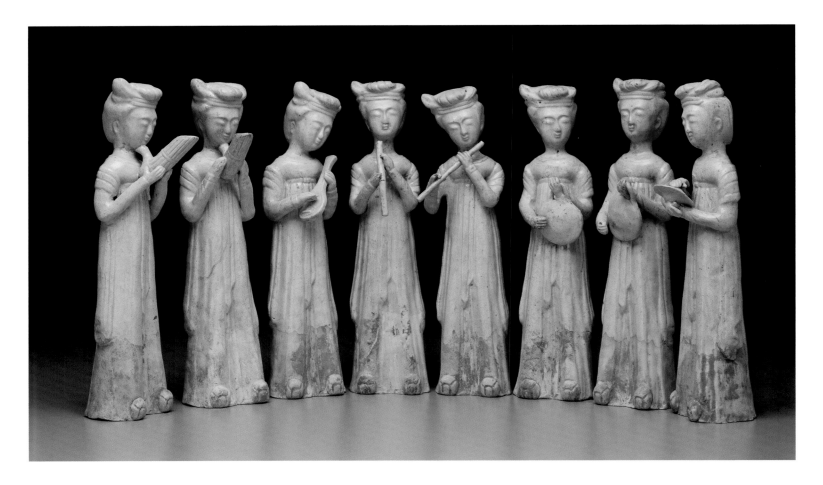

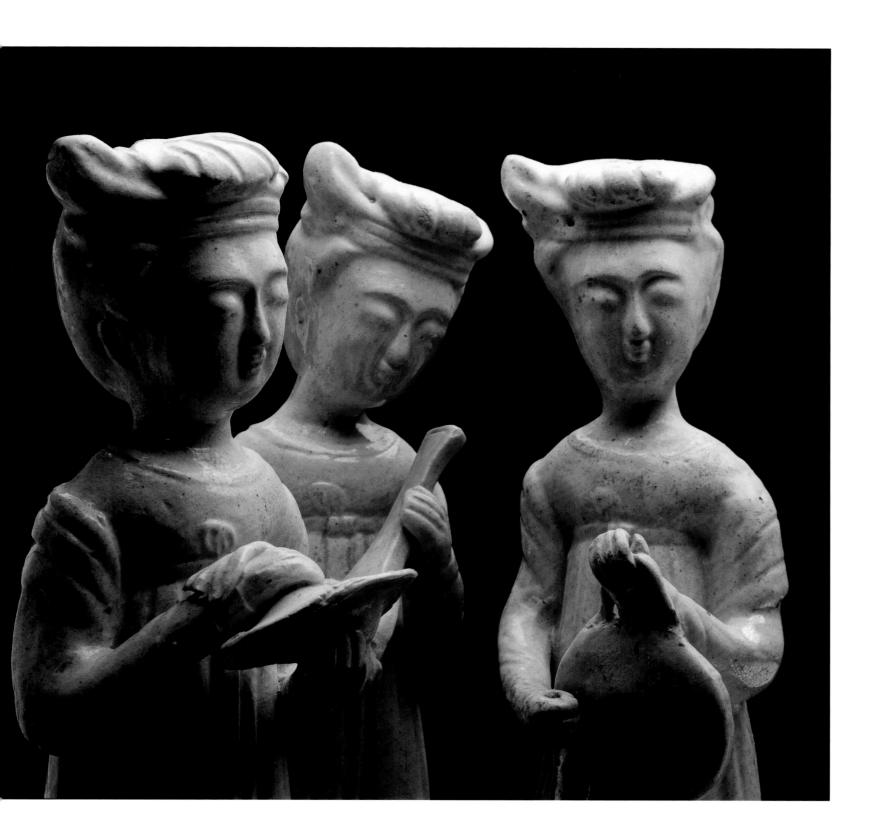

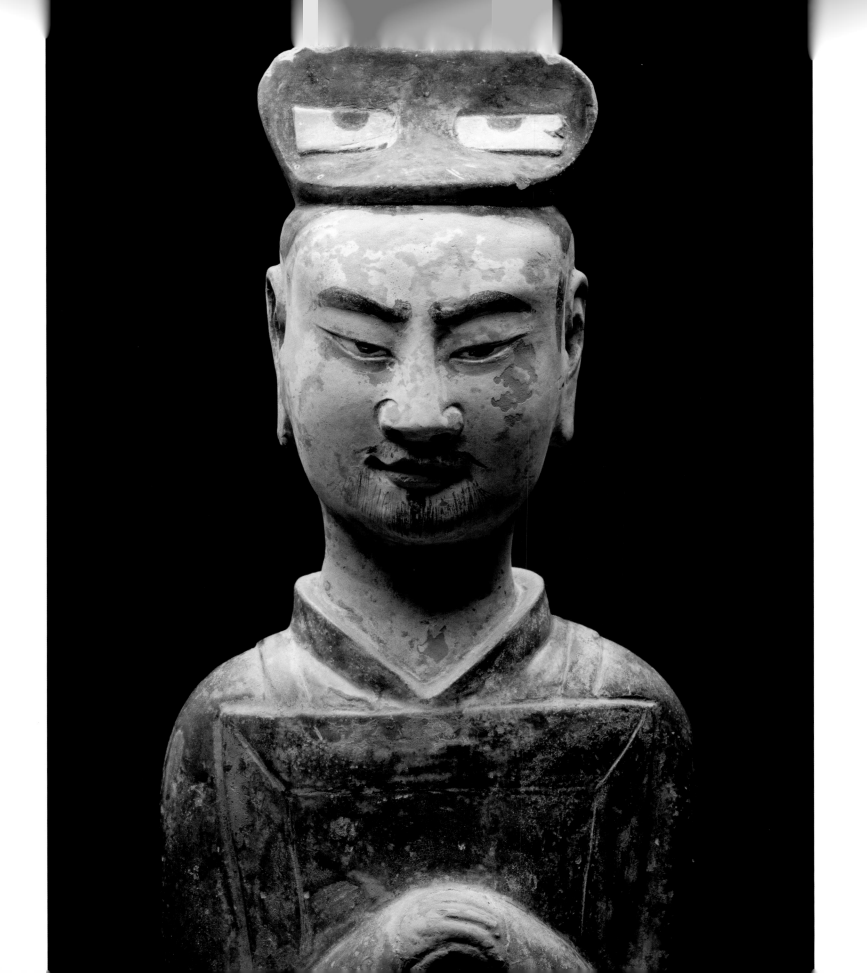

The Sui and Tang dynasties reinstituted civil service exams, which had originated during the Han era, to determine the best candidates for government positions. The power structure at court changed so as to balance the new class of Confucian-educated professional administrators with the older military elite. Tomb chambers also reflected the changes and came to resemble the spaces of the imperial court where martial and civil administrations met. This retinue includes a pair of civil officials and two military officers. One of the officers is a foreign mercenary who wears a long coat cape-like over his shoulders in a style that arose in Central Asia and on the Iranian plateau. Two earth spirits—one with a human head, the other with an animal face—complete the set.

China
Sui dynasty, 589–618
Earthenware with slip and lead glaze
Tallest figure H. 27¾ in. (70.5 cm)
Purchased with funds provided by the Lillie and Roy Cullen Endowment Fund
92.58.a–f

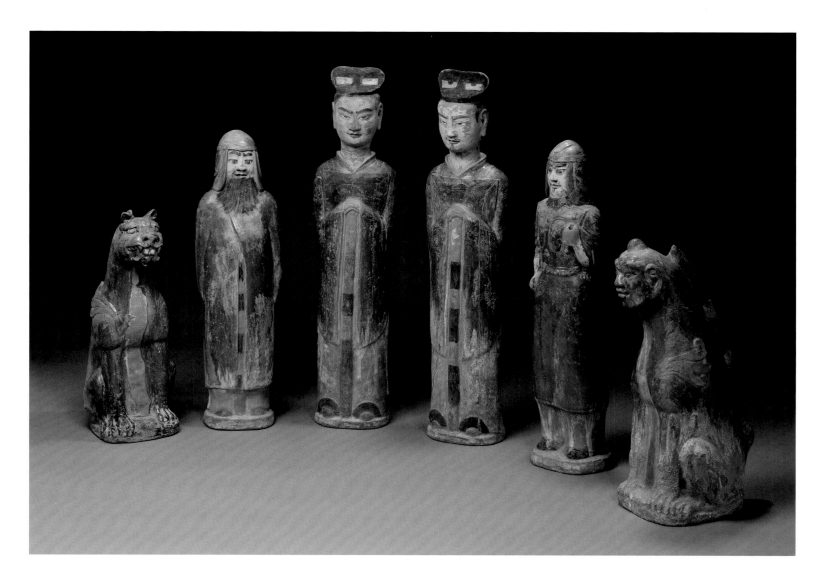

15 *Camel tomb model*

China
Tang dynasty, late 7th century
Earthenware with slip
H. 38 in. (96.5 cm); L. 34 in. (86.5 cm);
W. 14 in. (35.5 cm)
Purchased with funds provided by the
Bessie Timon Endowment Fund
2000.23

The domestication of the two-humped Bactrian camel made transcontinental commerce between China and the West possible. Although cantankerous, as this sculpture of a braying beast suggests, the species is endowed with extraordinary endurance. Camels could bear more than 400 pounds of cargo, travel long distances without fresh water, and weather sandstorms by constricting their nostril openings.

Models of camels and their foreign handlers were frequently included in Tang dynasty tombs. They represented both the economic and cultural gains to be obtained from commerce along the Silk Road, which linked the markets of China with those of Central Asia, Persia, and the Mediterranean.

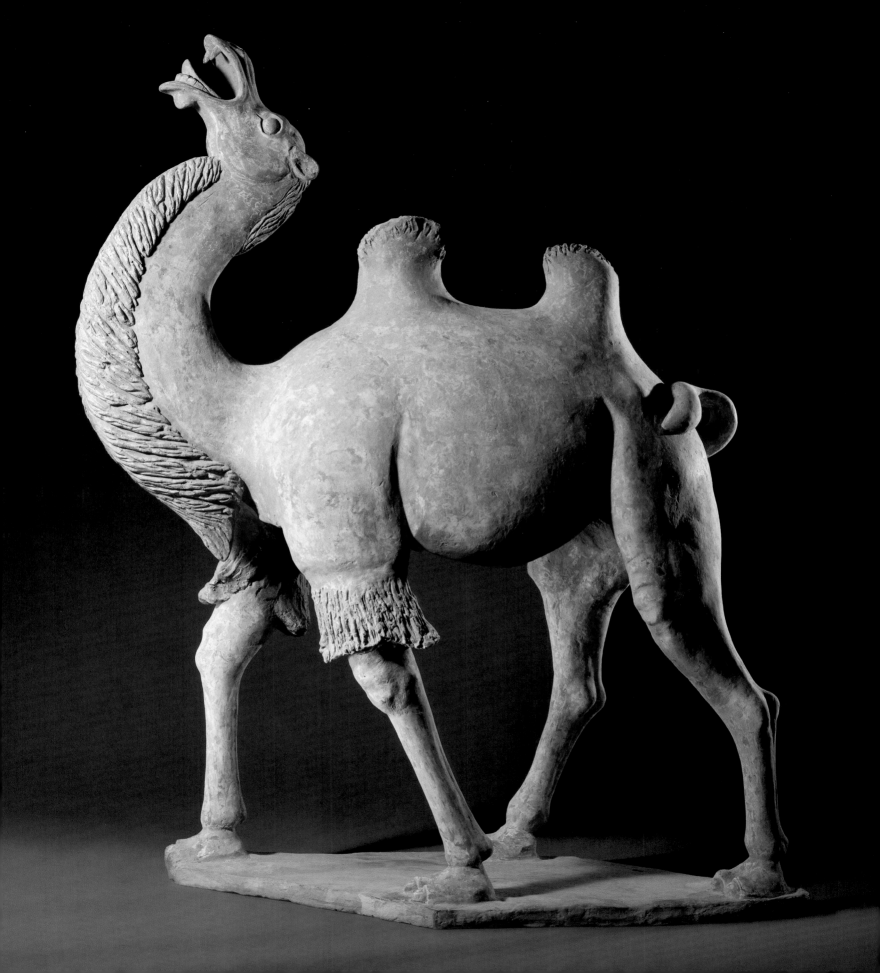

16 *Horse tomb model*

China
Tang dynasty, 618–906
Earthenware with slip and lead glazes;
Sancai ware
H. 24⅜ in. (62 cm); W. 24½ in. (62.3 cm)
Gift of Lenora and Walter F. Brown
82.174

For nearly 1,000 years, from the Han through the Tang dynasty, the *tianma,* or heavenly steeds, of Central Asia were prized by China's ruling elite. These highly coveted animals were imported from the pasturelands of Ferghana, in what is now Uzbekistan, often with their foreign grooms and trainers. Beautifully sculpted and glazed tomb models often accompanied the horses' owners in death, marking the high status and prestige of these aristocrats in life. Many of these deluxe steeds were caparisoned with elaborate harnesses and saddles, which were decorated with finely cast and gilded metal fittings.

In this example, the potter applied green, amber, and cream glazes to the surface. These glazes melt at slightly different temperatures causing them to run and blend together. The style of glazing is known as *sancai,* or "three colors." This dramatic glazing technique became synonymous with Tang dynasty taste.

Like today's private jets, the horses were trophies of position and rank. With the collapse of the Tang dynasty in the 10th century, political power passed from the military class to the civil bureaucracy of the Song imperial court. The flamboyant tastes of the Tang, which had extended to conspicuous displays of expensive status symbols in tombs, also passed out of style.

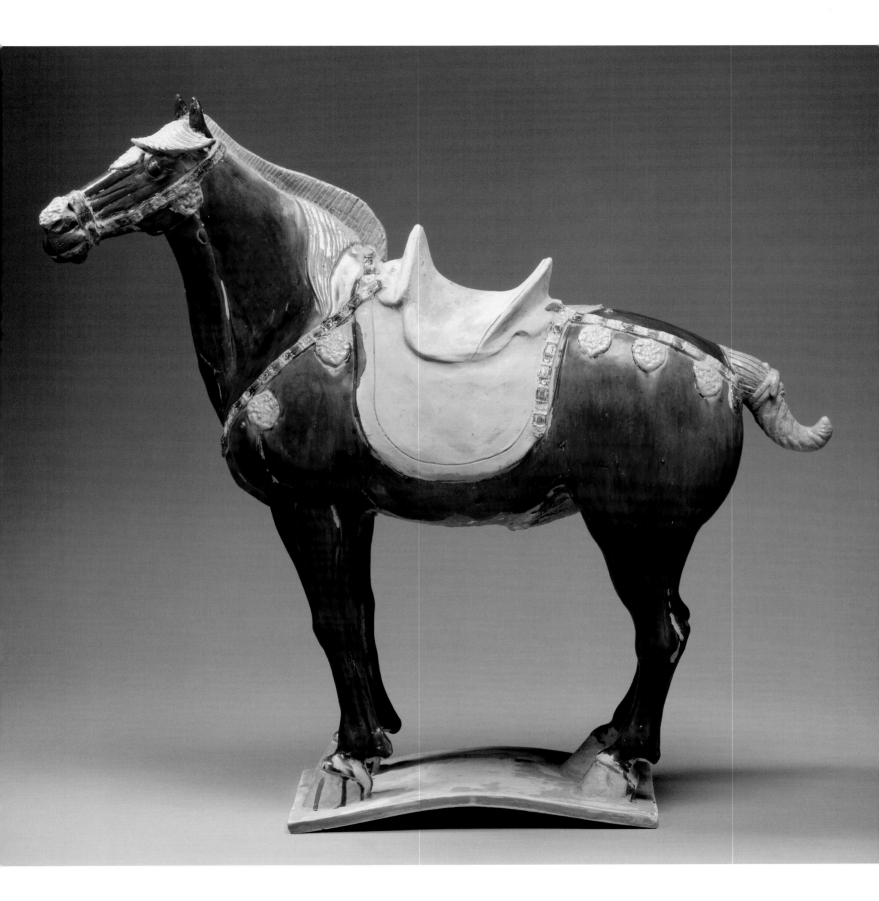

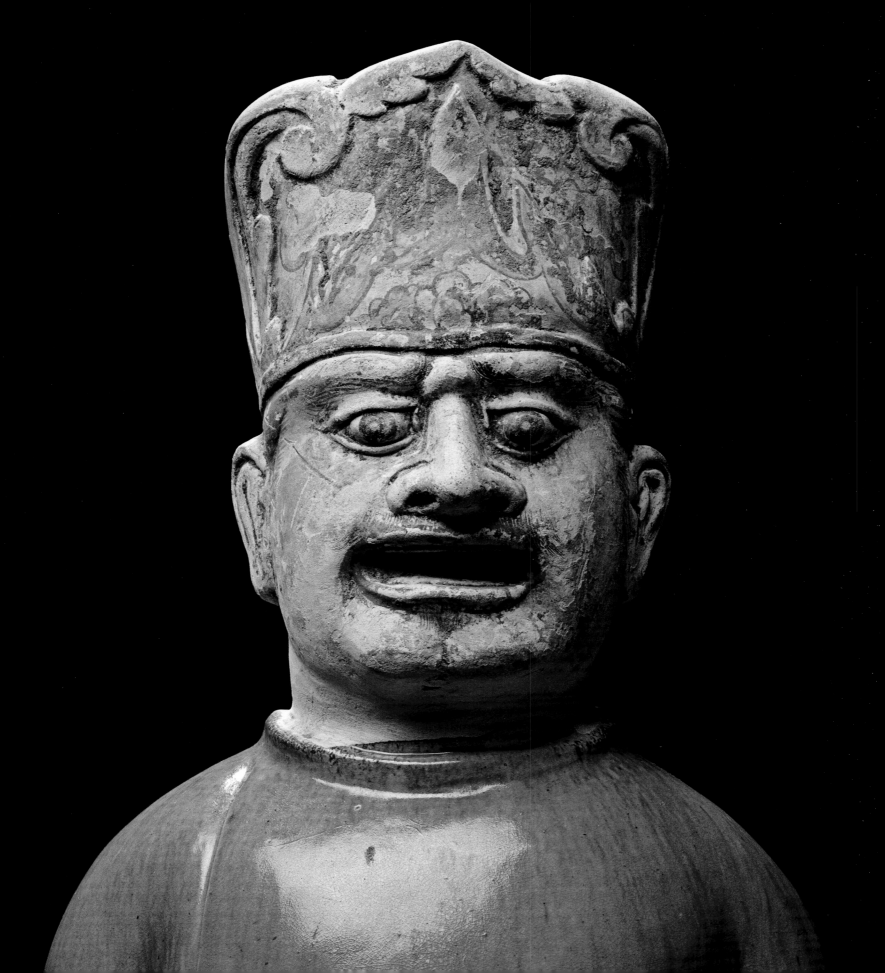

International commerce connected the Tang empire with other parts of Asia and the West and contributed to the cosmopolitanism of the Tang dynasty court. Foreign nationals were present in China, as were foreign goods and ideas. Representations of these exotic peoples were included in the tombs of high-ranking court officials and military leaders.

Models like this figure capture the non-Chinese elements of costume and facial features. The tall, crown-like hat and three-quarter-length coat, with its asymmetrical, overlapped closing, are related to the type of clothing worn by the Qidan groups from the north, founders of the Liao dynasty.

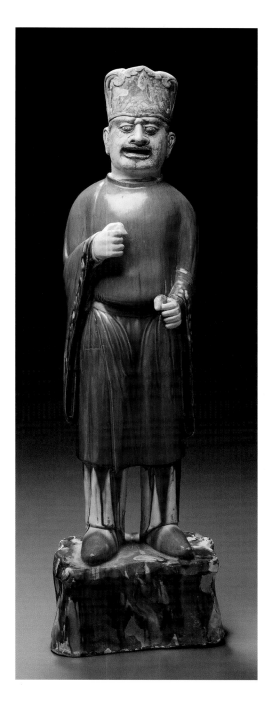

China
Tang dynasty, 7th–8th century
Earthenware with slip and lead glazes; *Sancai* ware
H. 35¼ in. (89.4 cm); w. at base 9⅞ in. (24.9 cm)
Purchased with funds provided by the Cowden Acquisition Fund
92.50

18 Earth spirit

China
Tang dynasty, 8th century
Earthenware with slip and pigments
H. 35¼ in. (89.5 cm)
Gift of Lenora and Walter F. Brown
2004.20.7

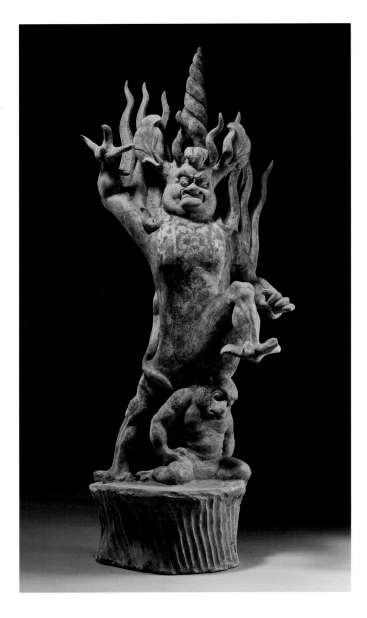

Guardian figures embodying the realm of demons and earth spirits were added to the retinue of Chinese tomb models, possibly in response to Buddhist influences coming from India and Central Asia. Within Sui and Tang dynasty burial practice, two types of *qitou*, or "earth spirits," were charged with keeping the soul of the deceased from wandering. One was human-headed; the other was depicted with an animal head.

This dynamic figure, with grotesque human face, horns, and flames, strides defiantly on taloned feet over a recumbent figure. The form embodies the animated expressiveness of the best of high Tang dynasty sculpture. The costume that covers his chest features the remains of an elaborately painted floral design, conveying the richness of contemporaneous silk brocades. These luxurious fabrics signaled status and rank in Tang society.

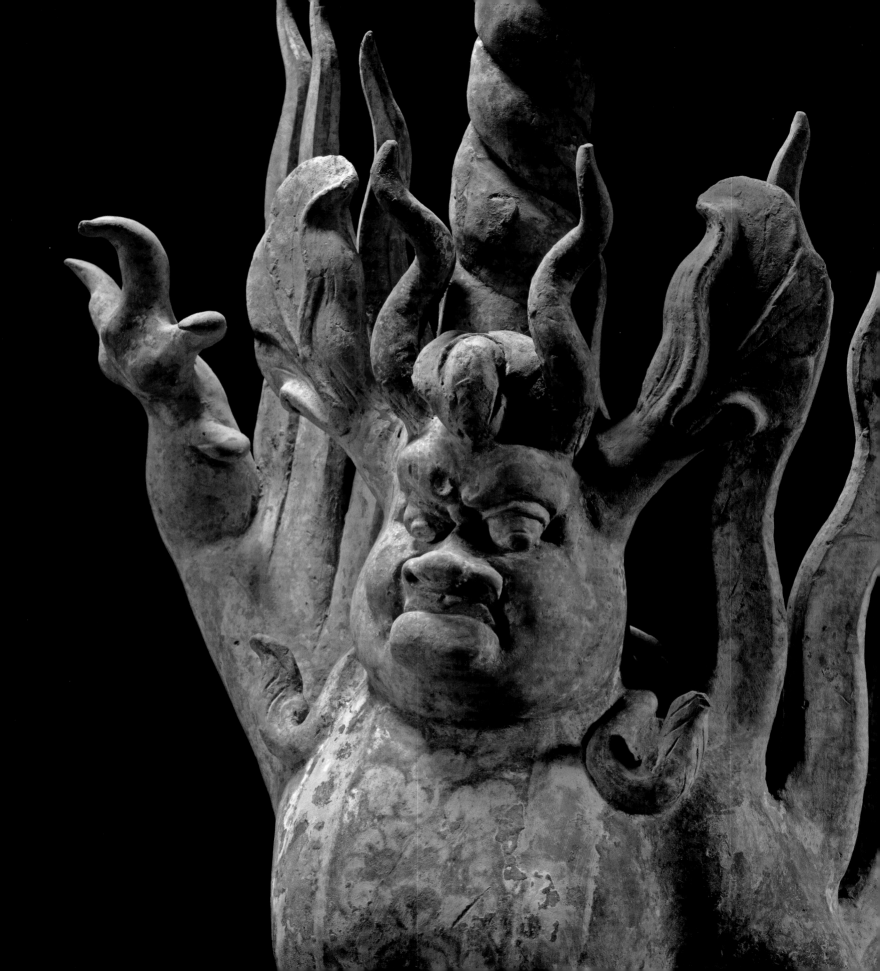

19 *Earth spirit*

China
Tang dynasty, 8th century
Earthenware with slip and lead glazes;
Sancai ware
H. 35¾ in. (90.8 cm)
Purchased with funds provided by the
Bessie Timon Endowment Fund
92.56

The complex shape of this flamboyant figure is a tour de force of the Tang potter's art. The large body parts were molded. Other details such as the feathered wings and spiky mane were separately molded and applied. Much of the finishing work was modeled by hand.

In this example, the potter generously applied the *sancai* glazes of amber, cream, and brown. These colors melt at different temperatures in the kiln producing a rich and vibrant effect seen here especially on the torso, legs, and base.

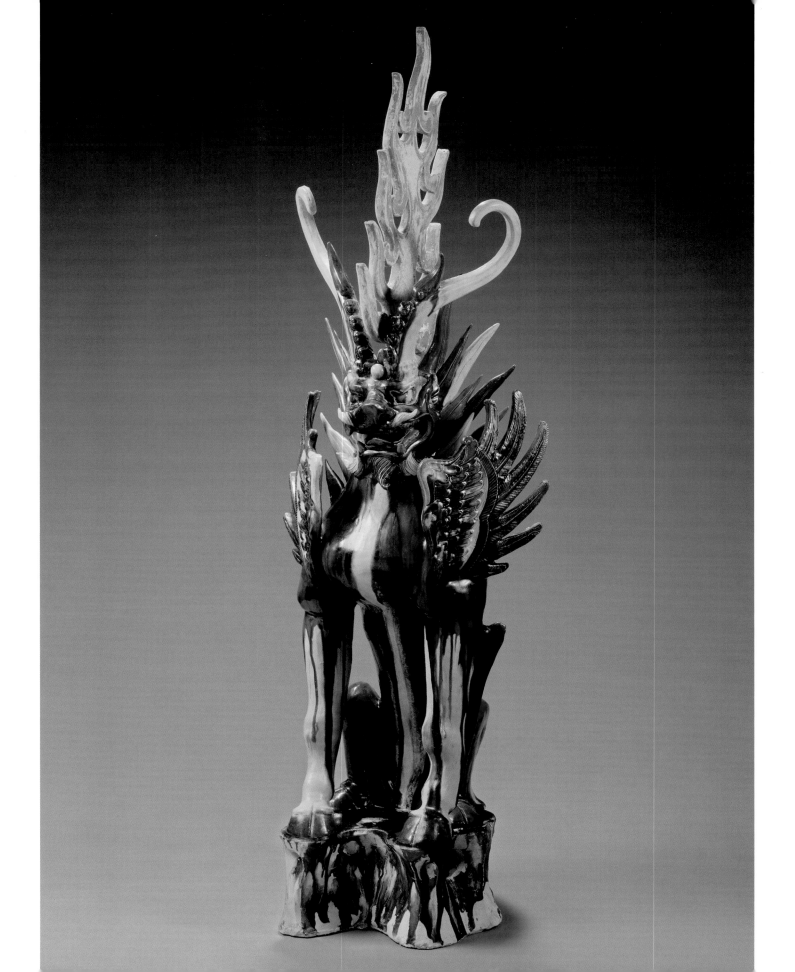

20 *Amphora-shaped vessel*

China, Hebei province
Tang dynasty, late 7th–early 8th century
Earthenware with white slip and lead glaze
H. 19½ in. (49.4 cm); DIAM. 10 in. (25.3 cm)
Gift of Lenora and Walter F. Brown
2004.20.9

Merchants from the Middle East introduced grape wine and viticulture to China during the sixth and seventh centuries. Drinking wine became an instant vogue. Ewers, cups, and bottles that imitated Western metal prototypes proliferated. After the collapse of the Tang dynasty, however, the Chinese reverted to traditional rice and millet spirits.

This handsome vessel imitates a silver or bronze bottle, complete with raised ridges on the neck. Chinese-looking dragon heads have replaced the griffin-headed handles of the prototypes. A circular medallion stamped with a design of a mythical beast—possibly a chimera—was applied to the neck.

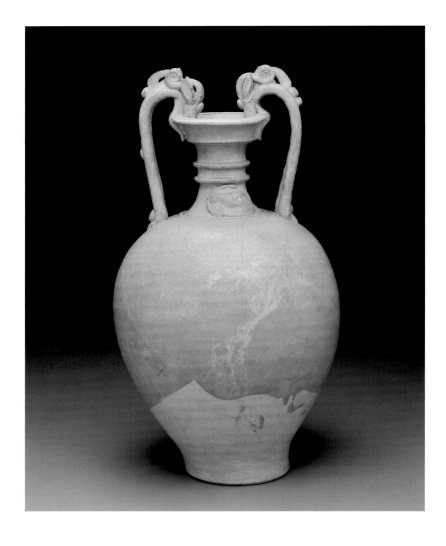

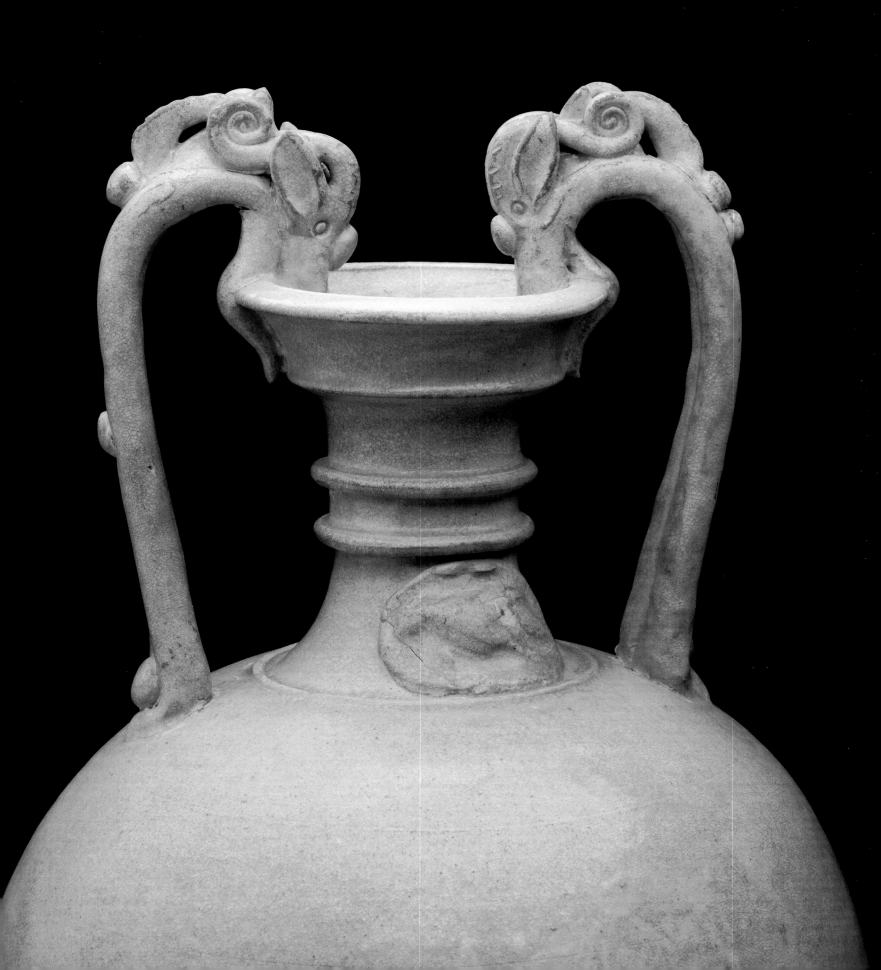

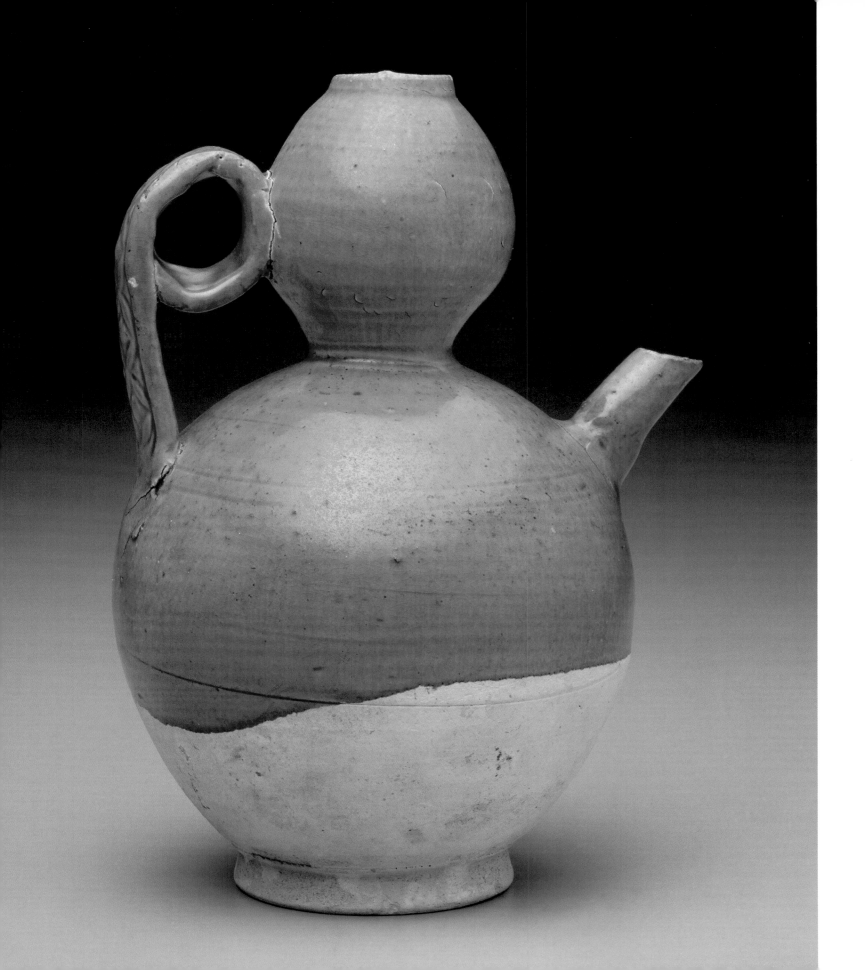

21 *Ewer in the shape of a double gourd*

In 907, just after the fall of the Tang dynasty, the Qidan, a semi-nomadic people from Manchuria, founded the Liao dynasty. Their borders consisted of the northern part of Hebei province, where Beijing would later be built, as well as parts of Manchuria and Inner Mongolia. After more than 200 years of rule, the Liao were defeated in 1125 by the Jurchen, who founded the Jin dynasty and ruled an even larger portion of Northern China, forcing the Song dynasty further south.

While the Qidan had no glazed pottery tradition of their own, they quickly adopted the sponsorship of kilns in their occupied territories and employed Chinese potters. New shapes and designs, uniquely Qidan in character, emerged during the Liao dynasty, as well as innovations in ceramic technology.

The Qidan had a penchant for natural shapes and forms, no doubt a reference to their nomadic heritage. This double gourd ewer closely approximates the shape of an actual gourd. It is comprised of a small elongated bulb which rests on top of a larger, globular bulb. The spout is short and straight. A flat-band handle with molded decoration unites the upper and lower sections. The foot is low and slightly angled. Incised lines provide the only surface decoration.

Liao ceramics prolong many Tang ceramic traditions. A technical link to the Tang can be seen in the application of the slip and the glaze. During the Tang dynasty, potters applied the "slip," a solution of very watery pigmented clay, to most of the vessel surface while leaving a band of natural clay exposed. The potters who made this ewer followed a similar tradition, slipping the vessel almost to the foot and glazing only three-quarters. The rich amber color is one of the three lead glazes used for the popular *sancai* wares of the Tang.

China
Liao dynasty, 907–1125
Earthenware with amber glaze
H. 7⅞ in. (20 cm)
Purchased with funds provided by
Faye Langley Cowden
92.14.16

22 *Offering dish*

China, Shangjing region, Inner Mongolia
Liao dynasty, 907–1125
Earthenware with slip and lead glazes;
Sancai ware
H. 3⅜ in. (8.3 cm); DIAM. 7½ in. (18.9 cm)
Gift of Lenora and Walter F. Brown
2004.20.1

Octagonal offering dishes are particularly identified with Liao dynasty ceramic traditions. They may have been based on carved-wood or cast-metal shapes. Although these dishes have frequently been identified as mortars or inkstones, their glazed interiors make them unsuited for that purpose. They may have continued to reflect the Qidan nomadic heritage and its requirements for simple, portable furnishings.

This example, like most, features vertical panels that were impressed with figures, which were then splashed with green and amber lead glazes. The design on this dish features four figures, possibly enacting the ritual for which the vessel was made. The man on the right wears robes similar to those of a scholar and holds a scepter-like object. Three men approach from the left with gestures that may depict illness. One grips his ear and contorts his body, seemingly in distress, while another clutches his arms to his chest, and a third appears to vomit.

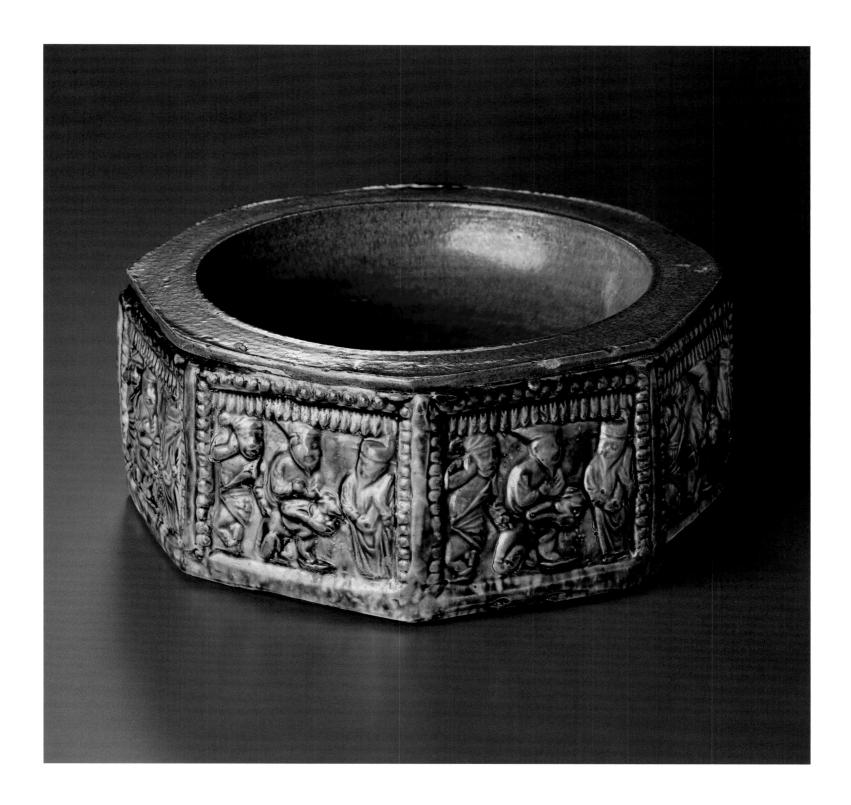

23 Dish

Molded dishes such as this plate, as well as square and petal-form dishes, imitated metalwork. Like their seventh- and eighth-century Tang dynasty prototypes, these wares were based on much more expensive repoussé silver dishes.

The mold was carved in clay as the negative of the silver prototype, with its sharp differentiation between flaring rim and flat base. The crisp details in the symmetrical pattern of flowers and stylized clouds mimic those on metal surfaces that have been hammered from the back and chased on the surface. The mold was then fired and used as the tool in the manufacturing of this plate.

Typically, these Liao molded wares are splashed with colored glazes that spread over the areas of the molded floral decoration. The irregular color applications contrast sharply and often obscure the finely shaped images of leaves, flowers, and clouds impressed on the clay.

China
Liao dynasty, 907–1125
Earthenware with slip and lead glazes; *Sancai* ware
DIAM. 9½ in. (24.2 cm)
Purchased with funds provided by Faye Langley Cowden
92.14.25

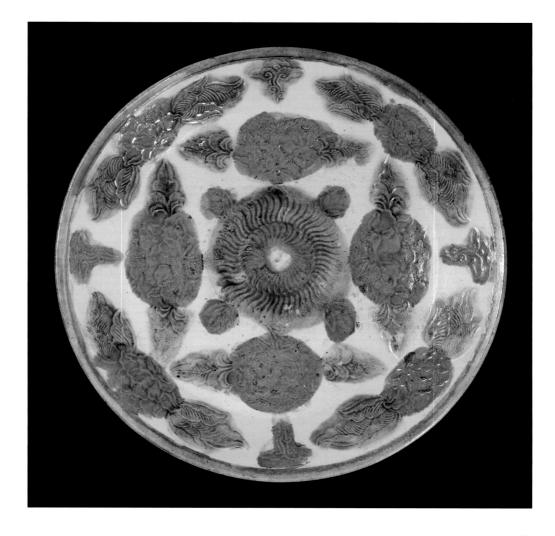

24 *Ewer in the shape of a pair of geese*

China
Liao dynasty, 907–1125
Earthenware with slip and lead glazes;
Sancai ware
H. 9⅞ in. (25.2 cm); L. 11⅞ in. (32.7 cm)
Purchased with funds provided by
Faye Langley Cowden
92.14.30

The animated naturalism captured by the potters of this vessel is one of the hallmarks of Liao ceramic style. Realized convincingly in three dimensions, the form is nonetheless contrived to serve as a pouring vessel with a handle. Individual components were molded and then assembled and modeled by hand. A molded band of clouds conveniently links both ends of the upraised wing to form the grip. The rounded base is constructed of overlapping lotus petals.

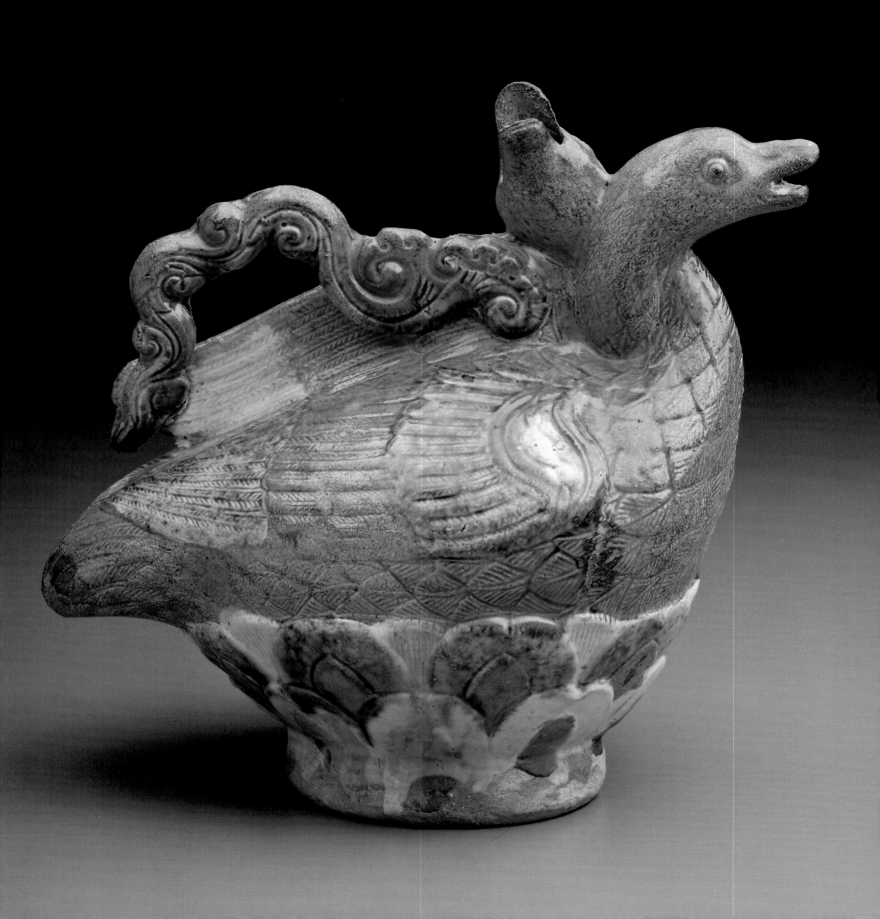

25 *Urn in the shape of a pagoda*

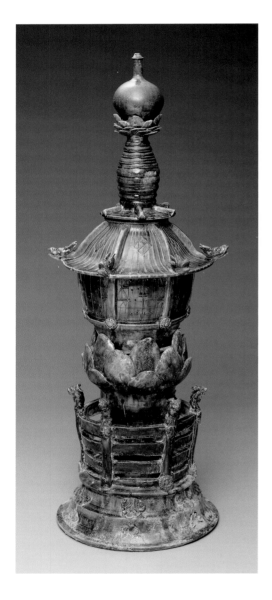

China
Liao dynasty, 907–1125
Stoneware with lead glaze
H. 32¼ in. (81.7 cm)
Gift of Lenora and Walter F. Brown
98.15.14.a–c

Buddhism's rise in popularity during the Tang dynasty influenced the production of a wide range of new domestic and funerary wares. The Buddhist practice of cremation contrasted sharply with Chinese Confucian burial practices. Whereas storage jars for grains and other foodstuffs had been produced in large quantities for burial since the Neolithic period [see nos. 2 and 10], vessels for holding human ashes, such as this one, appear with increasing frequency after the eighth century.

Buddhism also flourished under the Liao dynasty. Like the Tang dynasty prototypes, Liao reliquaries are architectonic. This flamboyant pagoda-shaped jar rests on a base that consists of a lotus flower rising from a fenced pond. It features an elaborate finial lid. Dragon tiles mark the roof ridges, and guardian lions sit atop each fence post.

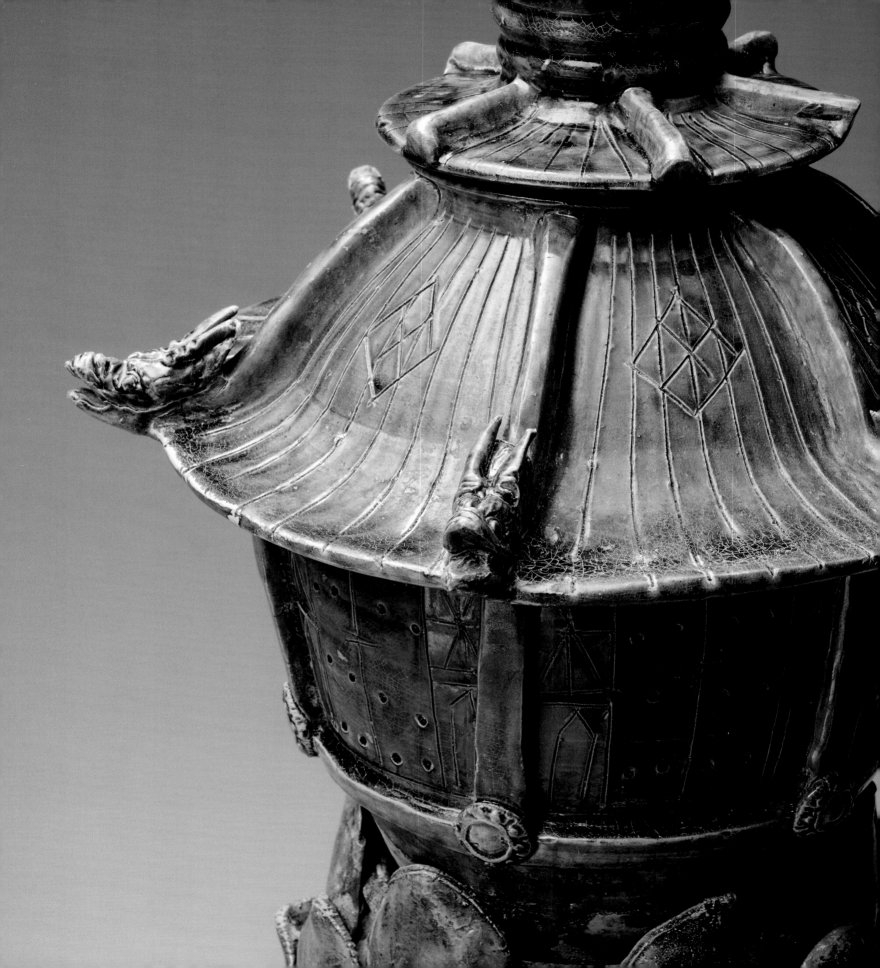

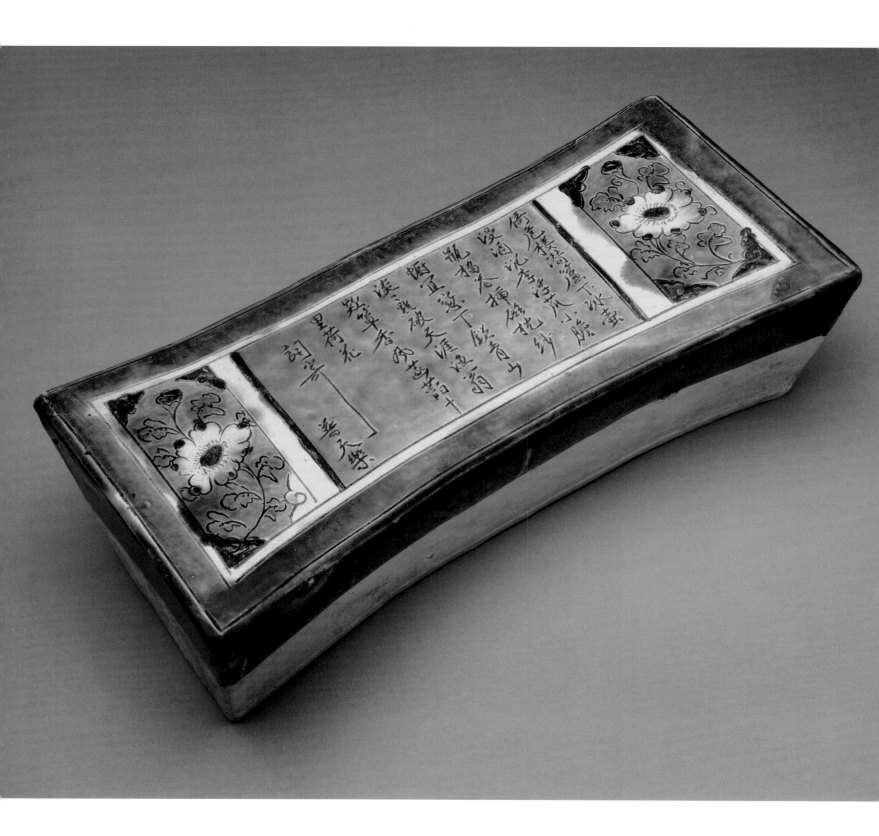

The Chinese believed that resting the head on the earth, one of the five elements of the universe, improved health and intellectual ability. Headrests and pillows made of clay, which represented earth, were very popular between the 7th and the 14th century. They evolved from small, brick-like shapes into more elaborate lobed forms and, finally, shaped rectangles such as this example.

By the 12th century, the tradition of ceramic pillows was so entrenched that pillows were also produced for the dead, who, it was believed, would enjoy them in the next world. This example is made to evoke a hand scroll with decorative end-papers. The potter has combined incising through colored slip, in the tradition of Song dynasty Cizhou wares, with *sancai* glazing familiar from the Tang and Liao traditions.

According to Jonathan Chaves, a Chinese literature scholar, this pillow is inscribed with a poem written in the *qu* form popular during the Jin and especially Yuan dynasties. This style of poetry was derived from the sung portions of plays.

This lyric is set to the tune, "Music Filling Heaven." The inscription reads:

I lean from the tall tower,
Concealed behind the blind.
In an ice-cold jar, wine is served;
Soaked plums float in this gourd!
Small "gall-bladder vase:"
Pomegranate blossoms arranged.
Porcelain pillow, gauze curtain
* just right beside the window:*
Green mountains, pale, pale,
Dots at the edge of the sky.
A fisherman, creaking his oar,
Fragrant on the breeze, budding flowers:
Ten miles of lotus bloom!

—Translation by Jonathan Chaves

China
Jin–Yuan dynasty, 1115–1368
Earthenware with slip and lead glazes;
Sancai ware
H. 4½ in. (11.5 cm); L. 12½ in. (31.8 cm)
Gift of Lenora and Walter F. Brown
2004.20.11

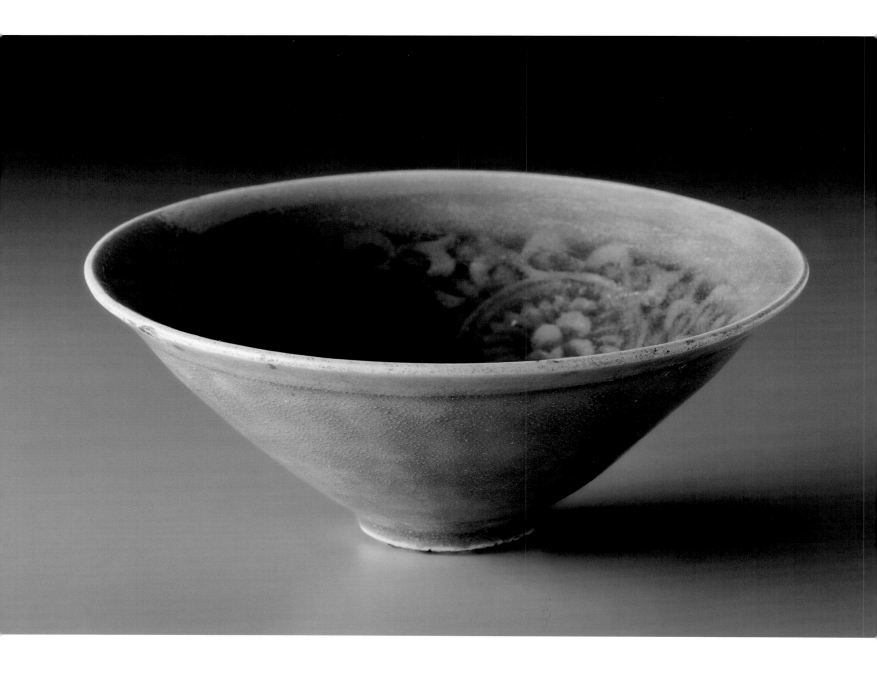

27 Bowl

The contrast between areas of thin, green glaze and the more intense color, where it pools in the depressions of the molded pattern, creates a rich, subtle surface on the interior of this bowl. Six lotus blossoms on an undulating stem surround a single flower. The flower centers are marked with three balls, possibly a reference to the Buddhist *tripitaka,* or "three jewels": the Buddha, the scriptures, and the monastic orders.

Fired ceramic molds, with patterns carefully carved in reverse, were used at Yaozhou and other kilns to mass-produce ceramics. The Yaozhou kilns in central Shaanxi province began manufacture during the Tang dynasty and reached the peak of their creative production during the Northern Song dynasty. A variety of ceramics was produced there, but the green wares are the most well known.

China
Northern Song dynasty, 960–1127
Porcelaneous stoneware, green glaze; Yaozhou ware
H. 1½ in. (3.7 cm); DIAM. 4 in. (10 cm)
Purchased with funds provided by the Bessie Timon Endowment Fund
73.168.5

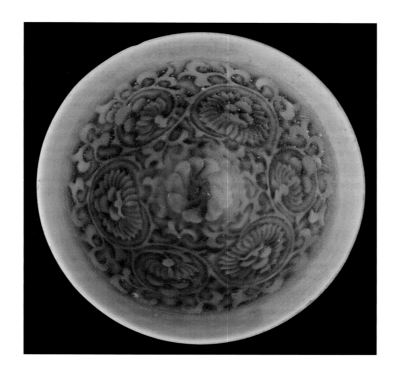

28 *Dish*

China
Northern Song dynasty, 960–1127
Stoneware with blue-lavender glaze;
Jun ware
DIAM. 7¾ in. (19.5 cm)
Purchased with funds provided by the
Bessie Timon Endowment Fund
92.19.3

Patronage of the court and aristocracy influenced the consumption of fine ceramic wares by gentry and merchant classes during the Song dynasty. This business contributed to increased production and the refinement of aesthetic standards. Mastery of forms, such as this simple foliate–rimmed plate, and subtle monochrome glazes are the hallmarks of Song dynasty ceramic achievement.

Jun wares from central Henan province are characterized by their thick, blue glazes, which are occasionally accented with splashes of purple. During firing, the glaze tended to pool in the crevices, in this case accentuating the crisp edges of the precisely formed rim where the buff body shows through the thinner glaze.

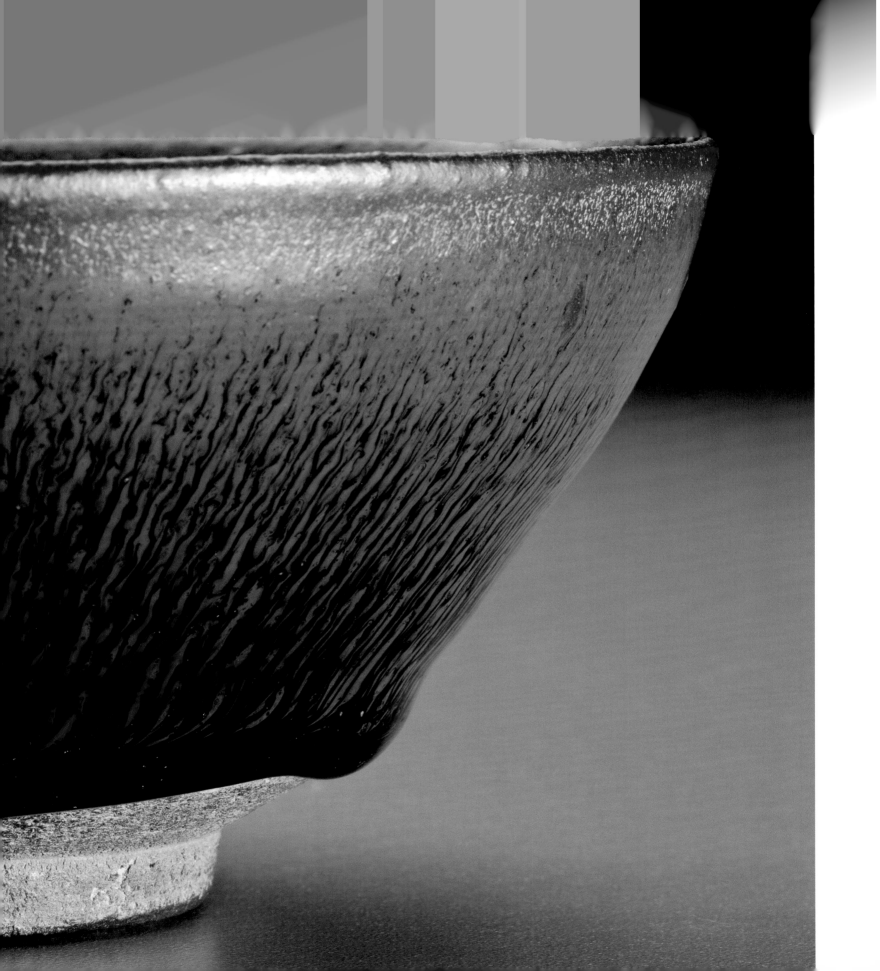

29 Tea bowl

Jian wares were produced in Fujian province, along China's southeastern coast. These kilns were particularly famous for tea bowls, which were celebrated by emperors, officials, Buddhist monks, and literati during the Song dynasty. Although green-glazed wares had been the most admired for drinking tea during the Tang dynasty, a renewed enthusiasm for tea and a vogue for tea parties and contests changed tastes during the Song dynasty. Connoisseurs prided themselves on their ability to prepare tea. Contests were devised for the preparation of whipped tea, which was whisked in the bowl to produce a white froth. Since the winner was the person whose froth lasted the longest, a dark-colored tea bowl that showed the froth to advantage was regarded as most desirable.

The rich, dark glazes on Jian wares were categorized by the effects caused by the natural separation of glazes as they melted and matured in the kiln. This vessel features fine streaks of light brown and ochre, which came to be known as "hare's fur."

These black and brown glazed wares were exported in large quantities to Japan, where they were known as *temmoku*.

China
Southern Song dynasty, 1127–1279
Stoneware with brown iron glaze;
Jian ware
H. 2⅜ in. (6 cm); DIAM. 4¾ in. (12.1 cm)
Purchased with funds provided by the
Bessie Timon Endowment Fund
73.168.3

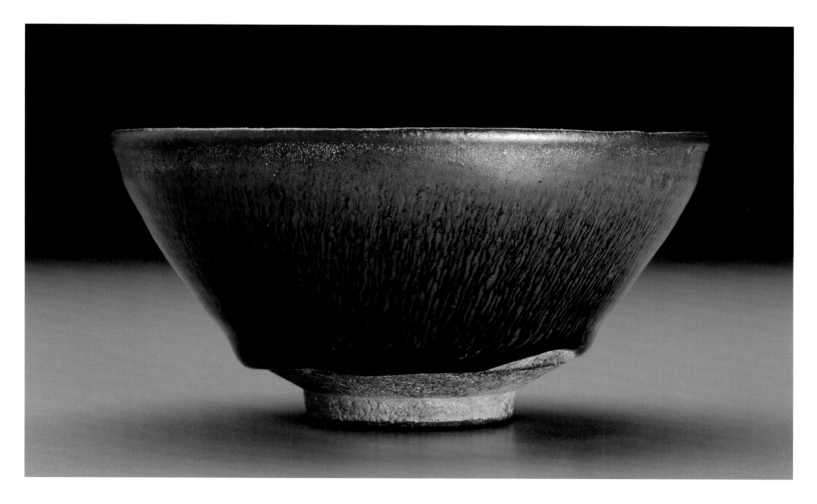

30 *Spouted jar and cover*

China
Southern Song dynasty, 1127–1279
Porcelaneous stoneware with celadon glaze;
Longquan ware
H. 8⅞ in. (22.5 cm); W. 4¾ in. (12 cm)
Purchased with funds provided by the
Bessie Timon Endowment Fund
92.19.2.a–b

Versions of this lidded vessel, which is shaped like a bamboo rhizome, were made in the Longquan region of Zhejiang province in southern China from the 8th through the 14th century. Some scholars speculate that the form may have evolved from a communal drinking vessel. However, by the Song dynasty, the five-spouted form was a popular funerary urn. The elegant potting and thick, lustrous glaze reflect the refined aesthetics associated with the Southern Song court.

The term "celadon" by which these pale, jade-green glazes are known, is distinctly un-Chinese. In Honoré d'Urfé's (1567–1625) French pastoral romance L'Astrée (published posthumously in 1627), a shepherd named Celadon wore a costume of a similar dusty green. European connoisseurs applied this term to the wares when pieces appeared in France during the 17th century.

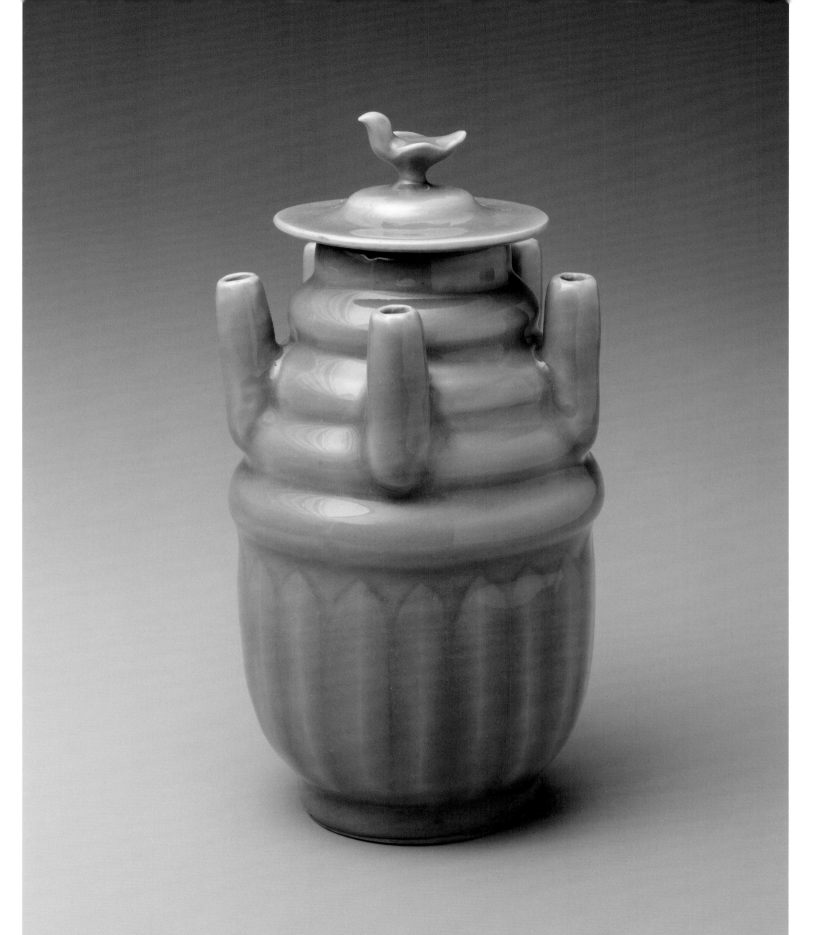

31 *Covered ewer and basin*

China
Southern Song dynasty, 1127–1279
Porcelaneous stoneware with blue-green glaze;
Qingbai ware
Ewer: H. 8¾ in. (22.2 cm)
Bowl: H. 4½ in. (11.5 cm); DIAM. 7¼ in. (18.3 cm)
Purchased with funds provided by the
Bessie Timon Endowment Fund
92.19.1.a–c

The word *qingbai* means "blue-white" and describes the glaze color of southern porcelains produced from the 10th to the 14th century in Jiangxi and Guangdong provinces. The reduction-fired glaze is transparent, with a bluish tinge that results from traces of ferrous (iron) oxide. This basin features lotus leaves, buds, and flowers rising from the foot ring; the ewer boasts an arrangement of overlapping leaves at the shoulder.

This ensemble of ewer and basin reflects the traditional Chinese custom of drinking warmed rice wine.

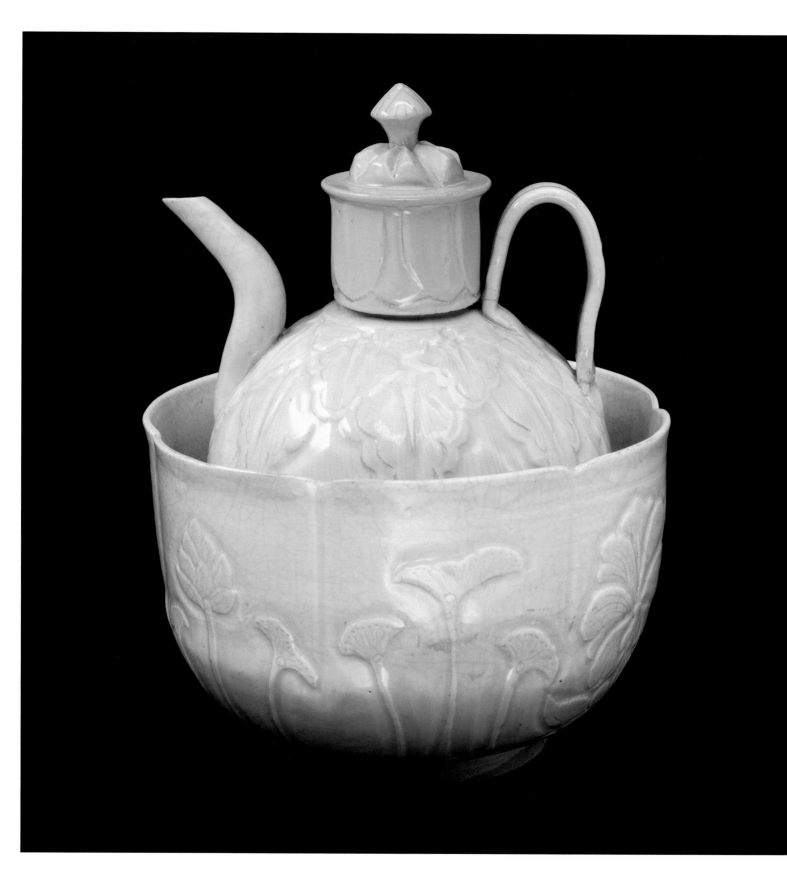

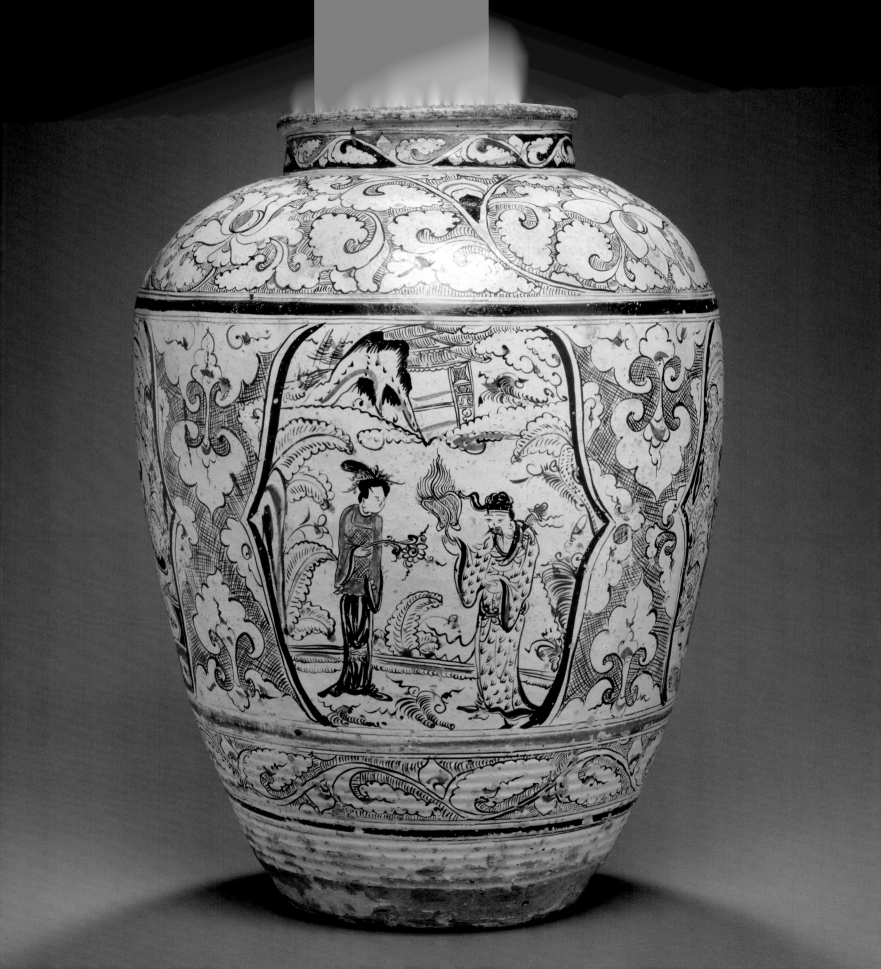

32 *Jar*

This large stoneware jar is a striking example of Cizhou ware, which was produced at many kilns throughout the northern provinces of Hebei, Henan, and Shaanxi from the 10th through the 16th century. This jar is decorated in brown pigments applied over a white slip body and under a clear glaze. The artist painted four cartouches with figures in a landscape. Additional bands of decoration cover the entire surface of the jar. In the detail shown, a slender female turns her head toward a scholar-official. One of her hands gestures toward the leaf on a tree, and she holds a basket in the other. The bearded gentleman wears a scholar's hat and robes. With his right hand, he offers her a token. The genre motifs on this vessel were probably copied from woodcut designs that illustrated popular novels and plays of the time.

China
Yuan dynasty, 1279–1368
Stoneware, white slip, painted and glazed; Cizhou ware
H. 23¾ in. (60.2 cm); DIAM. 17½ in. (44.2 cm)
Gift of Lenora and Walter F. Brown
2004.20.14

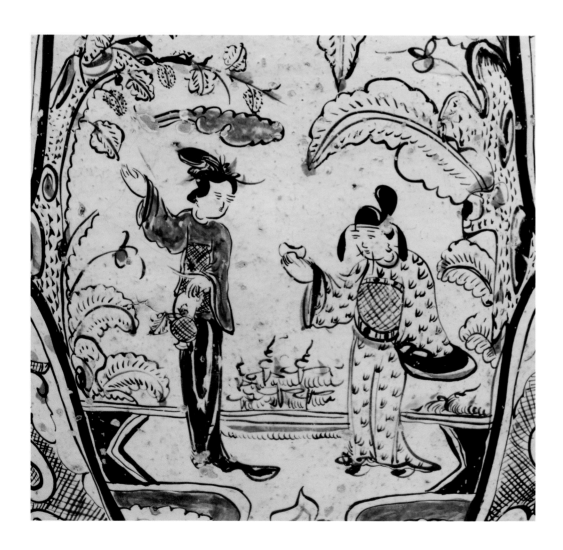

33 *Dish*

China
Ming dynasty, early 15th century
Porcelaneous stoneware with green glaze;
Longquan ware
H. 3½ in. (8.8 cm); DIAM. 17⅜ in. (44 cm)
Purchased with funds provided by the
John and Karen McFarlin Purchase Fund
90.12

The basin-shaped dish, with its fluted cavetto and crisply defined ogee-lobed rim, was based on contemporaneous Persian metalwares. The decorative scheme employs traditional Chinese motifs: A wreath with sprigs of peony, pomegranate, camellia, and chrysanthemum surrounds a six-petaled flower head and radiating sprays of chrysanthemums.

Throughout the Yuan and early Ming dynasties, celadon wares like this were popular export items for the Islamic market, but they were quickly overshadowed by the more fashionable 15th-century blue-and-white porcelains.

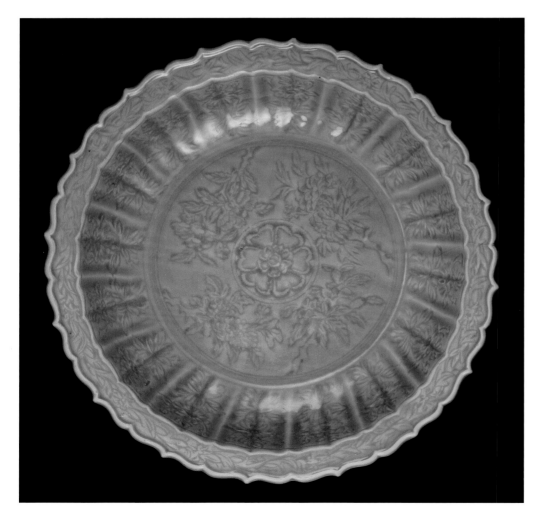

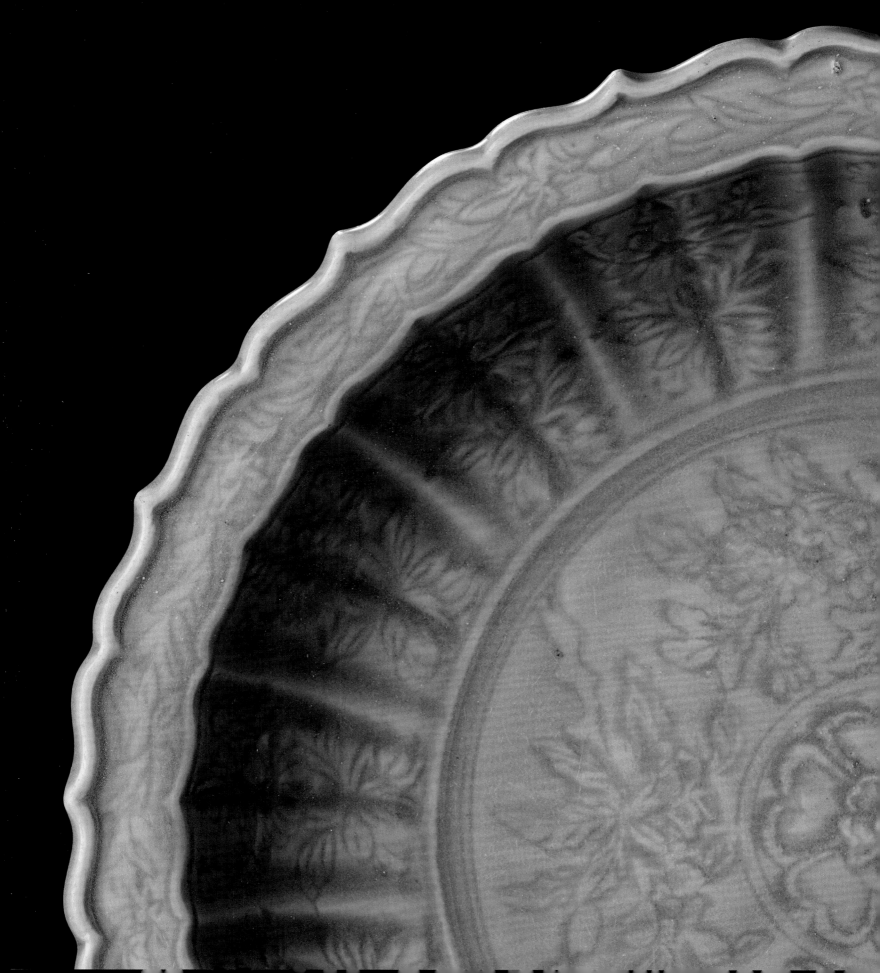

34 Landscape in Contemplation

Dao Yan (1335–1419)

China
Ming dynasty, dated 1382
Hand scroll, ink and colors on paper
Painting: H. 11⅛ in. (28.2 cm); W. 109¼ in. (275.3 cm)
Frontispiece: H. 11⅜ in. (28.3 cm); W. 37 in. (94 cm)
Colophons: H. 11¼ in. (28.6 cm); W. 20¼ in. (51.4 cm),
and 23 in. (58.5 cm), 106 in. (269.6 cm), and 41 in.
(104.2 cm)
Mount: H. 12½ in. (31.8 cm); W. 374 in. (960.8 cm)
Gift of the Ewing Halsell Foundation in honor of
Mr. and Mrs. W. H. George
87.19

The artist Dao Yan, also known as Yao Gungxiao, was a Buddhist monk, poet, and government official who later became an important advisor to the Yongle emperor (r. 1403–1425). At court, Dao Yan served as the head of the Buddhist Registry and as tutor to the imperial grandson.

According to the artist's inscription, this painting was made for a prominent early Ming political figure, Xu Da. Xu was first among the military commanders who founded the Ming dynasty and went on to serve the Yongle emperor as chief counselor. The connection between artist, emperor, and personal advisor gave genesis to this work.

The hand scroll features a mountainous landscape along a river, executed in loose, scratchy strokes in wet ink and light color. This innovative technique, the dramatic shifts in viewpoint from distant shoreline to impressive rock masses in the foreground, and the final view of a precipitous waterfall observed by two figures establish this work as an important transition between the spontaneous, abbreviated style of amateur Chan painters of the Southern Song dynasty (1127–1279) and the cursive Zhe school of brushwork that flourished during the 15th century.

While Dao's paintings of bamboo are well known, his landscapes are very rare. Today, the painting is accompanied by thirty-eight colophons, including several in French and English. It was given a frontispiece by Shen Shixian (1535–1614), who inscribed four large characters in running script, which reads *jing wan shan shui,* or "landscape in contemplation."

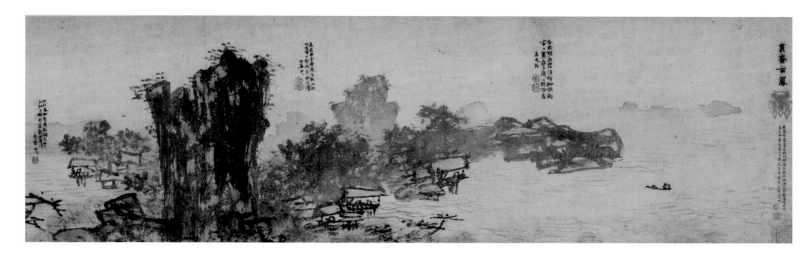

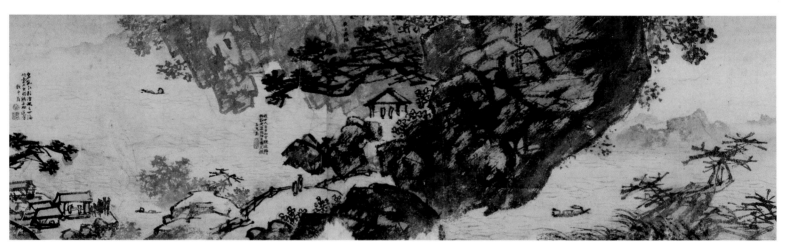

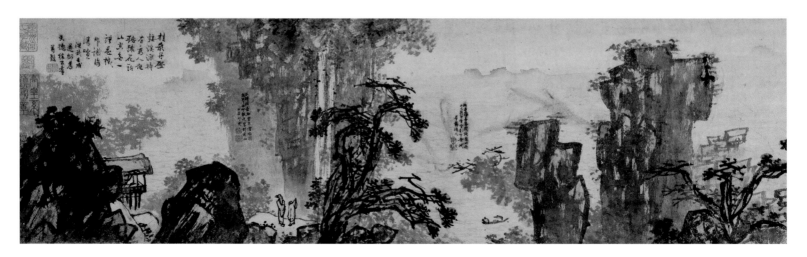

35 *Plate*

Select Jingdezhen kilns in Jiangxi province came under imperial control during the Yuan dynasty and continued for the next 500 years. Production at these kilns was geared toward providing wares for the imperial household, some to be used as gifts and others for trade.

This plate or charger was made during the early Ming dynasty. It is related stylistically to the wares created for the markets in Iran, India, and Turkey during the previous Yuan dynasty. The décor, with bands of waves and a scroll featuring a variety of flowers, is nonetheless directly inspired by Chinese patterns. Such hybrid designs appealed to both export and domestic markets.

The painter applied cobalt in different densities to create the variety of blue tones, ranging from pale blue to nearly black. Where the cobalt was oversaturated spots of inkiness developed, creating an effect called "heaped and piled," which was much admired by later collectors.

China
Ming dynasty, Yongle period, 1403–1425
Porcelain with painted cobalt blue under clear glaze; Jingdezhen ware
DIAM. 16 in. (40.5 cm)
Gift of Lenora and Walter F. Brown
85.135.7

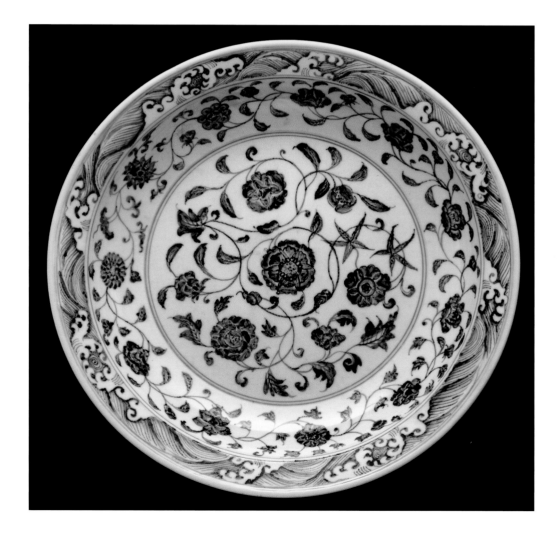

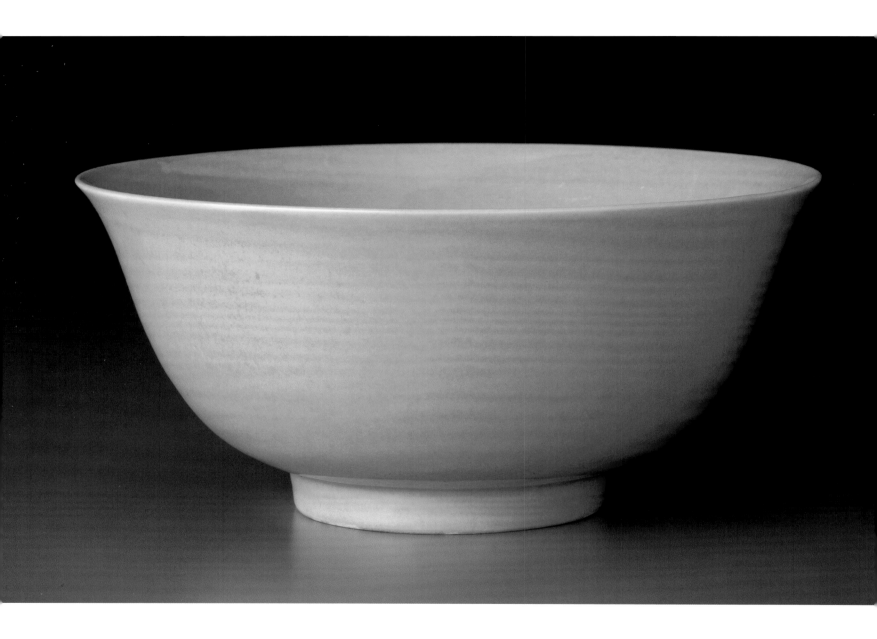

36 Bowl

A rich yellow enamel glaze covers the interior and exterior of this elegant bowl. On the base is a six-character reign mark of the Zhengde emperor (1506–1521) enclosed within a double ring executed in underglaze cobalt blue.

The yellow glaze is derived from a mixture of iron and antimony that first appeared in the late 1460s and 1470s during the reign of the Chenghua emperor. To create the rich and even color, the yellow enamel was carefully applied across the surface of a prefired glazed porcelain, which was then fired a second time.

Yellow monochromes were used as ritual vessels in imperial sacrifices performed by the Emperor at the Altar of the Earth in Beijing. Sets of variously shaped vessels were made for all four altars (Earth, Heaven, Sun, and Moon); only the colors were different. The color yellow and its link to the earth and imperial authority can be traced back to the legendary Yellow Emperor, or Huangdi, who was believed to have ruled during the third millennium BCE.

China
Ming dynasty, Zhengde mark and period, 1506–1521
Porcelain with yellow glaze; Jingdezhen ware
H. 3 in. (7.5 cm); DIAM. 6¼ in. (16 cm)
Purchased with funds provided by the Bessie Timon Endowment Fund
78.643

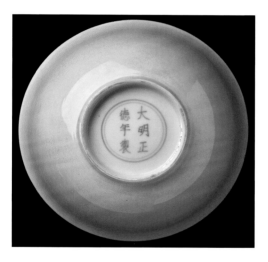

37 *Vase in the shape of a double gourd*

China
Ming dynasty, Jiajing period, 1522–1566
Porcelain with underglaze cobalt blue
and overglaze red and green enamels;
Jingdezhen ware
H. 18½ in. (47 cm); W. 8½ in. (21.7 cm)
Gift of Lenora and Walter F. Brown
92.25.43

A new interpretation of the classic double gourd shape emerged during the Jiajing period and remained popular through the Wanli period, roughly the 16th through the early 17th century. Rather than globular shapes (or gourd-like forms) stacked one on top of the other, the new shape included a base with square walls supporting a gourd-like top. The shape symbolically represented the Chinese notion of heaven and earth. The earth is symbolized by a square found on the lower segment of the vase while heaven is represented by a circular form which resides on top.

This vase employs an overall pattern of scrolling lotus in cobalt blue—iconography typical of the 14th and 15th century blue and white wares. But it does so in a new, bolder format: Overglaze enamels were painted in the white areas between the cobalt decoration, utilizing a technique introduced in the 15th century.

After the cobalt blue was painted and the vase was glazed and fired, colorful enamels, in this case red with hints of green, were applied to the vessel which was then fired a second time. In the case of this vase and other examples from this time period, the application of the enamels is often not precise. In some areas the red overlaps the blue. In other cases small areas of white porcelain remain exposed.

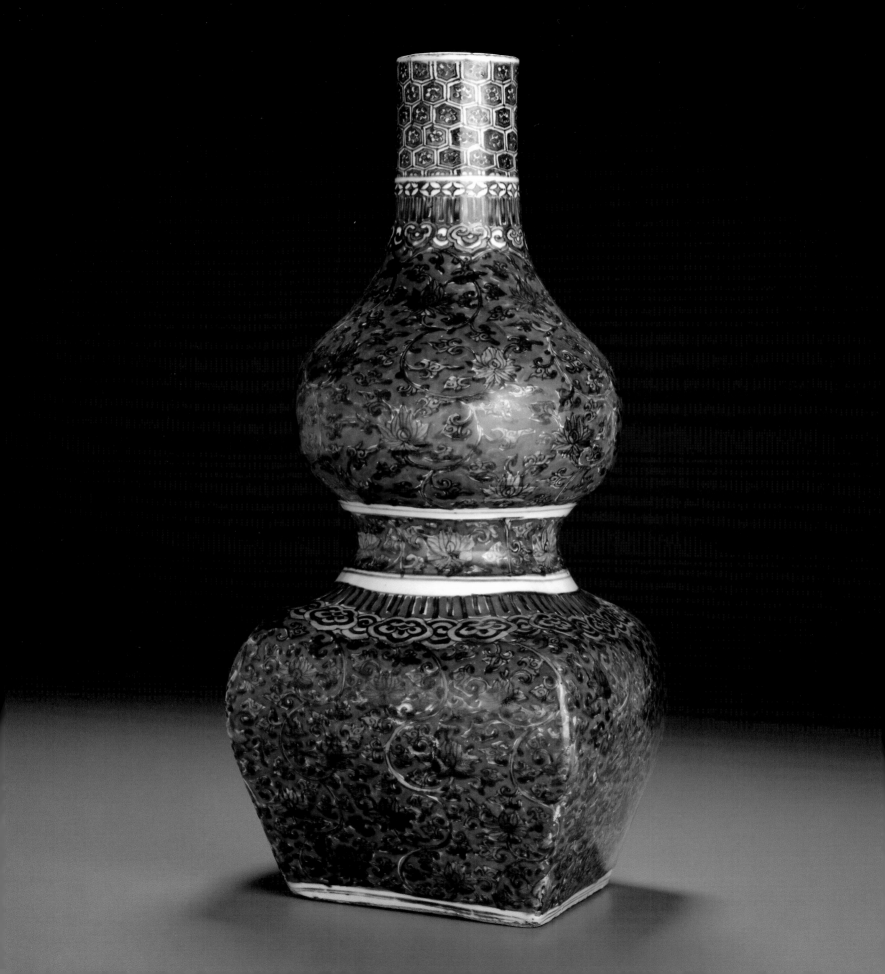

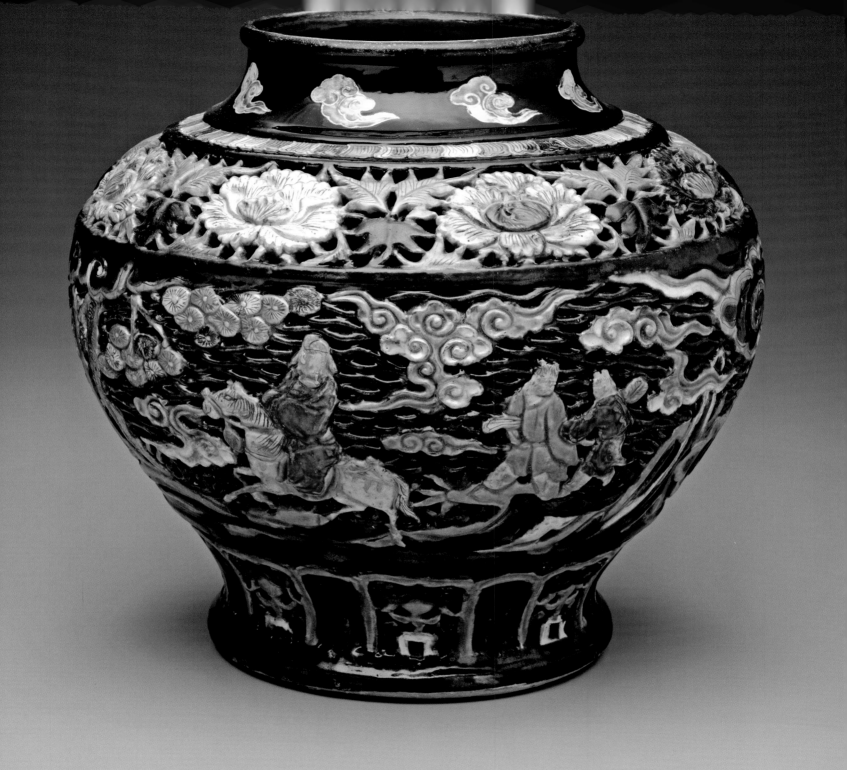

38 *Jar*

Fahua means "bound" or "ruled designs" and refers to a type of surface decoration on polychrome ceramics that, in many ways, resembles cloisonné metalwork. Similar to the metal wires that encapsulate the colored enamels on a cloisonné vase, the *fahua* potters used slip to build walls to contain the low firing glazes keeping the colors separate during firing. This technique solved the problem of colored glazes mixing or overlapping in the kiln.

This process involved multiple steps. After the jar was fired, low firing glazes were applied to the various cells. The jar was fired a second time at a lower temperature and the rich jewel-like colors of turquoise, aubergine, and yellow emerged. Some *fahua* wares, such as this example, feature a combination of decorative techniques including raised decoration on an openwork ground.

The central band features a gentleman on horseback riding along a trail with pine trees and clouds. He is followed by attendants who carry musical instruments. This imagery is evocative of books illustrated with woodcuts, which probably served as patterns for potters at the *fahua* and other kilns during the late Ming dynasty. Bands of peonies, clouds, and lotus petals fill the top and bottom registers.

China
Ming dynasty, 16th century
Earthenware with slip and alkaline glazes; *Fahua* ware
H. 13 in. (33 cm); DIAM. 13¾ in. (35 cm)
Gift of Lenora and Walter F. Brown
92.25.34

39 Jar

China
Ming dynasty, Jiajing mark and period, 1522–1566
Porcelain with painted cobalt blue under clear glaze;
Jingdezhen ware
H. 13¾ in. (34.6 cm); DIAM. 15 in. (38 cm)
Gift of Lenora and Walter F. Brown
2004.20.15

This vessel is decorated with the "three friends of winter"—pine, bamboo, and plum—which symbolize steadfastness, flexibility, and perseverance. These trees were considered auspicious for their ability to withstand the harshness of winter. The first two stay green throughout the year; the plum is the first to flower, often while there is still snow on the ground. In addition to their symbolic intent, the three friends have been given other levels of meaning on this jar. The pine is shaped into the Chinese character for "longevity," the bamboo into "good fortune," and the blossoming plum into "prosperity."

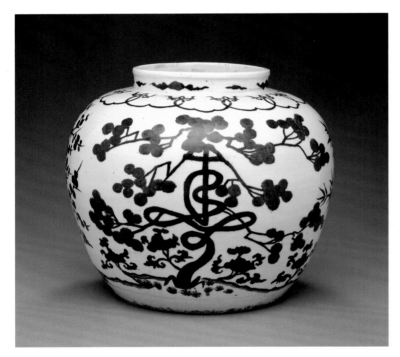 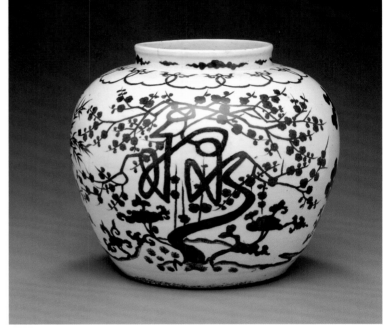

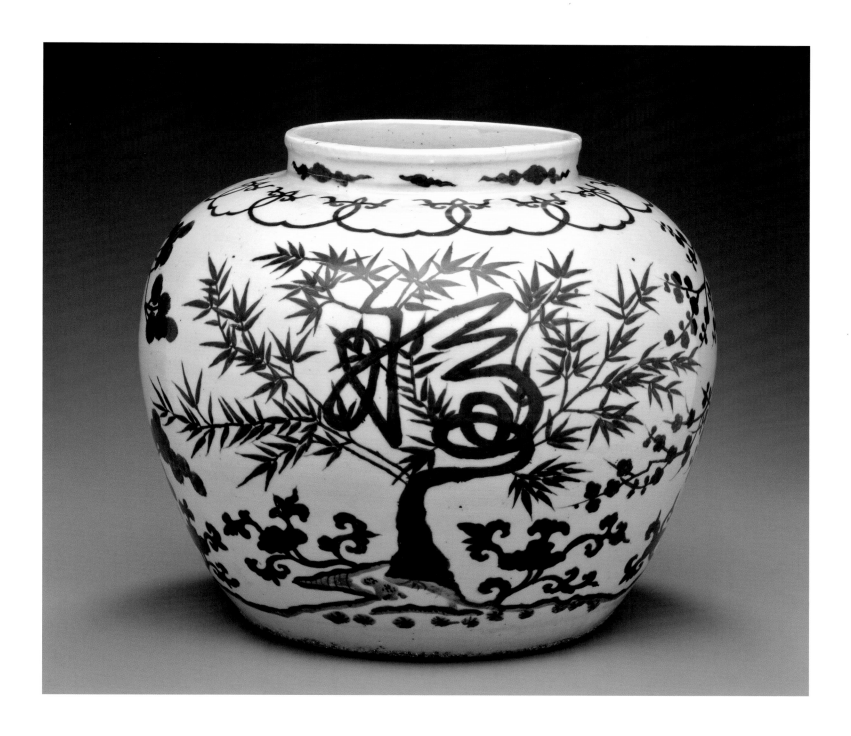

Sancai glazing techniques continued after the Tang dynasty and were utilized for architectural ceramics and other wares. This flamboyant tripod vessel, which features modeled vegetation, dragons, phoenix and other creatures, was probably part of a five-piece altar set for a Buddhist or Daoist temple. It is typical of vigorously modeled ritual vessels that appeared during the Yuan period and continued to be favored for these ceremonial sets into the late Ming dynasty.

The altar set of tripod censer flanked by a pair of beaker vases and a pair of candle-holders follows a pattern for ritual display begun during the Bronze Age.

China
Ming dynasty, 16th–17th century
Stoneware with slip and lead glazes;
Sancai ware
H. 26¼ in. (67.7 cm); W. 21¾ in. (56.3 cm)
Gift of Lenora and Walter F. Brown
81.193.11

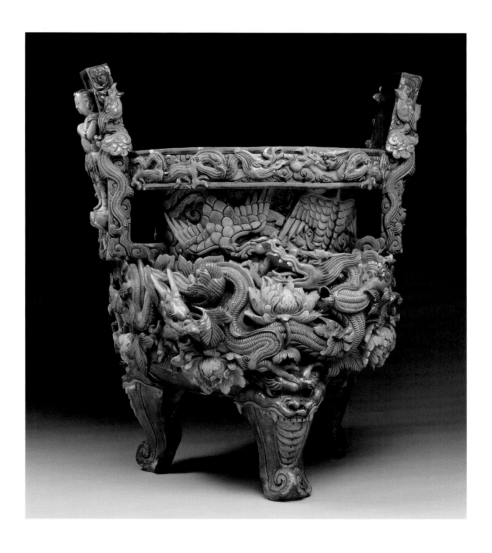

41 *Vase in meiping shape*

China
Ming dynasty, Wanli mark and period, 1573–1620
Porcelain with painted cobalt blue under clear glaze;
Jingdezhen ware
H. 15⅜ in. (39 cm)
Gift of Lenora and Walter F. Brown
92.25.55

By the end of the Ming dynasty, porcelains decorated with literary scenes and motifs were being created for scholar-officials. This class held rank and position dependent on education and the ability to pass three sets of rigorous examinations based on Confucian writings. Attaining the highest, or *jinshi,* degree guaranteed a position in the imperial civil service, which conferred prestige and status as well as a steady income.

The painting on this vessel, a *meiping,* or prunus vase, would have appealed to literati tastes in particular. The four scenes on this vase each depict a scholar in a garden setting with his appropriate floral emblem.

One scene (below left) features Tao Yuanming (365–427), who was identified with chrysanthemums because he planted rows of them along the fence of his garden after resigning his official position to take up a rural life and write poetry. Another (opposing page) shows Lin Bu (967–1028), a poet recluse, whose praise of the plum blossom linked it forever with Chinese cultural life. A third scene (below right) depicts Zhou Maoshu (1017–1073), known for combining elements of early Chinese cosmology and religious Daoism with Confucian doctrine; his work led to the revival of Confucianism during the Northern Song dynasty. He also wrote an essay in which he identified the lotus as the flower of purity and integrity, symbolizing the perfect or princely man. The fourth scene (see p. 180) features poet Huang Tingjian (1050–1110), who praised the orchid, which can survive snow and frost, for its steadfastness and resilience. It modestly evokes the princely man, as "it thrives in forests where its perfume is undiminished by the absence of people to appreciate it."

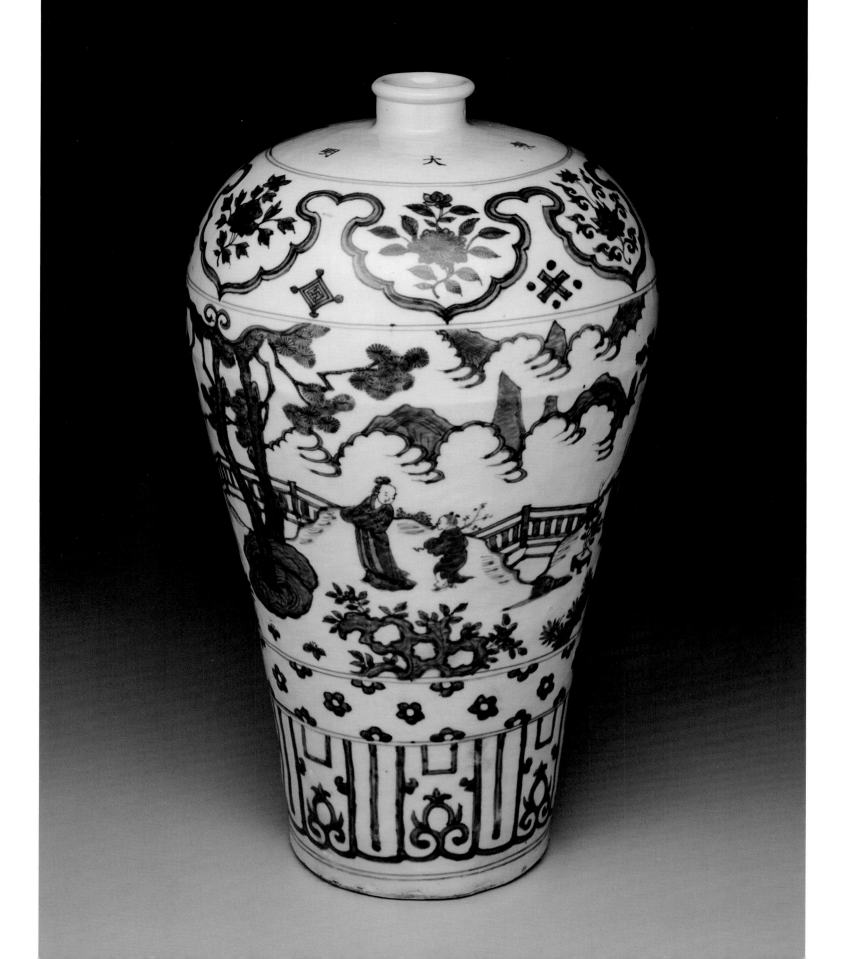

42 Landscape after Zhao Mengfu

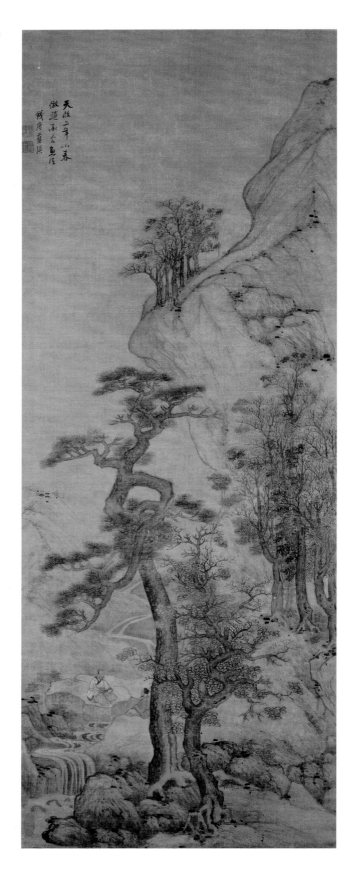

Lan Ying (1585–c. 1660)

China
Ming dynasty, dated 1622
Hanging scroll, ink and color on silk
Painting: L. 51⅛ in. (129.7 cm); W. 19 in. (48.2 cm)
Mounting: L. 77½ in. (196.8 cm); W. 25¼ in. (64 cm)
Purchased with funds provided by the
Lenora and Walter F. Brown Acquisition Endowment
88.14

Lan Ying lived and worked in Hangzhou in Zhejiang province, an important metropolitan and artistic center. He spent time with local literati circles and was very much drawn to the styles of past masters such as Huang Gongwang (1269–1354). This painting, which bears the artist's inscription dated 1622 and acknowledges the work to be in the style of Zhao Mengfu (1254–1322), is characteristic of Lan's early style. In it, he has adopted the practice of *fang,* or the simulation of creativity in the specific style of an earlier master, which was advocated by Lan's contemporary, the great Ming dynasty painter Dong Qichang (1555–1638).

The composition features a foreground, close to the viewer, which is dominated by two trees, a pine and a deciduous tree. This grouping is typical of Zhao Mengfu. The twisted brushstrokes that define the mountains and rock forms also evoke Zhao's style.

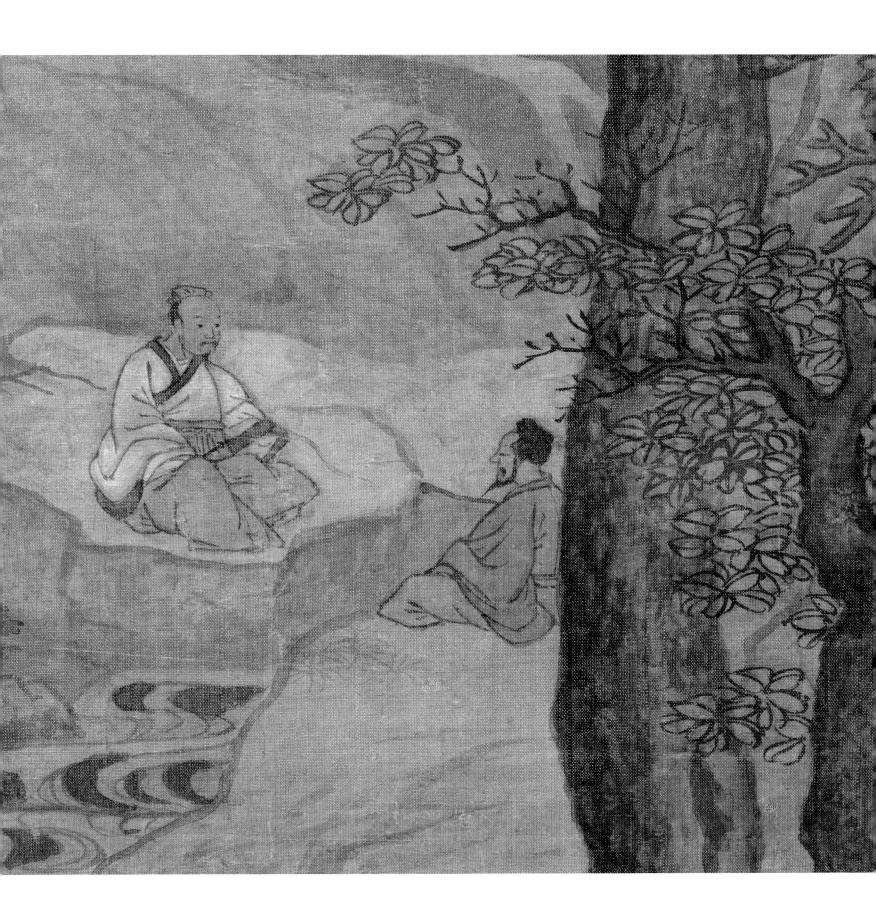

43 Vase

China
Ming–Qing dynasty, mid 17th century
Porcelain with painted cobalt blue under clear glaze;
Jingdezhen ware
H. 16⅞ in. (42.9 cm); DIAM. 6½ in. (15.9 cm)
Gift of Lenora and Walter F. Brown
2004.20.13

The decline of the Ming government escalated dramatically under the Wanli emperor. Following his death in 1620, imperial supervision of kilns at Jingdezhen lapsed, and imperially sponsored production of porcelain came to a halt.

The kilns were forced to seek new markets. Dutch and Japanese export markets emerged as new sources of income. Ceramics made for foreign export were generally of lesser quality than those made for the Chinese court. Many of the traditional shapes and decorative motifs of the Wanli period were replaced with new vessel forms and motifs that appealed to foreign tastes. Private Chinese commissions also flourished.

Without government supervision, which had imposed a controlled anonymity, potters had the opportunity to exercise greater artistic freedom. The forceful painting of this design of lotus and ducks is vibrant and expressive, reflecting this lively time period.

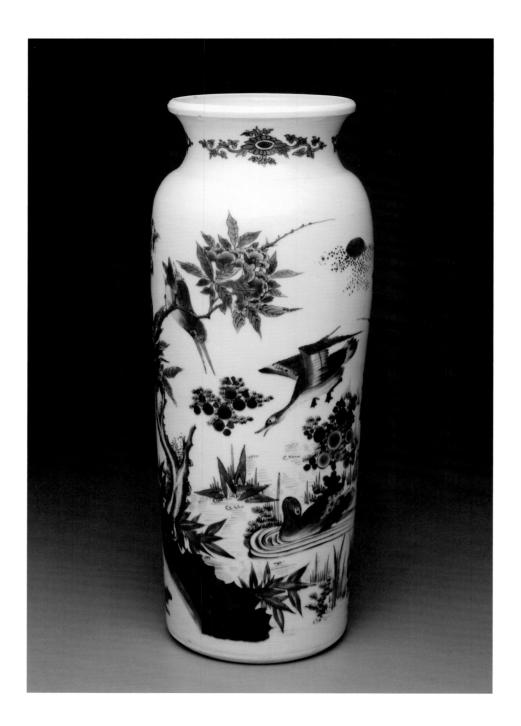

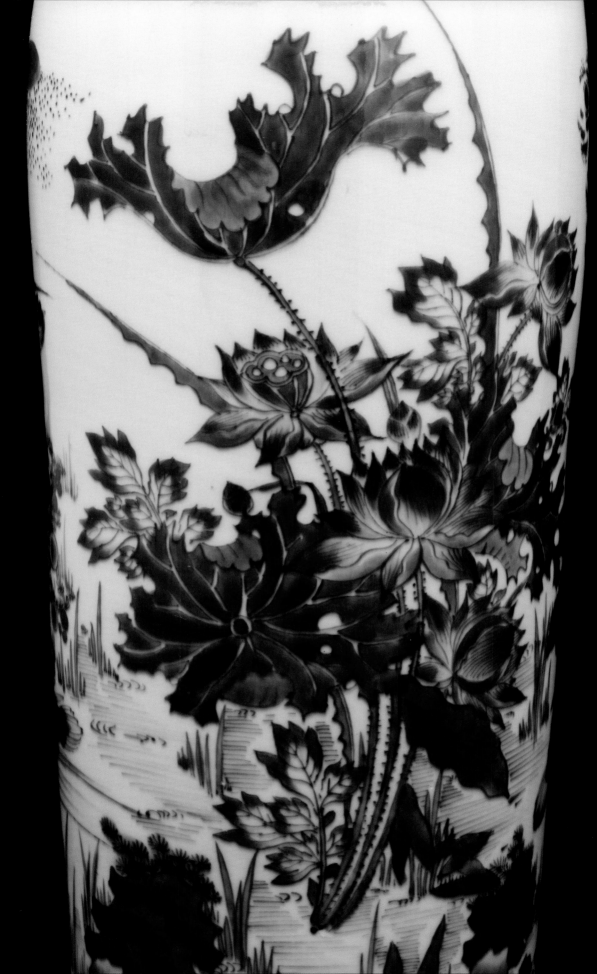

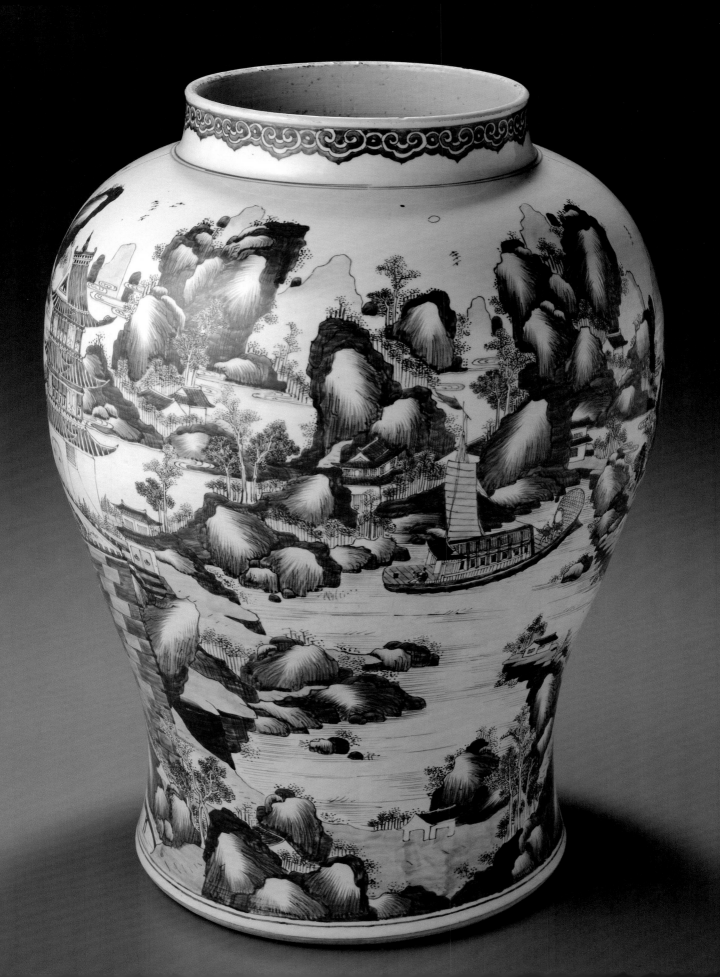

One side of this massive jar features a strik-ing landscape emulating the brushwork of an ink painting. The other side bears a very lengthy inscription that quotes a long preface and poem by the renowned Tang dynasty poet Wang Bo (649–676). It is among the most beloved works in Chinese literature.

The preface describes Wang's journey to the Pavilion of Prince Teng in Nanchang, the present-day capital of Zhejiang province, where Jingdezhen is located; he finds the pavilion neglected and in disrepair. Wang's concluding poem considers the transience of things.

> The lofty pavilion of Prince Teng
> stands facing the river.
> Sounds of jade pendants and carriage bells:
> The singing and dancing is over.
> Mornings, over the painted beam
> soar clouds from South Shore.
> Evenings, through raised vermilion blinds
> comes rain from West Mountain.
> The reflection of the leisurely
> clouds in the lake
> is sadder by the day;
> The scene changes, stars shift in the sky:
> How many autumns have come and gone?
> The pavilion's prince—where is he now?
> Beyond the railing, the long river
> flows emptily on its own.

—Adapted from a translation by Richard E. Strassberg; see *Inscribed Landscapes: Travel Writing from Imperial China*, translated with annotations and an introduction by Richard E. Strassberg, Berkeley, University of California Press, 1994, p. 109.

China
Qing dynasty, Kangxi period, 1662–1722
Porcelain with painted cobalt blue under clear glaze; Jingdezhen ware
H. 28 in. (70.9 cm)
Gift of Lenora and Walter F. Brown
92.25.49

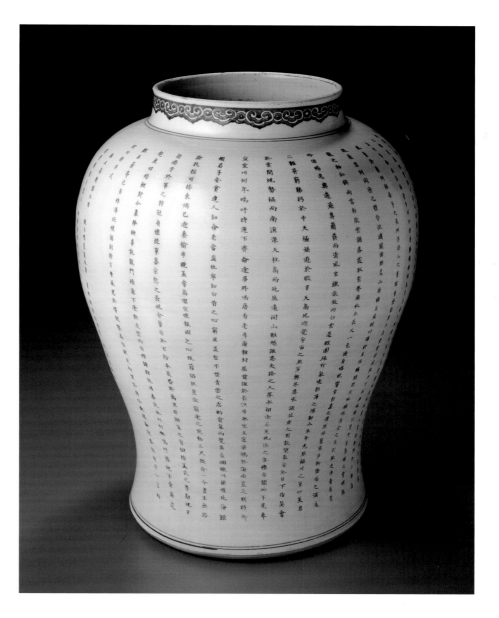

45 Dish

China
Qing dynasty, Kangxi period, 1662–1722
Porcelain with underglaze cobalt
blue and overglaze enamels, gilding;
Jingdezhen ware
H. 2½ in. (6.4 cm); DIAM. 16 in. (41.6 cm)
Gift of Lenora and Walter F. Brown
92.25.47

The kilns at Jingdezhen were largely
destroyed in 1674–75 during the civil war,
which raged in the south following the
Manchu conquest in 1644. In 1683, the
second Qing dynasty ruler, the Kangxi
emperor (r. 1662–1722), commanded the
kilns rebuilt, thus reestablishing imperial
patronage after a lapse of nearly sixty
years. The Kangxi emperor's personal
interest in and enthusiasm for innovation
and novelty, in part inspired by diplomatic
gifts such as European enameled copper-
wares, influenced production at Jingdezhen
as well as at the special enamel workshops
he set up in the capital.

This plate is typical of the new, extrava-
gant imperial taste and the kilns' technical
achievement. The effect of the underglaze
cobalt blue is referred to as "powder blue" or
"soufflé" in the West. The color was applied
to the surface of this plate by blowing it
through a tube; paper templates reserved
the white porcelain body. After application
of a transparent glaze, the piece was fired.
Colored overglaze enamels were then painted
in the cartouches, and the piece was refired
at a lower temperature. Finally, it was gilded.

The decoration features a landscape
scene with three hunters on horseback. The
men use a variety of weapons. One aims a
gun at a distant flock of birds, another wields
a trident, and the third, an archer who has
just shot a rabbit, wears a sheathed sword
on his hip.

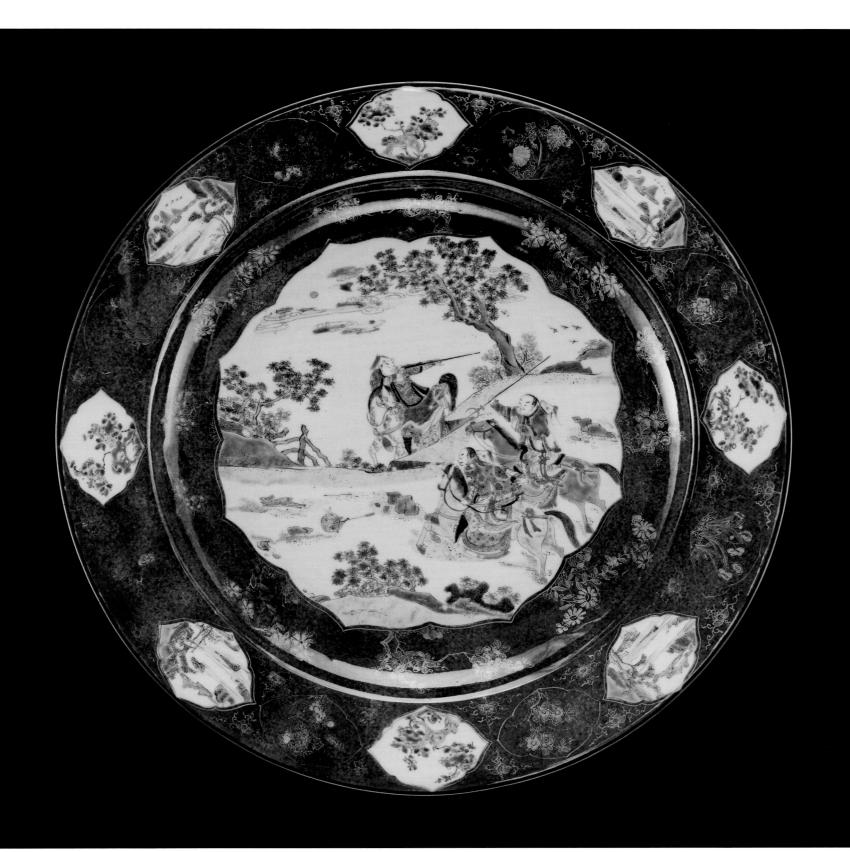

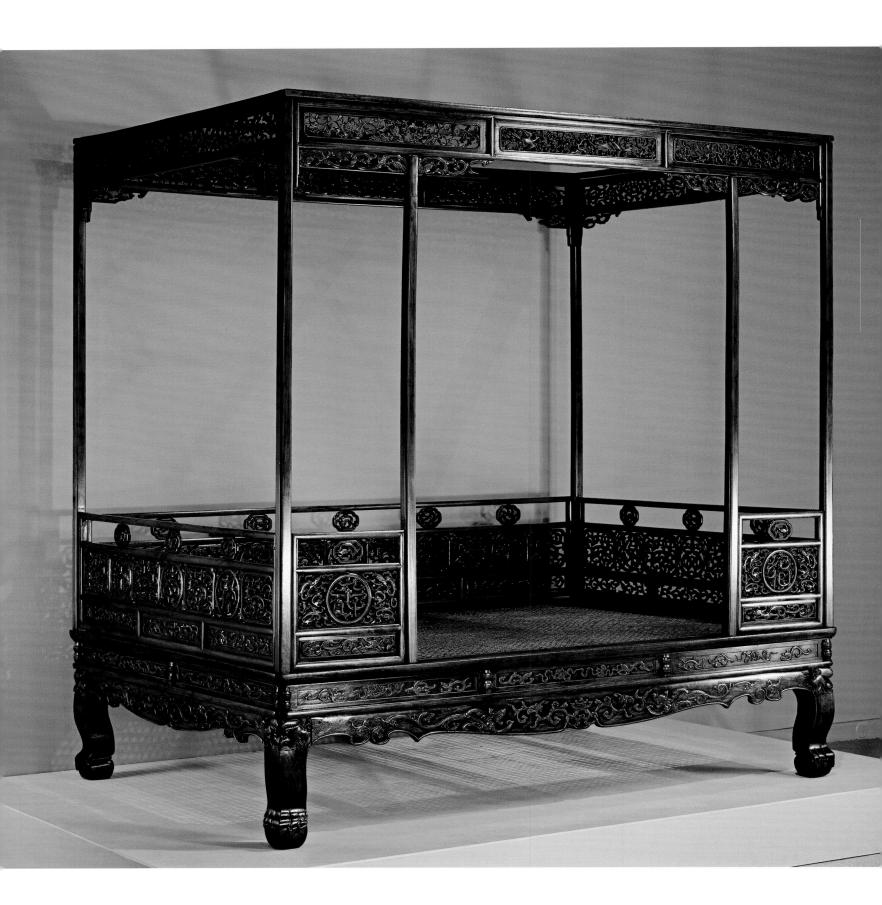

46 *Canopy bed*

The primary object in a woman's dowry was the bed. Meant for daytime activities of overseeing the household (tables were frequently pulled up beside the bed) as well as for sleeping, these beds were among the largest and most important items of furniture. They are frequently elaborate and celebrate their implicit connection to procreation as well as their practical role as seating enclosures.

This elegant bed is highly detailed, with beautifully crafted carvings. Its design balances the open work of the top and side portions of the bed with the more grounded, heavier, and deeply carved support of the base and legs. Within the detailed carving are roundels containing auspicious Chinese characters, including those for "good luck," "long life," and "prosperity." Each roundel is surrounded by stylized, scrolling dragons.

The precious *huanghuali* wood in this specimen is rare even for furniture of this period; now, the source, a type of rosewood, is essentially extinct. Like all Chinese furniture of the era, the bed is carved and constructed in multiple pieces. The mortise and tenon joints allow for easy disassembly.

China
Qing dynasty, late 17th century
Huanghuali wood
H. 108 in. (274 cm); W. 96 in. (244 cm); D. 60 in. (152.5 cm)
Gift of Bessie Timon
65.111

47 Vase

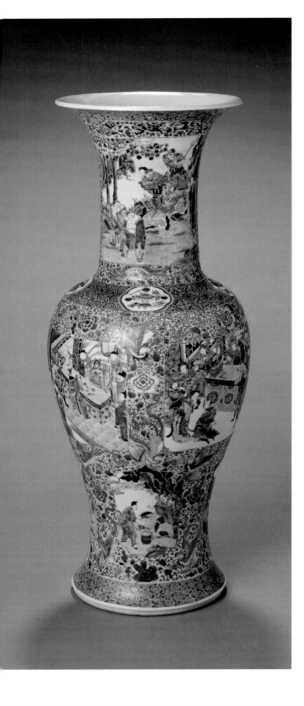

China
Qing dynasty, Kangxi period, 1662–1722
Porcelain with overglaze enamels;
Jingdezhen ware (*famille verte* type)
H. 28¾ in. (73.2 cm); DIAM. 10⅞ in. (28.5 cm)
Gift of Lenora and Walter F. Brown
92.25.50

Diplomatic gifts of European enameled copperwares appeared at the Qing court at the end of the 17th century and inspired major changes in Chinese porcelain production. The imported enamels used pulverized glass frit in a wide range of colors to produce elaborate, intricately detailed patterns. The Kangxi emperor was so impressed with them that he commanded efforts be made to transfer the technique to enameled porcelain decoration. Porcelains, like this outstanding vase, were decorated in shades of blue and green with accents in red, yellow, and black. Today, we know them as *famille verte,* or "green family," after the classifications created by the French connoisseur Albert Jacquemart (1808–1875).

The *famille verte* palette allowed porcelain painters to create bold, lively surfaces. Here, elaborate borders resembling colorful silk brocades separate eleven cartouches, each featuring narrative scenes, possibly based on popular collections of famous stories like *Water Margin,* or *Shuihu zhuan.*

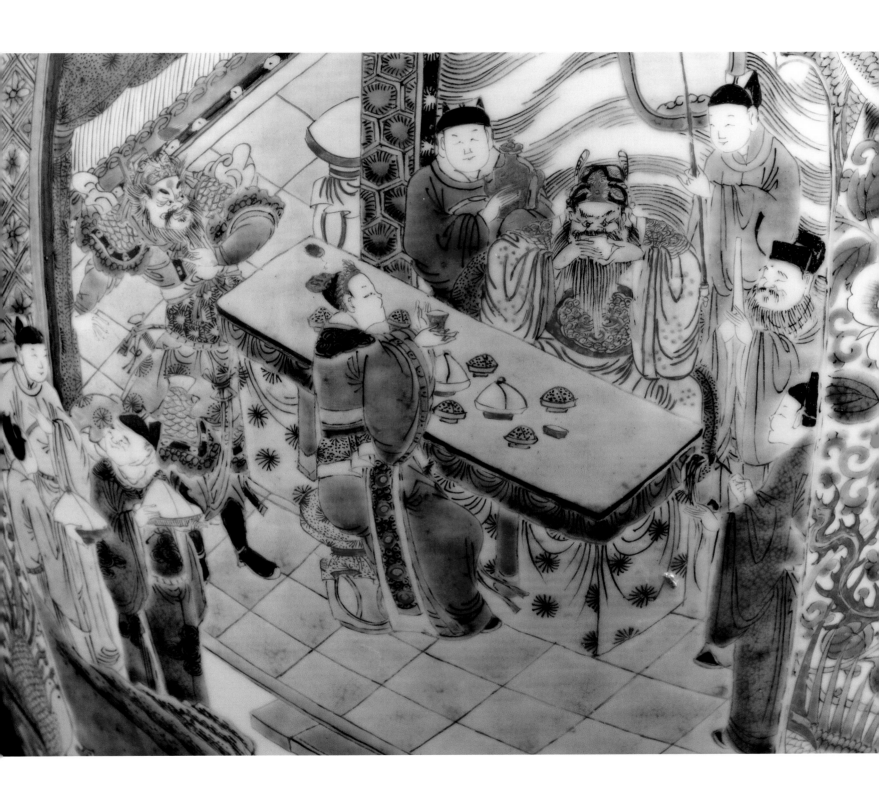

48 Vase and cover

China
Qing dynasty, Yongzheng period, 1723–1735
Porcelain with overglaze enamels;
Jingdezhen ware (*famille rose* type)
H. 24⅜ in. (62.7 cm); DIAM. 13¾ in. (35 cm)
Gift of Lenora and Walter F. Brown
92.25.4

Painted porcelains added shades of pink to the overglaze-enamel palette during the Qing dynasty. The first successful use of pink enamels in China can be traced to a set of dishes made for the emperor Kangxi's 60th birthday celebrations in 1713.

White and pink colors are very difficult to manufacture and were among the last opaque enamels developed. White was derived from lead arsenite, and pink had colloidal gold or fine fragments of gold metal in suspension in the enamel. The use of gold chloride to produce a pink coloring agent had been pioneered in Holland in 1650 by Andreas Cassius, which may account for the Chinese name *yangcai,* or "foreign colors," that describes these wares.

In the West, these pink-tinted enamels gave rise to the designation *famille rose,* or "pink family." The expansion of the overglaze-enamel palette changed the appearance of Chinese porcelain decoration, which increasingly emphasized the graphic qualities of the painter's art. During the 17th and early 18th centuries, all categories of painting subjects were used by enamellers: landscape [no. 45], figure painting [no. 47], and bird and flower studies, as on this handsome covered jar. The shape of this large jar embodies typical Yongzheng period refinements such as the slight swelling at the foot, which imparts a lightness to the overall mass of the vessel.

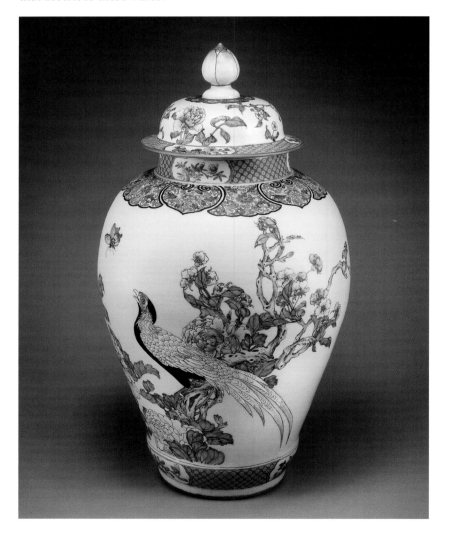

This set of vases (three covered balusters and two beakers) was made for the European export market. The configuration of five vessels evokes Chinese altar furnishings and has been traced to that inspiration. But the *garniture de cheminée,* as such sets of vases were called in the West, reflects northern European Baroque interior-design tastes. The *cheminée,* or fireplace, marked the visual and comfort focus of most private rooms and provided a prominent place for exhibiting symmetrical arrangements of rare and expensive Chinese porcelains. The fashion for *garniture de cheminée* was introduced to England at the end of the 17th century when the Dutch Prince William and his wife Mary ascended to the British throne.

These vases were created specifically to meet Western concepts of Chinese styles, which we know as chinoiserie. They were undoubtedly copied from drawings or patterns made in Europe and supplied to Chinese porcelain workshops. Like miniature pieces of furniture, each vessel panel is fitted with spotted blue and green bamboo frames. Sprays of flowers, inspired by branches of peach blossoms, are given a comparable plastic reality. Genre scenes of peasants tilling fields or fishing, possibly the most authentic Chinese aspect of the decoration, are placed in peach and pomegranate cartouches.

China
Qing dynasty, Qianlong period, 1736–1795
Porcelain with overglaze enamels and gilding; Jingdezhen ware (*famille rose* type)
Baluster vases: H. 25⅜ in. (64.5 cm); W. 9¼ in. (23.5 cm)
Beaker vases: H. 20 in. (50.9 cm); W. 9⅜ in. (24 cm)
Gift of Lenora and Walter F. Brown
85.135.18.1–5

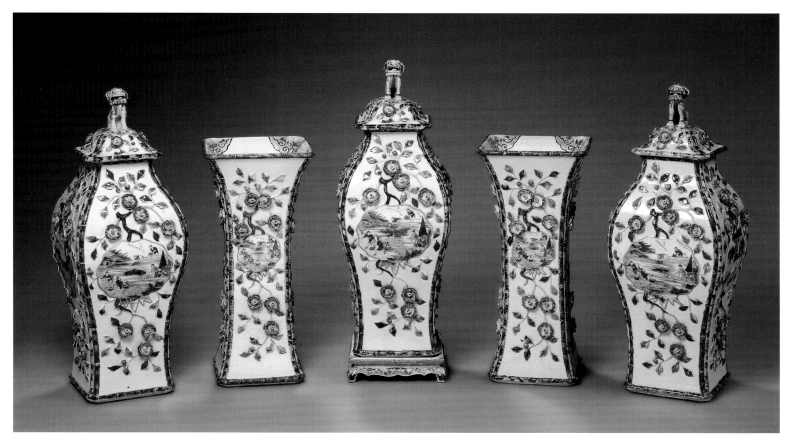

50 *Vase in the shape of a moon flask*

China
Qing dynasty, Qianlong mark and period, 1736–1795
Porcelain with painted cobalt blue under clear glaze;
Jingdezhen ware
H. 19¾ in. (52 cm)
Gift of Lenora and Walter F. Brown
85.135.12

The court of the Qianlong emperor was characterized by sophisticated, eclectic tastes that frequently looked back at historical precedents for inspiration. The flattened, round flask with enlarged, garlic-shaped top and strap handles was based on Islamic metalwork prototypes. This shape was first produced by Chinese potters during the 14th and 15th centuries.

The workshop that produced this vessel copied the shape, the scrolling floral patterns with lotus, chrysanthemum, and peonies, and the "heaped and piled" painting styles that were so admired in the blue-and-white porcelains dating from the Yongle period [no. 35]. Reverence for the past is an important element of Confucian thought and was particularly embraced by the Kangxi, Yongzheng, and Qianlong emperors, who transformed the role of the Qing dynasty emperors from alien conqueror to embodiment of Chinese Confucian values.

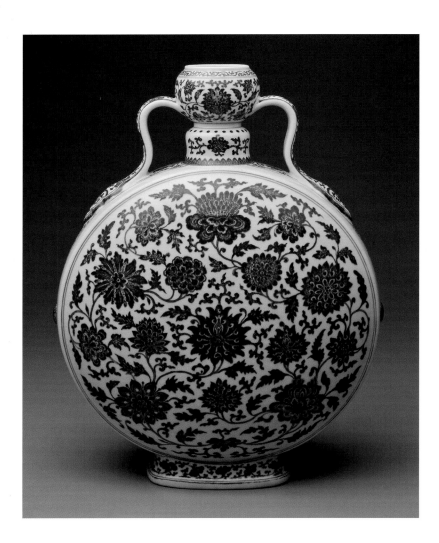

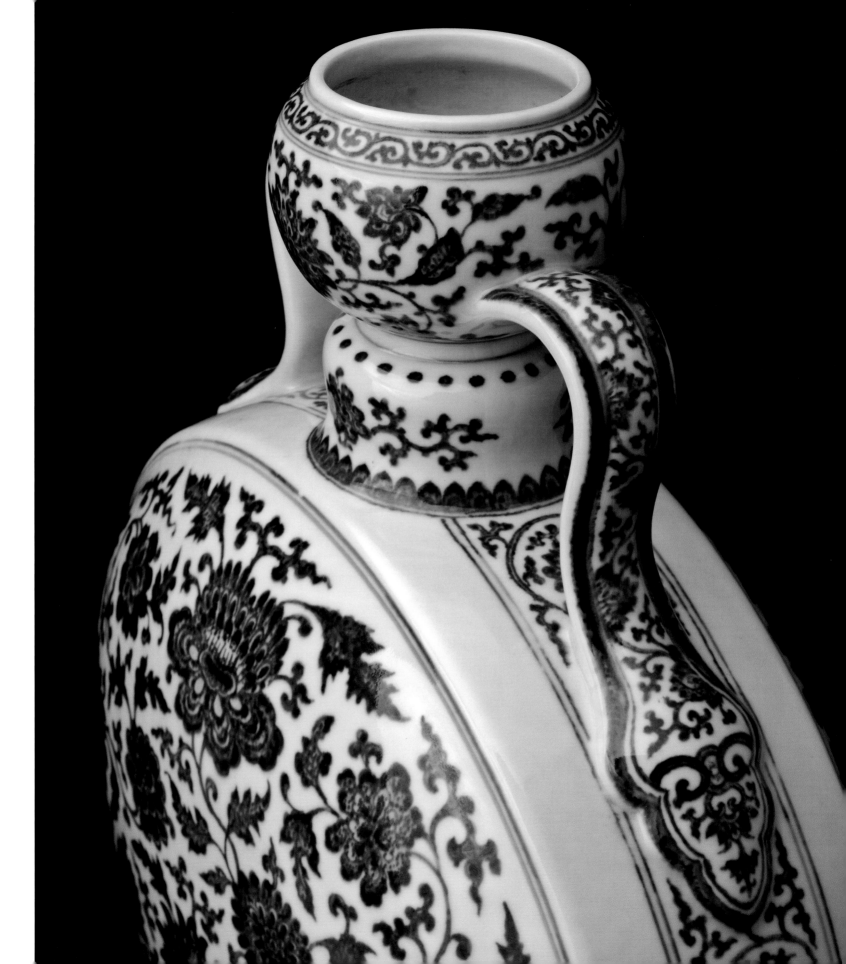

51 *Woman's semiformal court robe, or jifu*

China
Qing dynasty, early to mid 19th century
Silk gauze embroidered with floss silk and
gold-wrapped threads
H. 55 in. (139.7 cm); w. across shoulders 70 in. (178 cm)
Gift of John T. Murray
52.14

The semiformal court robe was among the clearest statements of Qing dynasty intentions concerning the political and social functions of costume. The decoration was a schematic diagram of the universe. The lower border of diagonal bands and rounded billows represents water, the universal ocean that surrounds the earth. At the four axes of the coat, the cardinal points—prism-shaped rocks—rise to symbolize the earth mountain. Above, in the cloud-filled firmament, dragons—symbols of imperial authority—coil and twist. The symbolism was complete only when the garment was worn. The human body became the world's axis: The neck opening became the gate of heaven, or apex of the universe, separating the material world of the coat from the realm of the spiritual represented by the wearer's head.

Women's semiformal robes were differentiated from those of men by the placement of vents at the sides, rather than at the front and back, and by the addition of an extra band, matching the neck and overlap facings, between the body of the coat and the sleeve extension. This particular shade of green gauze was assigned to ranking concubines in the imperial harem.

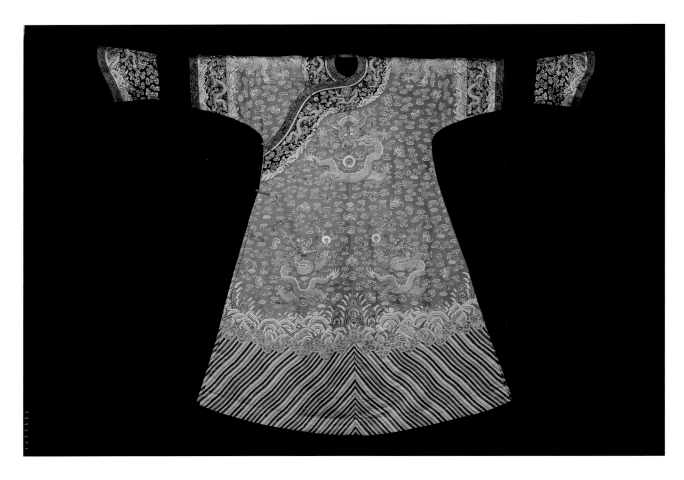

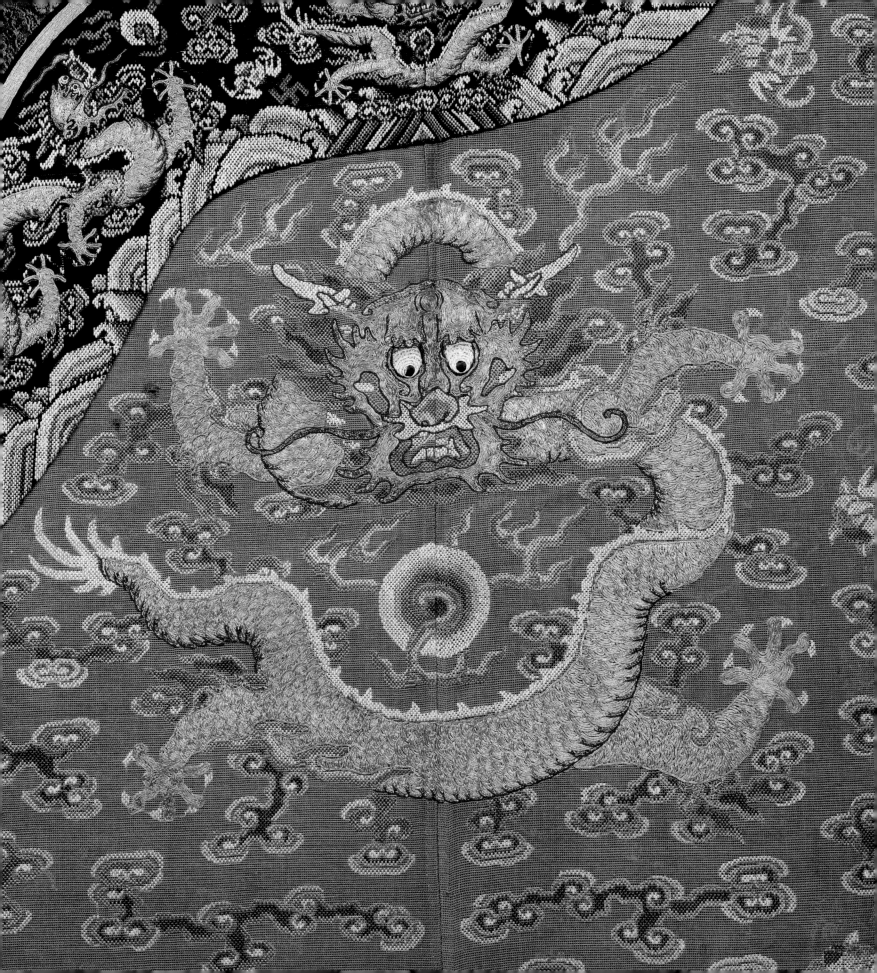

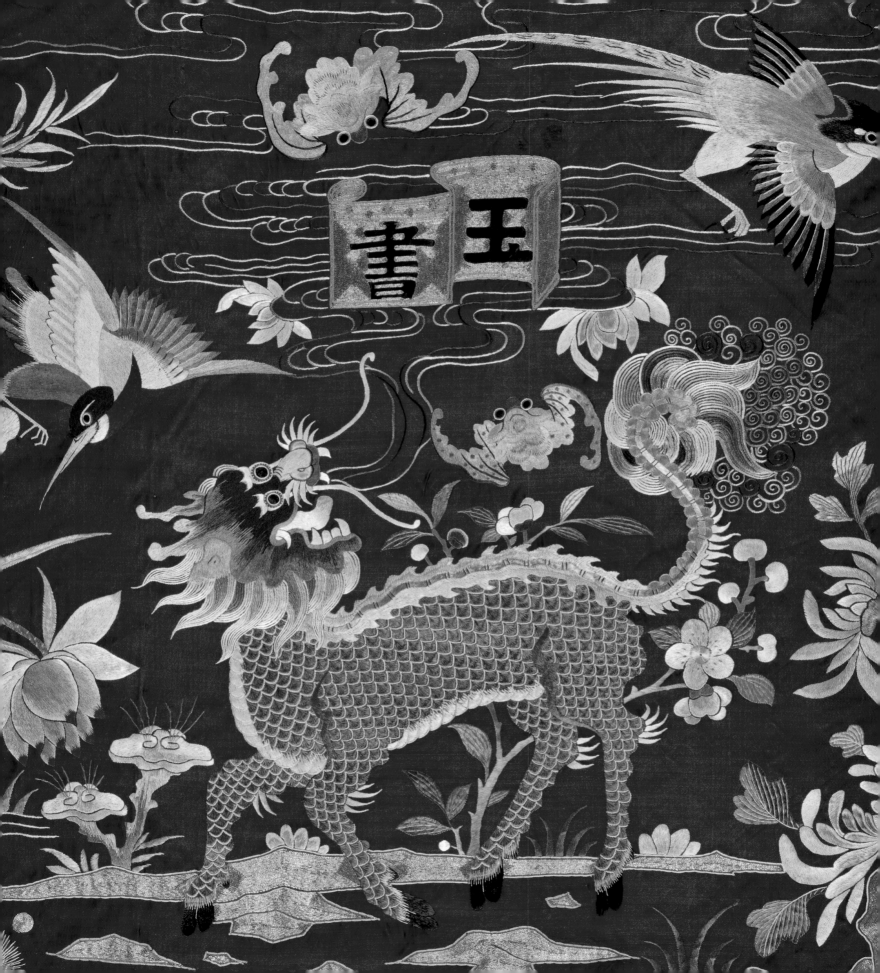

Silk textiles adorned furniture and interiors much as costume adorned people: Cloth transformed both for ceremonial and social occasions. This large valance, made to hang in the doorway of a reception hall, is decorated on both sides. The embroidered side features a variety of fantastic beasts amid scenes with birds and flowers, all conveying auspicious wishes. For example, a pale green *qilin* stands in a landscape below a partially opened hand scroll with Chinese characters that read *Yushu*, or "Jade Books." This is an allusion to the legendary *qilin*, who brought jade books filled with magical writings from heaven to the mother of Confucius before his birth.

The reverse side features a painting in ink and colors of Daoist deities attending a birthday celebration for the Queen Mother of the West, ruler of Mount Kunlun, the sacred mountain of immortality. The Queen Mother is seated on a phoenix in the center of the composition. Surrounding her are Shou Xing, the God of Longevity, the Eight Immortals, and the Monkey King with offerings of peaches. A kneeling attendant to the left of the Queen Mother holds a scroll that reads, "May the Sovereign enjoy longevity without end," a birthday greeting usually reserved for the Emperor, but in this case meant for the Queen Mother of the West.

Embroidered on the painted side is an inscription, which informs us of the piece's celebratory function. It tells who made it, when it was made, and where it was to be displayed. The inscription reads:

> Manufactured in the Yusheng Shop
> on Zhuangyuan Street in the
> Provincial Capital of Guangdong Province
> Placed in the Jiqing, or Hall of Auspicious
> Celebration, Ji County
> Autumn of the Third Year of the Xuantong
> Reign Period (1911)

—Translation by Jonathan Chaves

52 *Valance*

China
Qing dynasty, dated to 1911
Embroidered silk satin (face) and painted cotton tabby (reverse)
H. 45¼ in. (114.8 cm); w. 256½ in. (651.3 cm)
Gift of the family of
Mr. and Mrs. William M. Young
2003.35

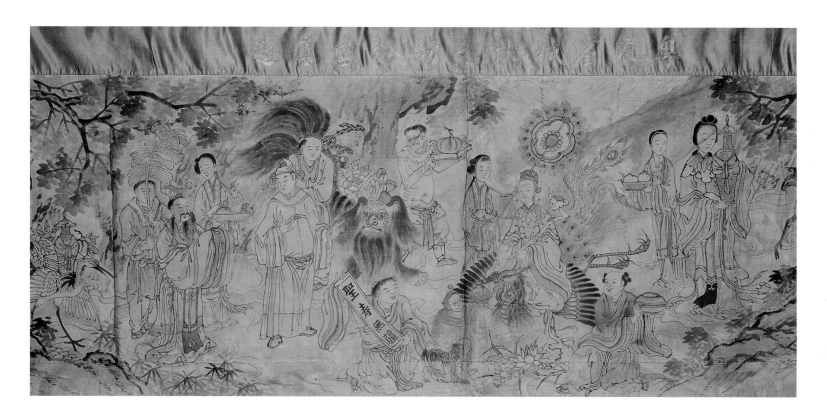

Japan and Korea

Japan and Korea—one an archipelago, the other a peninsula—lie at the eastern edge of the Asian continent. For both, harsh terrain and the sea contribute to a sense of isolation and self-sufficiency. Geography also shapes attitudes about nature and human existence within it. Although each nation is small, rugged mountains and swift-flowing rivers cut the land into parcels, making travel and communication disproportionately difficult. For this reason, both countries turned to the sea, which augmented agriculture for sustenance, provided local and international transport, supplied lines of communication, and at times fostered careers in trading or piracy.

Korea and Japan each evolved distinct social and political systems over long periods of time, while their relative isolation allowed tribal communities to evolve into refined court systems. The geography of each conferred a degree of autonomy. As technologies in transportation and materials advanced, other influences intruded, most notably those of China, the region's dynamo for a millennium.

The arts of Japan and Korea therefore reflect both countries' proximity to China and its nearly overwhelming size, economic power, and political might as well as its written language. China served as a conduit for ideas and goods moving eastward across Asia; these were sometimes carried by missionaries and merchants and sometimes imposed by invasion or tribute. In spite of the scope of Chinese influence, Japanese and Korean arts remain distinctive from those of the Middle Kingdom in style, execution, materials, and temperament. They reflect the complex interaction of geography, climate, social pressures, religious beliefs, and history that influences art production and the opportunities afforded its makers.

Korea's climate, like its geography, is severe, buffeted by the weather patterns of the Asian landmass. Summers are hot and humid; winters are bitterly cold and dry. Sudden weather changes and a rugged terrain made for a hard life. To cope with the precariousness of human existence within these environmental extremes, Koreans turned to the mediation of the shaman, who traveled between the world of spirits and that of humans. The shaman tradition evolved from the practices of peoples of the Siberian taiga and nomads from the Eurasian steppe, ancestors of Korea's original settlers. Korean artists often infuse their works with a boldness and naturalism unknown in China.

By contrast, Japan's climate is moderated by the surrounding ocean, which produces a more hospitable environment. Throughout the islands, four distinct seasons occur with predictable regularity, measuring time and

giving the Japanese an acute awareness of nature. For the Japanese, viewing cherry blossoms or observing maple leaves are major social occasions, often promoting a kind of celebratory craze. Japan's indigenous religion, Shinto, is based on awe and respect for nature. Whereas Chinese art-making emphasized technical mastery, Japanese artists believe that materials found in nature, such as wood, clay, and rock, are imbued with the spirit of the *kami,* or gods; they therefore tend to prize "natural" effects, imperfections, and spontaneity.

The Longshan culture tripod ewer from Shaanxi province [no. 1] and the Jomon period jar [no. 53] are comparable in date but reveal two very different attitudes about production standards. Both were made in the third millennium BCE and are formed of coils of clay that were pressed together and smoothed by hand. Both are complex shapes. The Chinese potter paid particular attention to make each of the leg units identical; all traces of the potter's hand have been eliminated, suggesting mechanical perfection. The surface has been burnished to a metal-like sheen. The Japanese potter, on the other hand, made a point of being spontaneous. Finger marks remain on the elaborately sculpted crown with pierced projections, which give the vessel its name, *kaenshiki,* or fire-flame type.

Whereas conscripted labor and mass-production methods encouraged monumental projects in China, Japanese art production is generally more intimate in scale. Art production was traditionally carried out in family workshops dedicated to particular fields such as ceramics, lacquer, or sculpture. Individual craftsmen held a much higher position in Japan than in China, as objects reflect the artist's involvement and personal respect for the materials. In the 19th century, Westerners first observed this underlying respect

for nature in things such as bonsai, ikebana, and temple gardens; it remains a fixture of our perception of Japan.

Less focused on the natural world, China's cultural conceit placed it at the center of the universe, a position the nation's political and economic might guaranteed. Korea and Japan reacted with a mixture of dread and envy. For them, being dominated or independent, receptive or exclusionary, were constant factors of life.

The northern half of Korea was colonized by China as early as the 2nd century BCE—part of a strategy to secure the empire's northern borders from nomadic invaders. In 1218, the peninsula was incorporated into the empire; it was controlled by the Mongols when they ruled as China's Yuan dynasty (1279–1368).

The Korean peninsula was frequently a launching pad for invasions of Japan. The Mongols used it as a base of operations to launch assaults on Japan in 1279 and again in 1281. They had no navy of their own but appropriated Korean vessels, sea captains, and fighting forces. Weather intervened: Winter storms in the Sea of Japan, and the threat of being stranded without secure lines of supply, caused the first invasion to be abandoned. A second ended in catastrophe because of a typhoon. Rescued once again by nature, the Japanese immortalized this feature of the East Asian climate as the "heavenly winds," or *kamikaze.* Others, including the Russians in the early years of the 20th century, would continue to use Korea from which to assail Japan.

Throughout the centuries, China also practiced means other than force to exert its influence. Among potentially hostile nomadic groups to the northeast, Chinese strategy was to play favorites, conferring status on one group to set the factions

against one another, thus weakening collective political and military power. This divide-and-conquer philosophy reflected China's cultural bias that its 'non-Han' Chinese neighbors were barbarians. With Korea and Japan, Chinese strategies were markedly different; shared histories and common values linked Korea and Japan to China.

The Korean court received China's imperial envoys and became a tributary to the Son of Heaven in the 7th century and again in the 14th century. Japan maintained diplomatic relations with the Chinese court from the mid 7th through the early 9th century. In acknowledging the supremacy of the Chinese emperor, Korea and Japan entered into what was essentially a nonaggression pact and most-favored-nation trading arrangement. Tribute guaranteed trade with China and gave Korea and Japan access to markets along the Silk Road farther west.

Significantly, the Silk Road not only served as a trans-Asian conduit of commerce but facilitated the movement of people and ideas. In the fourth century, merchants and monks brought Buddhism to Korea; from there, it was transmitted to the Japanese court in the mid 6th century. Buddhism's flexibility and inclusiveness introduced rich new ways of thinking.

Iconographic models for Buddhist images were transmitted from India and Central Asia together with a vast number of scriptures and a complex liturgy. The finely cast bronze image of A'mita Buddha [no. 59], which dates from the 18th century, acknowledges 1,500-year-old iconographic models for making images of this Buddha. Its proportions, physical marks such as the snail-shell curls and domed cranium, yogic posture, and hand gestures were fixed. Nonetheless, the Korean artist's hand is present in the sweet

disposition of the Buddha's face and the precision of casting, which captures the floral patterns on the textiles of his patchwork mantle.

In contrast, the scriptural basis for the wrathful appearance of Aizen Myo-o [no. 55] originates in an 8th-century Chinese text that returning pilgrim monks brought to Japan, where his fierce image was formulated during the 13th century.

The seemingly greater independence in Japanese artistic tradition reflects an actual political and social condition: China's attempts to keep Japan a tributary of the Dragon Throne were less successful, and somewhat less pressing, because of distance. The *Legend of the Great Woven Cap,* or *Taishokan,* focuses on the mission sent by the Chinese emperor Taizong (r. 627–650) to ask for the hand of the daughter of Fujiwara Kamatari (614–699). Kamatari founded the Fujiwara clan, which established the dynasty that ruled Japan during the late 9th through 12th centuries. Such diplomatic marriages added immeasurably to local prestige and gave China a foothold in foreign politics.

In contrast, the Wanli emperor's (r. 1573–1619) efforts to subdue the growing power of Japan met with the wrath of the ruling generalissimo Hideyoshi Toyotomi in the 1580s, when the general discovered that the emperor's gifts of presentation robes were appropriate only to the rank of duke, not king. This diplomatic faux pas may have solidified Hideyoshi's resolve to mount a campaign to conquer China. Japan's invasions in 1592 and 1597 wreaked havoc on Korea. The campaign was called off with Hideyoshi's death in 1598.

Korea and Japan were also affected by a wide range of nonpolitical influences from China. The introduction of the Chinese system of writing and Chinese Confucian philosophy were critical factors in the early development of both countries.

When Chinese statecraft was imposed, Korea quickly adjusted its centralized government, headed by a hereditary monarch. Unlike the Chinese ideal—which opened advancement to the most qualified candidates regardless of family background—the scholar-bureaucrats who served the king in Korea were drawn almost exclusively from old aristocratic families: The traditional court wore a kind of Confucian veneer. Patronage by the ruler and the circle of aristocratic families affected technical and aesthetic achievements such as the development of celadon wares that gained international renown as "first under Heaven" during the 12th and 13th centuries. Under the Korean court, ceramics had a magnificent development—fully the equal of anything in China—particularly in a consistent tradition of excellence in fine porcelain.

Japan was freer to select the aspects of Chinese culture that suited its needs, thus maintaining a stronger sense of what constituted "Chinese" in contrast to its "Japanese" identity. While certain Confucian concepts, such as filial piety and a hierarchical class system, were adopted and even celebrated, they were redefined to meet the needs of Japan's martial society. Bushido, or the way of the warrior, outranked the *Analects,* the teachings of Confucius.

For most of its history, Japan was governed simultaneously by an emperor and a shogun. In China, although the emperor was called "Son of Heaven" and expected to fulfill ritual functions, his primary responsibilities as political leader and commander in chief placed him at the head of all administrative and military operations. Japan's emperor, in contrast, claimed divine ancestry; as a living god, his function was only ceremonial. This opened the way for aristocratic families to manage the military and political operations of the country. While China advocated a meritocracy, Japanese society remained locked in feudal rigidity.

The severe discipline and codes of behavior that militarism imposed on Japanese society also set the stage for a kind of duplicity in the arts. The lacquered palanquin, or *norimono* [no. 61], like today's ultra-luxury car, celebrated the status of its owner. Lest an observer mistake the owner's identity, a family crest, or *mon,* is liberally displayed on the carriage and carrying bar. During the early 19th centuries, when this object was made, the use of such ostentatious luxury goods was strictly regulated. Only the wives of *daimyo,* or feudal lords, would have been entitled to travel in such a splendidly decorated palanquin.

This vehicle bears a woman who is never seen. Dressed ornately in a silk kimono beautifully patterned with embroidery or special dyeing techniques (that were also strictly regulated), she rides in a kind of elaborate gift box. The palanquin is lavishly decorated inside and out with patterns and images that charm and delight the eye with their sumptuous materials and imaginative design. A comparable woman's space in China, such as the canopy bed with its elaborately carved ornament [no. 46], is squarely focused on Confucian values of social harmony and continuity. The marriage bed was the most important piece of furniture, signifying a woman's role as a marital partner to her husband and her social role as the bearer of sons. The words "prosperity," "good luck," and "long life," which form part of the decoratively carved railing, reinforce the social obligations of its inhabitant. Chinese art emphasized social, therefore public, function.

There was no private role for art and no equivalent to the private, playful images made for the appreciation of the woman transported in the Japanese palanquin.

Throughout history, there were periods during which political power plays in East Asia ignored Korea and Japan. These decades offered opportunities for independent action and development. At times, Japan, more remote and distant than Korea (whose land links with the Asian continent prohibited strict isolationism), restricted the entry of foreigners and banned Japanese from traveling abroad. Such exchange was forbidden for 250 years during the Edo period (1615–1868).

This isolationism not only served as a defense from Chinese influence but also buffered Japan from the colonial aspirations of European nations. Seen as an enviable market and source of trade goods, Japan was also viewed by Western interests as a thorn in the side of colonialism. So long as Japan held out its independence, other occupied nations would resist the advances of Western capital interests. In 1853, superior military technology forced the opening of Japan when a small fleet of U.S. warships, led by Commodore Matthew Perry, fired on the harbor at Edo (modern-day Tokyo).

Long steeped in a martial tradition that emphasized a warrior code, Japan had nonetheless made few advances in military technology. While battles were fought with other Asian nations and within its own borders, the strategies and materials of warfare changed slowly. With the harsh introduction of Western military technology, Japan's isolationism collapsed, and the Japanese began to embrace and adapt the technologies the West presented. The ability to adopt and expand on introduced technologies—honed through long exposure to China—is now recognized as a force behind Japan's emergence as a major world economic power.

In the 20th century, military activities in and occupation of both Japan and Korea would serve to bring both cultures more forcefully into Western consciousness. As China vanished into its own era of isolationism under Mao Zedong and communism, these two nations established their identities in the world. Korean and Japanese arts, with their elaborate and elegant expression of philosophies, history, ideas, and relationship to materials, provide a rich and compelling entry into engaging their unique cultures.

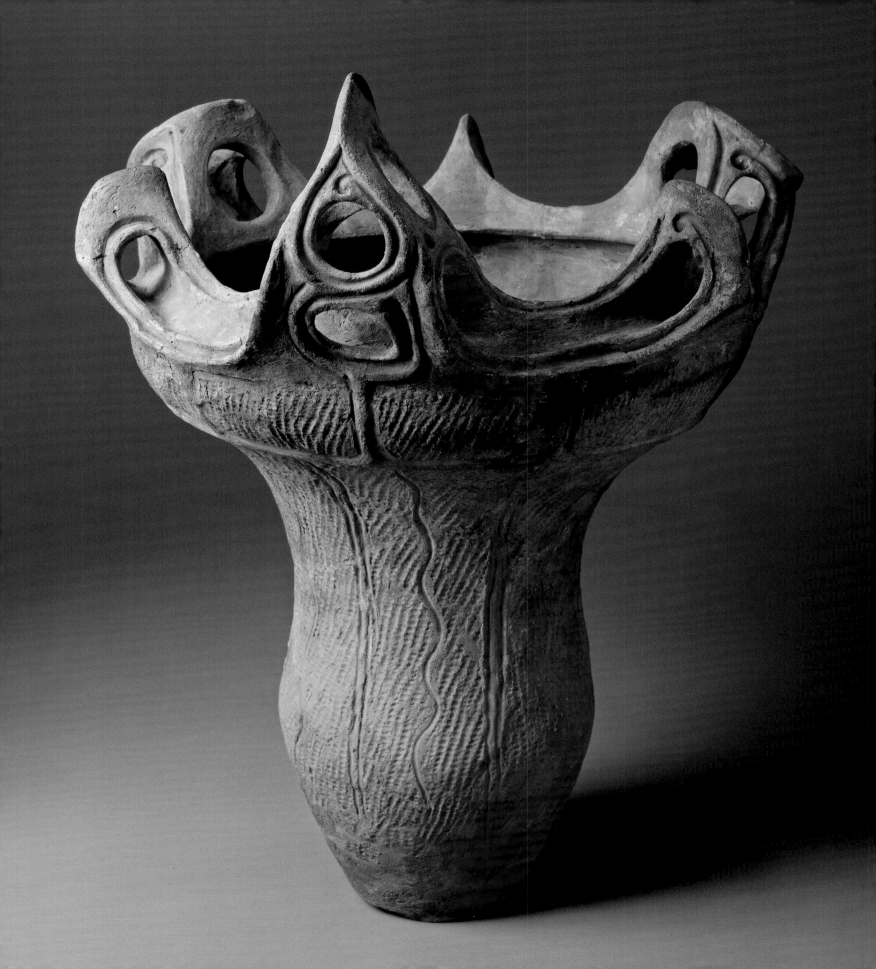

53 *Jar*

The Jomon people were Japan's earliest inhabitants. They lived in small communities on Japan's central island of Honshu from approximately 10,000–300 BCE. They were primarily hunters and gatherers and are best known for their hand-built ceramics with cord-impressed decoration. The term "Jomon" means "cord markings."

This narrow, cylindrical vessel supports a substantially larger, yet delicate, rim. The vessel begins with a narrow base and gradually swells outward. It tapers in and then projects out dramatically. The artist who made this pot stacked long ropes of clay in a circular pattern and paddled them together. Additional coils were used to create the elaborate rim with its circular openings and passageways. The dramatic projections and recessions in the clay are similar to the spikes and recesses from flames in a fire. Japanese scholars refer to this style, as the "fire flame," or *kaenshiki*.

The rough, corn-cob texture is made from rolling the rope horizontally across the moist clay. The artist probably used a sharp bamboo tool to incise vertical lines that divide the vessel into registers as well as the whimsical curving designs that decorate these spaces.

The extensive and delicate projections on the vessel's rim make it impossible to imagine this vessel was used for daily cooking or storage of food. With this degree of detail, it seems more likely that it was used for ceremonial purposes. Like other fire-flame style Jomon pots, this example has singe marks on the shoulder and rim. Scholars have suggested that these pots were used for ritual cooking and placed on an open fire during ceremonies.

Japan
Jomon period, 3000–2000 BCE
Earthenware
H. 24 in. (60.8 cm);
DIAM. at mouth 18 in. (45.6 cm)
Purchased with funds provided by the Lenora and Walter F. Brown Asian Art Challenge Fund
88.3

54 *Bishamonten*

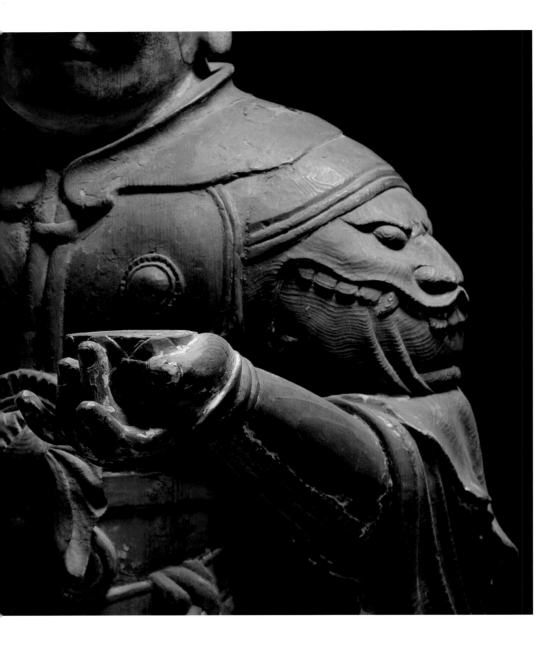

Japan
Heian period, 12th century
Cypress (*hinoki*) wood with traces of gesso and pigment
H. 44 in. (111.8 cm); w. 25 in. (63.4 cm);
D. 15 in. (38.2 cm)
Gift of Alice Kleberg Meyer and
Friends of Asian Art
88.25

Bishamonten is one of the four Guardian Kings, or Lokapala, who protect the Buddhist Law. The Guardian Kings safeguard the four quadrants surrounding Mount Sumeru, the center of the Buddhist universe. Bishamonten is chief among them and guards the northern direction. In India, where the deity originated, he is depicted in the guise of a king; in China and Japan, he is represented as a warrior.

This dynamic guardian figure, carved of cypress wood, stands in a martial pose holding a trident with his right hand; his left hand originally would have held his other attribute, a small pagoda. With his furrowed brow and bulging eyes, he stares down at his prospective enemy with a menacing gaze. Bishamonten wears complex, Chinese-style "bright-and-shining" armor with metal breastplates, elaborate animal-headed shoulder guards, and lion-faced belt buckle (see no. 12).

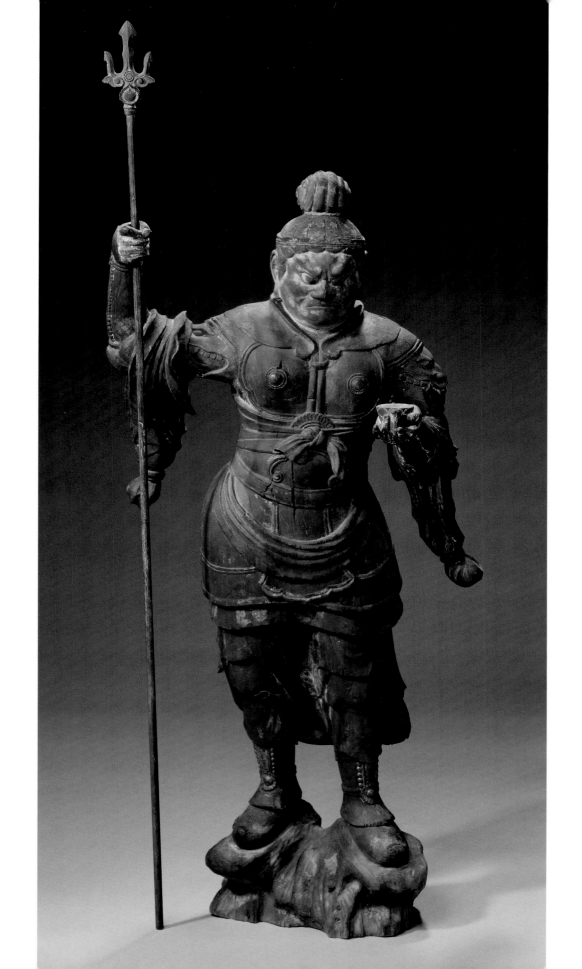

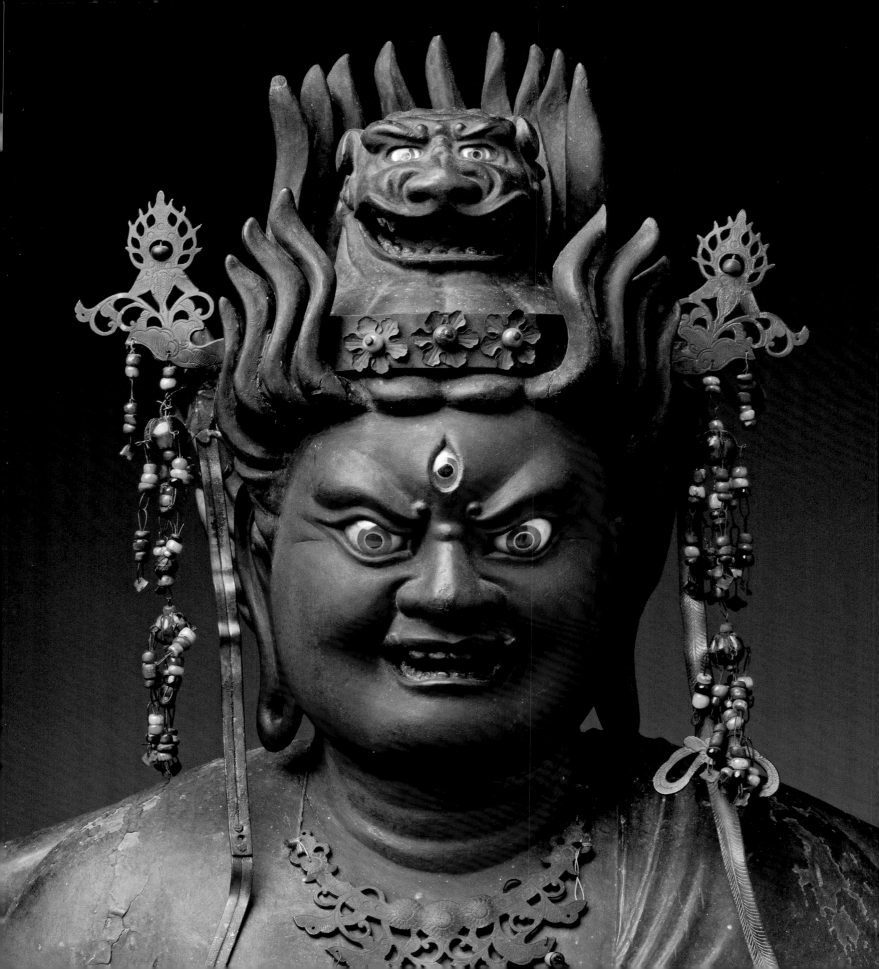

Japan
Late Kamakura period, 14th century
Cypress (*hinoki*) wood with gesso, pigment,
and gold with gilt metal fittings
Figure: H. 19¾ in. (49.8 cm)
Pedestal: H. 18¼ in. (46.2 cm)
Purchased with funds provided by the
Lenora and Walter F. Brown Challenge Fund
91.20

Aizen Myo-o, the Lord of Passions, one of
the guardian kings of Buddhist truth, was a
major deity within the pantheon of Japanese
esoteric Buddhism as taught by the Shingon
sect. The scriptural basis for Aizen's wrath-
ful appearance originates in an 8th-century
Chinese text, but it was in 13th-century
Japan that his fierce image was formulated.
Colored red, emblematic of human desire,
Aizen sits on a lotus throne, glaring intensely
and baring teeth. His energy and foreboding
aspect serve as strong warning: He exists to
defeat demons and defend the faith. A third
eye and the lion crown symbolize his com-
mitment to the path of spiritual awakening.
The remaining attributes held in his six
hands include a bow, indicating his swift-
ness of action, a ritual bell, and the *vajra*,
or thunderbolt scepter.

Aizen's piercing gaze inspires awe and
respect. Crystal eyes first appeared in Japa-
nese Buddhist sculptures around the 12th
century, in an attempt to invest the figure
with greater realism. Images of Aizen, like
this one, were considered so powerful that
they were kept in shrines behind closed
doors and opened for viewing at fixed times
of the year.

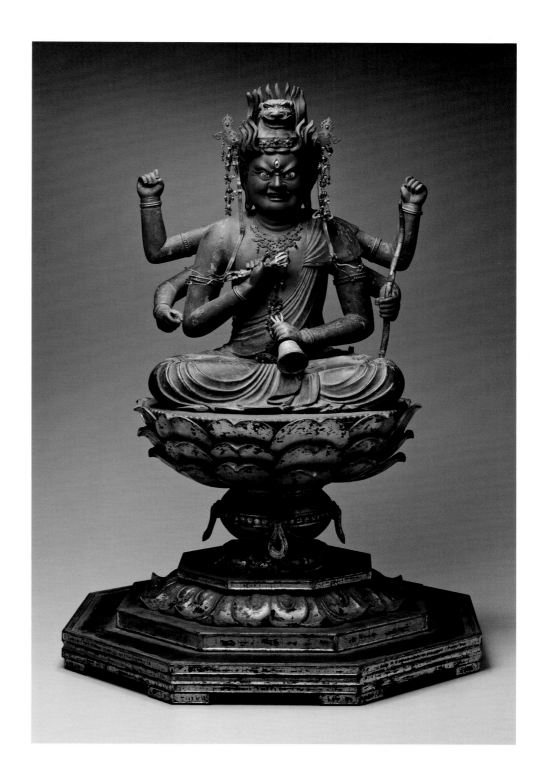

56 *Taima mandala*

Japan
Edo period, c. late 17th to first half of 18th century
Hanging scroll; ink and color on silk
H. 94¾ in. (240.7 cm); W. 71¼ in. (181 cm)
Purchased with funds provided by
Lenora and Walter F. Brown
2001.29

Pure Land Buddhism, or Jodo Shu, was introduced to Japan from China at the end of the 10th century and became immensely popular. It remains the leading form of Buddhism in Japan today. Pure Land Buddhism emphasizes salvation through faith in Amida (Sanskrit: Amitabha). Devotees believed they could be reborn in Amida's Western Paradise if they could visualize it before dying. Paintings of paradise, such as this one, functioned as aids for meditation.

The central composition, a sacred landscape, features Amida enthroned before a palace complex, flanked by his principal attendants—Kannon (Sanskrit: Avalokiteshvara), Bodhisattva of Compassion, and Seishi (Sanskrit: Mahasthamaprapta), Bodhisattva of Wisdom. They are surrounded by hundreds of adoring lesser deities. Angels, or *apsaras*, make music above, while in the pond newly born souls rise from lotus buds to be welcomed into paradise. The paneled border at the sides and bottom present the basic ideas from the scriptural sources of Pure Land Buddhism.

The name Taima is derived from the Buddhist temple that preserves one of the oldest versions of this icon, in the village of Taima, near Nara, Japan.

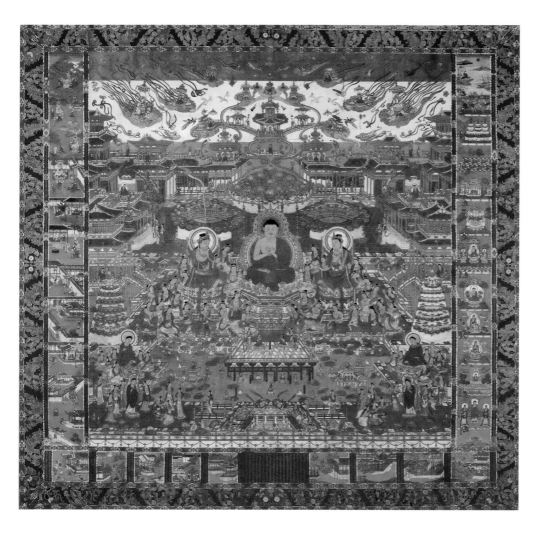

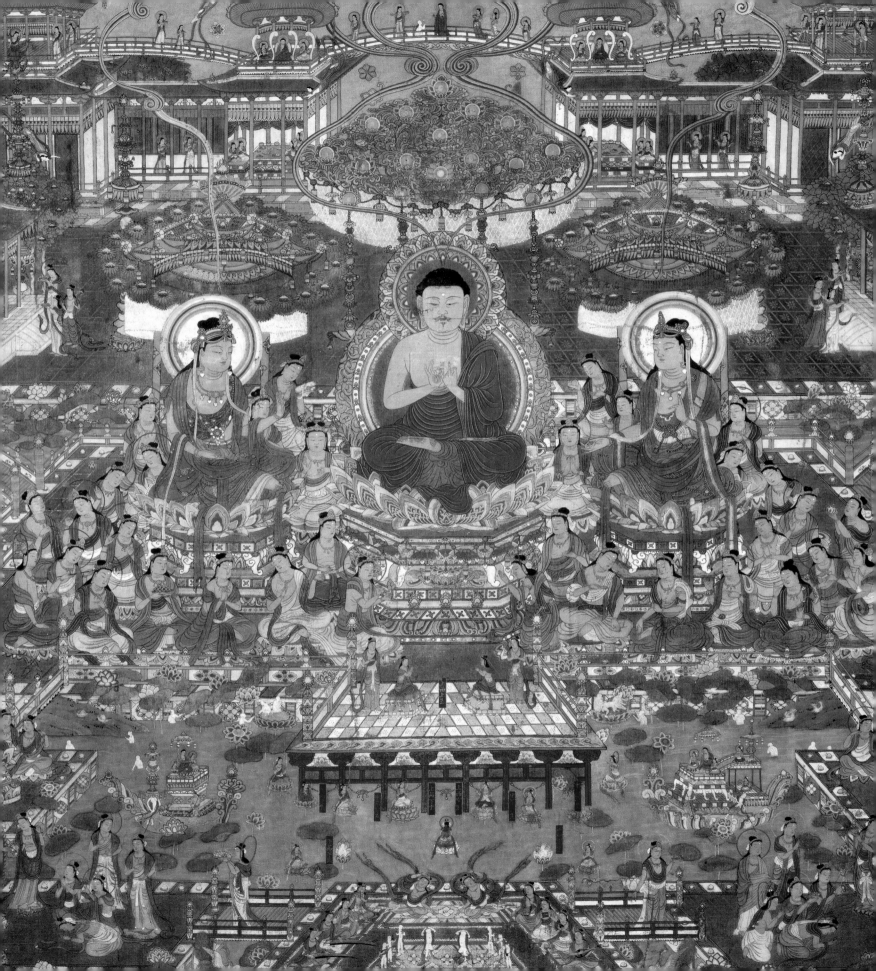

57 Scenes In and Around Kyoto, *or* Rakuchu rakugai-zu

Japan
Edo period, first half of 17th century
Pair of six-fold screens: ink, pigments, and gold leaf
on paper
Each screen H. 66 in. (165.4 cm); W. 144 in. (366 cm)
Purchased with funds provided by the
Lillie and Roy Cullen Endowment Fund
2001.51.a–b

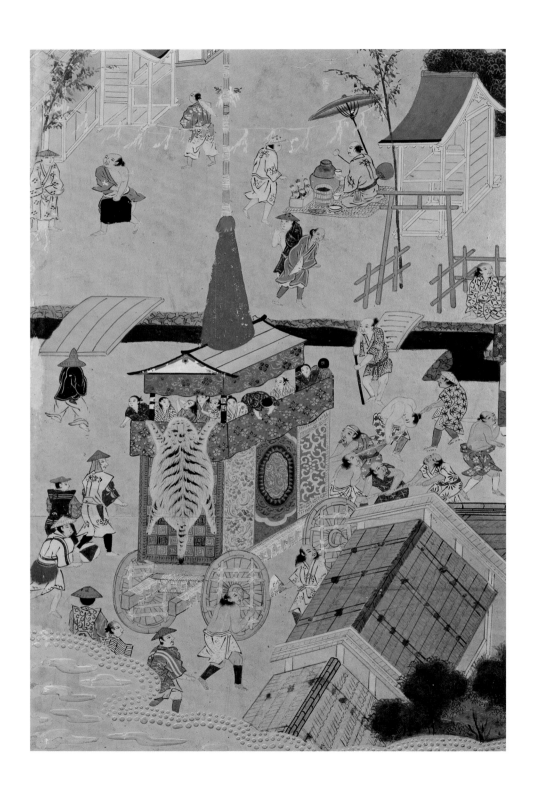

These screens present a bird's-eye view of the ancient Japanese capital with its major thoroughfares and buildings. The screens focus on scenes of bustling life in the crowded streets. An unusual feature of this set of screens is the inclusion of a Jesuit priest with Dutch or Portuguese merchants, and a servant, probably from Goa (see detail on p. 133). Equally distinctive is the focus on the Gion Festival, an ancient celebration of the Gion district sponsored by Kyoto merchants. The prominent display of this event across both screens suggests a wealthy merchant may have commissioned these paintings.

During the late 16th and the 17th century, peace brought prosperity. A burgeoning merchant class clamored for art that reflected its members' lives. Very much like today's deluxe tourist picture books and videos, the screens of *Scenes In and Around Kyoto,* or *Rakuchu rakugai-zu,* functioned as a record of activities and the landscape of the time.

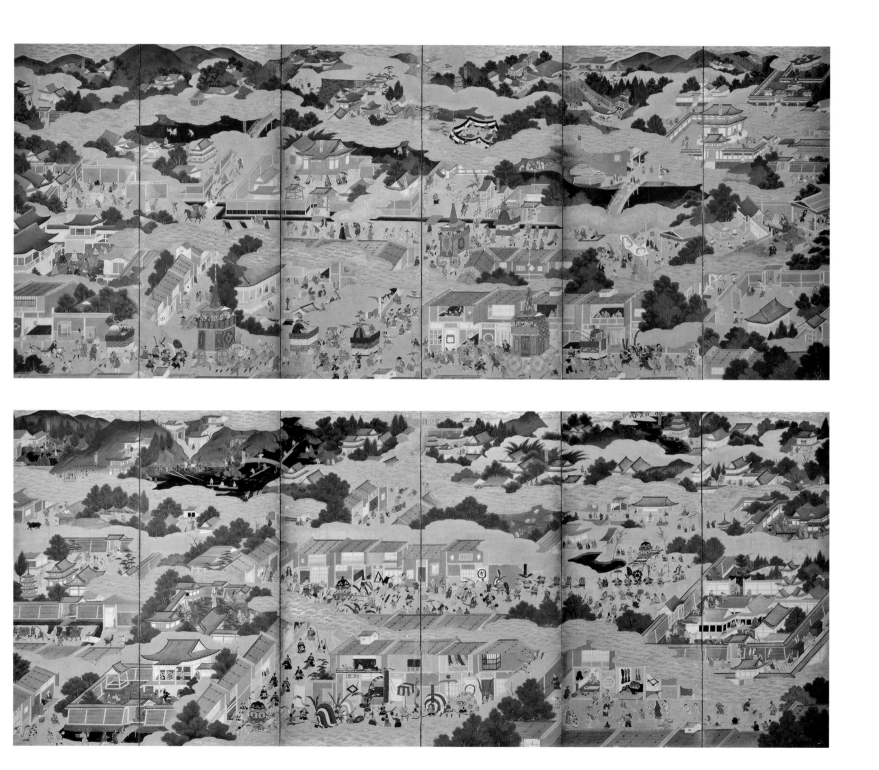

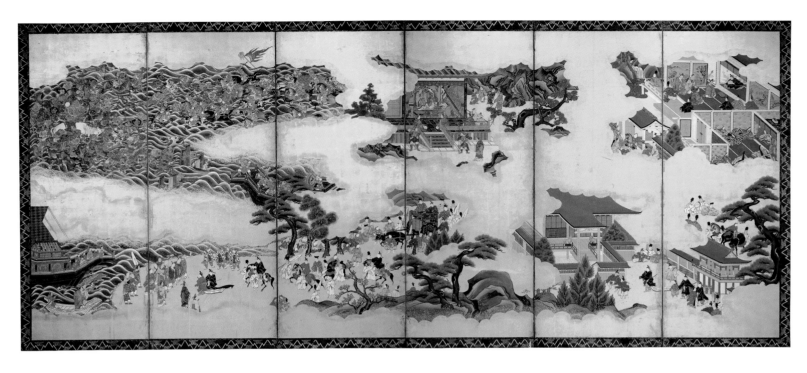

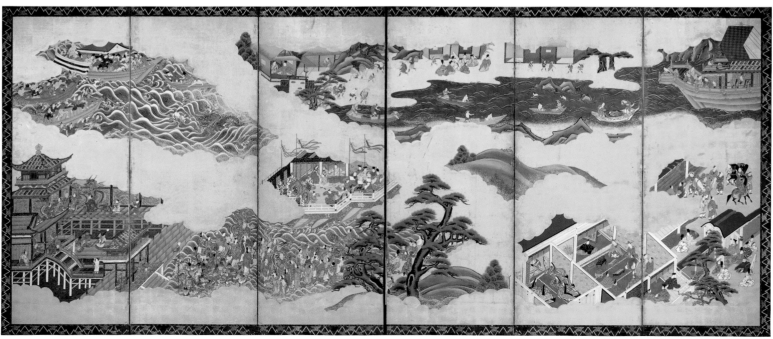

58 Legend of the Great Woven Cap, *or Taishokan*

This pair of screens illustrates the *Legend of the Great Woven Cap,* or *Taishokan,* which is based on events surrounding the life of Fujiwara Kamatari (614–699). Kamatari founded the Fujiwara clan, establishing the dynasty that ruled Japan during the late 9th through 12th centuries. Vignettes of the narrative are arranged across the surface of the screens like a movie in which gold clouds act as cinemagraphic breaks between scenes.

The setup for the story was Kamatari's decision to construct Kofukuji temple in Nara. Key events from the legend in the first screen include Kamatari's visit to Kasuga Shrine, and the arrival of a diplomatic mission from the emperor of Tang China, summoning Kamatari's daughter to become an imperial consort. The story continues with her departure, accompanied by a great retinue.

From China, Kamatari's daughter sends precious gifts, including a rare jewel for the temple. The ship is attacked and the treasures stolen by agents of the Dragon King. The second screen shows the adventures involved with the retrieval of the treasure by Kamatari's second wife, a pearl diver. Although Kamatari's wife reclaims the treasure from the Dragon King, she sacrifices her life to do so.

Japan
Edo period, early 18th century
Pair of six-fold screens: ink, pigments, and gold leaf on paper
Each screen H. 67 in. (170.3 cm); W. 149 in. (378.6 cm)
Gift of David Douglas Duncan in memory of Stanley Marcus
2001.48.1a–b

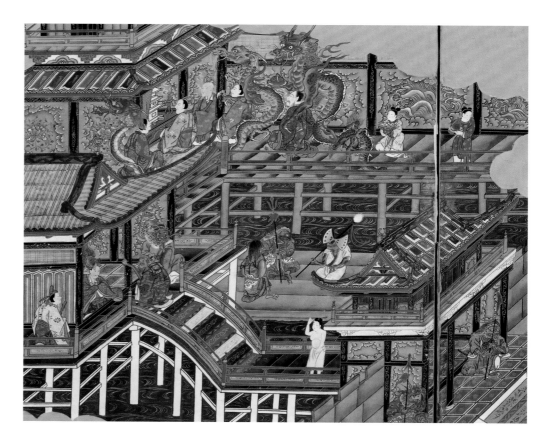

59 *A'mita Buddha*

Korea
Choson dynasty, 18th century
Bronze
H. 20¼ in. (55.5 cm); w. 15½ in. (40 cm)
Gift of Floyd L. Whittington
97.11.117.a–b

This figure is seated in the lotus position, his right hand over his knee touching the ground and his left hand upturned with his middle finger elegantly raised. This position, known as the *bhumisparsha mudra,* is associated with the historical Buddha Shakyamuni and represents the moment when he calls the earth to witness just prior to his enlightenment. In Korean Buddhist art, there are examples of A'mita (Sanskrit: Amitabha), or the Buddha of Boundless Light, depicted in this same position.

Originally, this bronze statue was probably gilded and meant to be viewed from all sides. The casting is particularly fine. Great care has been taken to copy the floral patterns of the textiles and the seam lines of the Buddha's patchwork mantle. This garment was meant to symbolize the vows of poverty and renunciation of the world. It was traditionally worn by all Buddhist monks.

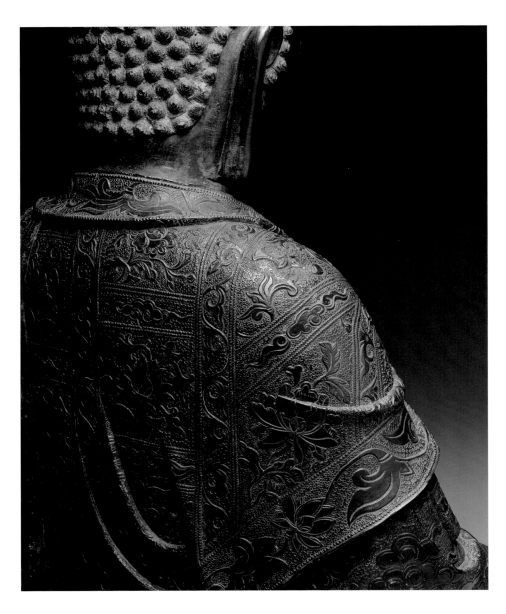

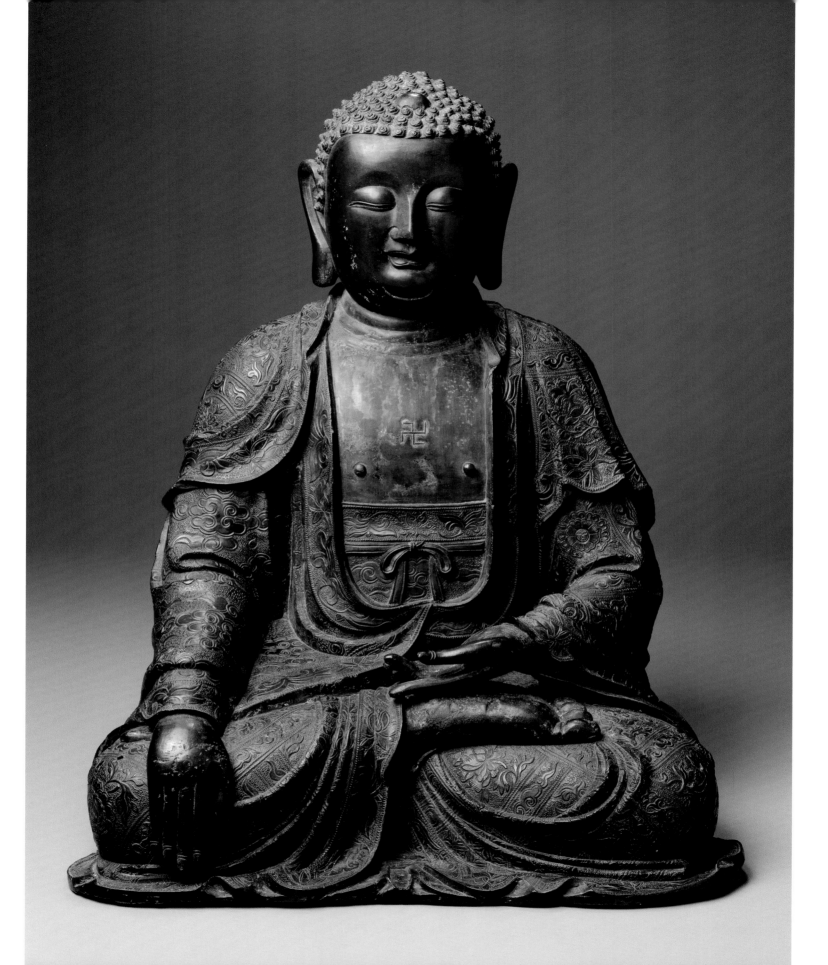

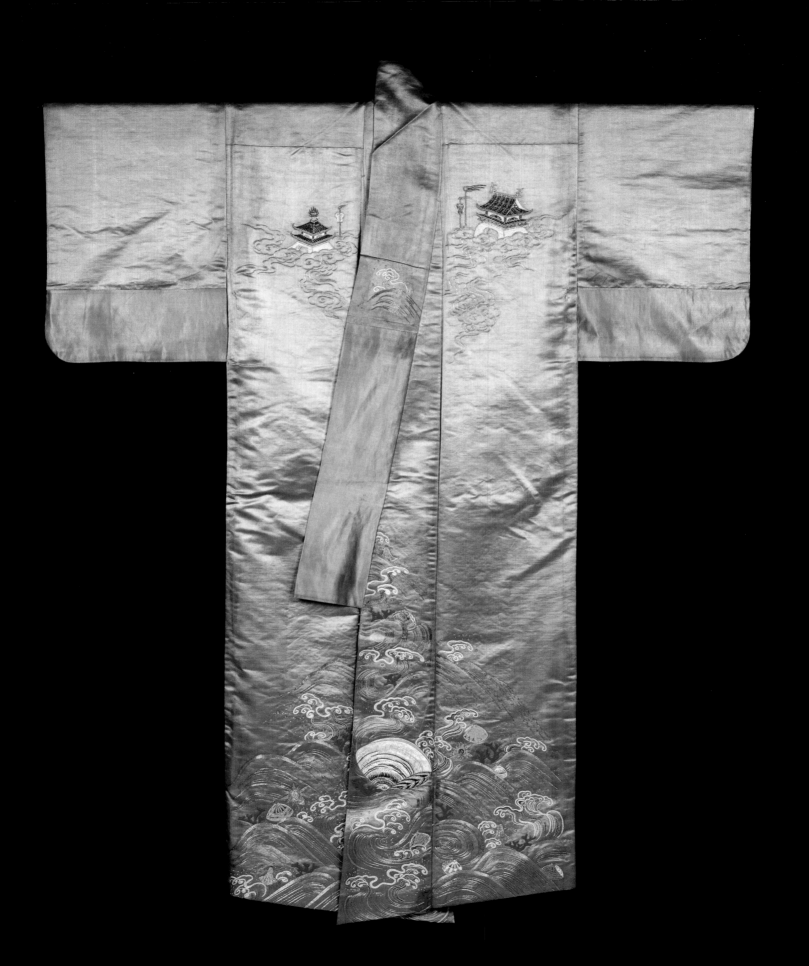

60 *Noh theater robe*

This pale blue silk satin robe is embroidered with a variety of sea treasures. A large white clamshell dominates the center, while smaller white and gold clamshells undulate rhythmically across the waves, punctuated by red corals. White foam crests the golden waves, and the gates of an underwater palace are glimpsed in the distance.

A skilled embroiderer used bright, crisp colors to create this lively composition. The embroidery features a variety of twisted metallic and silk threads applied with couching and padded satin stitches. The stitching is elegant but restrained, leaving most of the robe undecorated; the wearer (and the viewer) can appreciate both the luxurious fabric and its rich detailing.

This robe, a short-sleeved woman's kimono, or *kosode,* was originally the property of a woman of feudal rank. The remains of three embroidered *mon,* or family crests, can be found on the back and shoulders of the garment. The sleeves and fronts of this robe were reassembled and a double-width collar, or *edi,* was added to make it conform to the style of Noh garments. In Noh theater, *kosode* robes were the standard costume for female characters and it was not uncommon for a fashionable garment such as this to be converted into a Noh theater costume. In addition, Noh theater patrons and members of the audience often gave robes to the actors as a sign of their support.

It is possible that this robe with its ocean-blue ground and sea treasure iconography was worn by an actor playing the role of the pearl diver in either *The Great Woven Cap (Taishokan)* or *The Diver (Ama),* two popular Edo-period Noh plays. See object 58 in this catalog for more information on *The Great Woven Cap (Taishokan).*

Japan
Edo period, early 19th century
Silk satin, embroidered
L. 62½ in. (159 cm); w. across shoulders
52 in. (132 cm)
Purchased with funds provided by
Emory A. Hamilton, James Dickie II,
Lenora and Walter F. Brown, Christopher
Hill, and Rick Liberto
2002.17

61 *Palanquin, or norimono*

Japan
Edo period, early 19th century
Wood with lacquer and gold leaf; gilt copper mounts;
interior painting: ink, color, and gold on paper
Cab: H. 40⅞ in. (122 cm); L. 46 in. (116.8 cm);
w. 32½ in. (82.5 cm)
Carrying bar: L. 163 in. (414.5 cm)
Purchased with funds provided by the Lenora and
Walter F. Brown Fund, the John and Karen McFarlin
Purchase Fund, and an anonymous donor
91.130

During the Edo period, palanquin were the primary conveyance for the highest-ranked members of Japanese society—the ruling military class. Paintings from the era frequently feature various types of palanquin and provide a contrast between the elite, who were carried in these coaches by servants, and the pedestrian masses.

This palanquin is decorated in gold scrolling leafwork with interspersed diamond-shaped crests against a black lacquer ground. Gilt metal fittings with the same decorative scheme ornament the sides and corners, as well as the carrying bar. The notched diamond-shaped symbol is called a *matsu-kawabishi,* a term that describes its "pine bark" shape. Since this mark is prominently featured throughout the decoration on the palanquin, it is probably the *mon* or family mark identifying the samurai family that originally owned this vehicle.

Japanese family marks are stylized symbols usually taken from nature. During the Edo period they appear on clothing, lacquer objects, and a variety of materials. Families often used more than one mark, making identification complicated.

The passenger compartment is shaped like a small room with sliding doors and three windows for ventilation and viewing. The interior is painted with seasonal landscapes and the back wall features a composition of cranes, pine trees, and turtles, all symbols of longevity. The ceiling is coffered, like those in fine feudal residences, with sprays of flowers in each coffer (see detail on p. 128). A palanquin with elaborate decoration such as this one would have been reserved for the wife of a *daimyo* or high-ranking samurai.

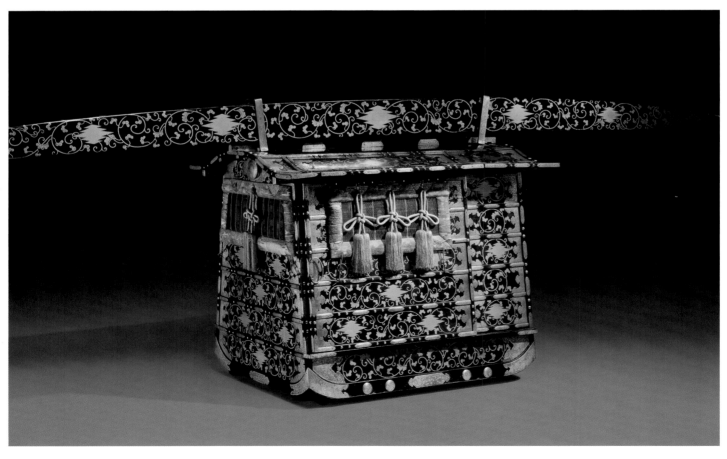

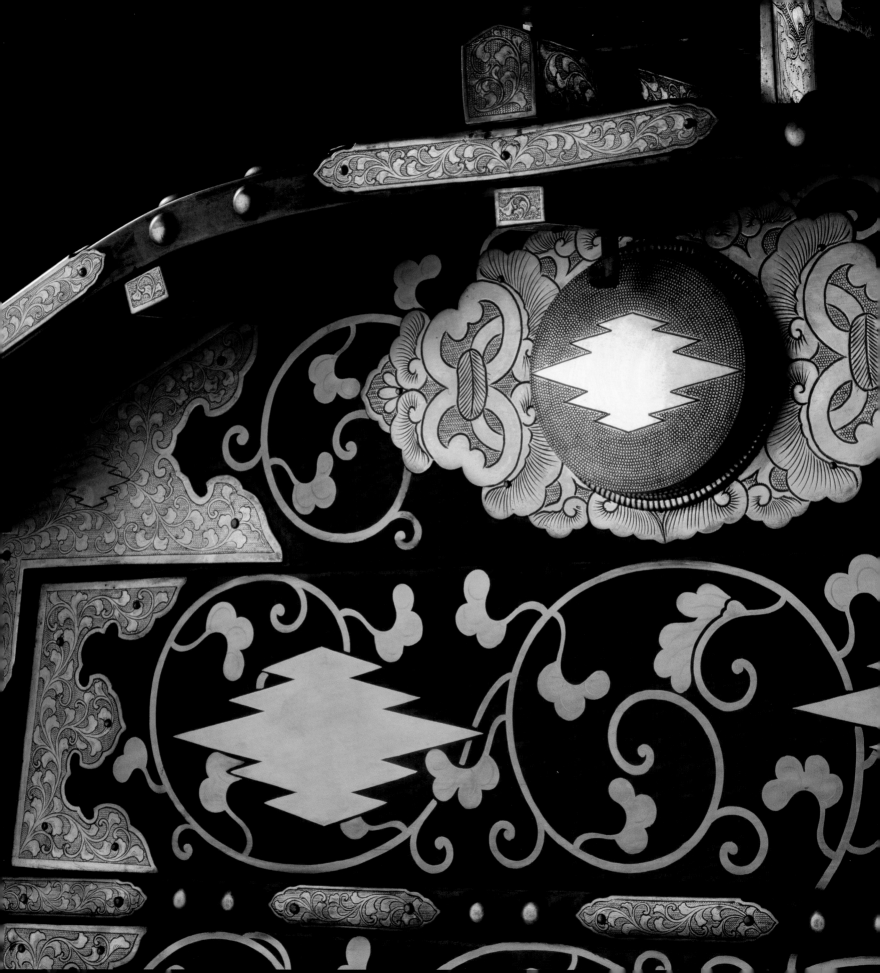

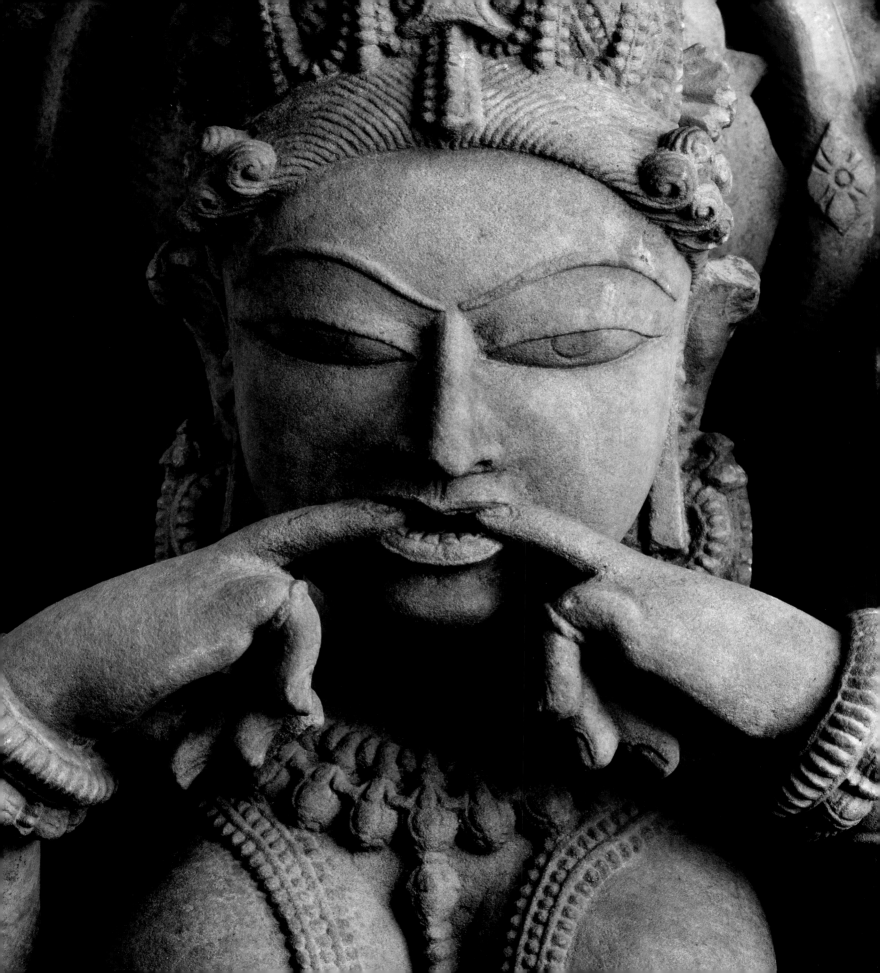

South Asia, the Himalayas, and the Tibetan Plateau

Western cultural myth runs deep about South Asia, the Himalayas, and the Tibetan Plateau. The arts are rich and mysterious to an outsider, laden with a sense of esoteric knowledge, demanding clues to decode them. Yet, in many ways, the mystery exists only because traditions of the West have so deeply entrenched an aura of the exotic.

Geography and climate sharply differentiate South Asia from the Himalayas and Tibet, marking all three as distinct from other regions of Asia. The tropical south can be lush. Changes in climate are determined largely by monsoons blowing southwest from May to October and northeast from November to April. In contrast, at the "roof of the world," the climate is dry; summer offers a brief respite from fierce winter. For both north and south, environment produced extremes that influenced attitudes about nature and the place for human society within it. Violent, relentless weather patterns affected mobility and survival and shaped cultural principles about coexistence with a hostile nature. Meditation strategies arose, aimed at extinguishing human existence in order to merge with a greater force. Notions of cyclical time emerged, to encompass the universe throughout eons of existence.

With its keen spirituality and complex pantheon of deities, many of which celebrated sensual subject matter, this area overall captivated Europeans as perhaps no other. Towering peaks of the Himalayas added to the mystique. The first British outpost in India was established in 1619, in an era of profound religious intolerance in Europe. India's spiritual beliefs, necessary to a comprehension of its art, could not be examined, only dismissed as heretical. Europeans formally colonized the region in the 19th century. England claimed India, and France colonized Vietnam, Cambodia, and Laos. Many traditions and cultural characteristics would vanish during the years of colonial rule.

Entering Asia as merchants and conquerors, Europeans also emphasized the exotic and developed a highly romanticized vision of the region. Western notions of India and Southeast Asia are derived largely from the reflections of writers of European extraction, such as Rudyard Kipling, who celebrated English colonial achievements. Seen through the lens of the British Empire, the dominated cultures are often portrayed as childlike, naïve, or cruel. "Real-life" accounts, such as that of Anna and the King of Siam, were frequently highly fictionalized.

Similarly, the first literary work to impact the Western world with images of the Himalayas was *Lost Horizon,* which creates a utopian vision of a village at the edge of the clouds, Shangri-La, where time stands still. These infantilized and romanticized notions

obscure a complex truth, in which long-standing social and class divisions have been offset by expansive, evolving, religious development that has resulted in elaborate mythology and iconography.

In contrast to the political and economic forces that unified Chinese society, class and religion defined and segregated society in South Asia and the Himalayas. In India, caste membership by lineage and associated occupations created an inescapable identity for the individual and the group. This social structure can be traced to the Aryan invasion of the India subcontinent around 1500 BCE. The Aryans, an Indo-Iranian group, came to the subcontinent from Central Asia and the West. Their superior weapons, chariot warfare, and disciplined society probably precipitated the collapse of the Indus Valley civilization in what is now northwestern India and Pakistan. That society had boasted extensive cities, irrigation systems, and trade networks and had flourished for 1,000 years.

The physical environment also affected the emotional and psychological framework in which people lived. Nothing could be done about nature. Similarly, there was nothing people could do, individually or collectively, to change their lot in life. Family and caste bestowed identity and social cohesion through rigorously enforced codes of conduct. Like the despotism that marked political control in South Asia and the Himalayas, the codes were repressive. Issues of status and prestige were philosophically irrelevant, so people looked beyond the current reality. Rather than idealizing political power or social institutions, as was the case in China, South Asians focused on a cosmic vision beyond manifest existence. The challenge of making the invisible visible became an all-consuming endeavor.

At the core of the Aryan caste system was religious purity, which shaped notions of status and entitlement. An individual's life was governed by karma. The doctrine of karma asserts that one's state in this life is a result of physical and mental actions in past incarnations and that actions in this life can determine one's destiny in future incarnations. Karma is a natural, impersonal law of moral cause and effect and has no connection with the idea of a supreme power that decrees punishment for or forgiveness of sins. Karmic law is universally applicable, and only those who have attained liberation from rebirth can transcend it.

Yoga, which we in the West are most familiar with as an exercise regime, is actually a physical and spiritual discipline. The devout combine yoga with meditation to seek detachment from the results of action and the karmic cycle. Yogic discipline is at the core of Hindu and Buddhist practice and is often emphasized in art. The Buddha is frequently shown seated in lotus position [nos. 59, 62, 68] to mark the six years of intense meditation and austerity that led to his enlightenment. In the gilt bronze portrait statue, Lama Mipham [no. 71] wears a yogic strap over his shoulder. Although a Tibetan, Mipham is represented as a *mahasiddha,* or mystic in the Indian Hindu tradition, with matted hair in a prominent topknot and robes exposing his chest. Like the Buddha, he sits in the lotus position, in contrast to Vajrapani, Holder of the Thunderbolt Scepter [no. 65], who—as a special protector of the historical Buddha—strikes the posture of the active warrior, known as *pratyalidhasa.*

Belief in the interconnectedness of all things made Indian theologies complex and dynamic. Within multilingual populations, Sanskrit, the language of the conquerors, became the language of worship and the transmitter of scripture. Artists responded to the subtleties of scriptural descriptions of divinity with a complex pictorial and sculptural language, rendering infinite manifestations of the divine. For an outsider, Hindu iconography can initially be confusing, not only because there are many deities, but because each god may be known by multiple names and in many manifestations, including past, present, and future incarnations. The principal deities are Vishnu, Brahma, and Shiva.

Vishnu is often called Narayana, one who dwells upon the waters, because he is the infinite ocean from which the world emerges. From his navel grows the lotus out of which Brahma, the creator of the universe, appears. Along with Shiva, the destroyer of the universe, they form the principal trinity in Hinduism. As the preserver of the universe, Vishnu is concerned with forces of good and evil that struggle for domination over the world: He descends to earth when the balance is upset.

Some images, such as the panel depicting the historical Buddha Shakyamuni [no. 62], depict time using a more conventional narrative strategy—linked to late Hellenistic artistic traditions from the West. Four events from the Buddha's life are arranged to the left and right of the central figure. Their counterclockwise organization reflects the karmic cycle, from which Buddha's enlightenment offered escape. Others, like the cult image of the yogini [no. 63] and the chlorite Vishnu stele [no. 64], alter human anatomy with additional limbs to evoke transcendent power and simultaneous action.

The Hindu concept of karma and its infinite manifestations of the divine influenced Jainism and Buddhism, which also arose on the Indian subcontinent. Successive waves of missionaries, teachers, and monks spread these ideas across Asia. Maritime trade with the kingdoms of Southeast Asia

and Indonesia hastened the spread of these beliefs across South Asia. Hindu iconography also affected Buddhist theology and its artistic expression, which not only moved south and east over maritime routes but also traveled north and east to Central Asia, China, Korea, and Japan with transcontinental commerce. Indications of this movement can be found in the Museum's collection, depicted in numbers 54 and 55. Subsequently, Buddhism also spread north to Tibet, where a particularly exuberant form of esoteric tantric Buddhism flourished, as reflected in number 65. This form of Buddhism was also patronized by Ming and Qing dynasty emperors, as evidenced by the gilded bronze Amitayus Buddha in number 68.

The interest in discourse and the delight in philosophical debate that formed an important part of intellectual and religious life are embodied in the miniature of circa 1765 [no. 72], which illustrates an episode from the 41st chapter of the *Bhagavata Purana*. This Hindu classic is concerned with all the incarnations of Vishnu. This section describes the life and activities of Krishna, the eighth incarnation, together with his brother Balarama, in discussion with King Kamsa and his court at the holy city of Mathura. The artist has placed the scene within a palace garden, mixing gods and mortals in daily life.

During the colonial era, many traditions were supplanted or intentionally eradicated. The British outlawed certain Hindu practices and worship of specific deities. India became independent in 1947 and has continued to emerge as an important nation. Home to the second-largest population on the planet, it is the world's most populous democracy. India's role as a nuclear power, its high levels of emigration to every part of the globe, and its evolving economic relationship with the West have continued to shape modern perceptions of the region, replacing outmoded colonial notions with more accurate understanding.

In 1953, an event occurred that would further demystify the region: Man first set foot on the peak of Mount Everest. Websites and history books record that achievement as belonging to Sir Edmund Hillary, the "first man" to "conquer" the mountain. More detailed sources note that he was traveling with a native Sherpa guide, Tenzin Norgay, who also summitted. Norgay knew more about the mountain than any living man, had made the most prior attempts, and had come the closest to the summit before that fated day. Locked within its cultural hegemony, the West views the summit as a conquest for European man, yet the summit is Norgay's achievement, too. By the philosophy of the native peoples, the conquest itself is an illusion, and Hillary as conqueror is, properly, also illusory.

Throughout the centuries, India continued to be the homeland to several of Asia's major religions and has remained a site of pilgrimage and spiritual renewal, even as those religions were supplanted by other faiths. The profound and mystical visualizations of the universe that arose there created a communal focus that continues to promote the spread of these doctrines and inform spiritual education for devotees. Nonetheless, in the West such beliefs continued to be viewed as suspect and exotic until late into the 20th century. Not until the Dalai Lama fled Tibet in 1959 did Buddhism begin to penetrate the Western consciousness as a cohesive philosophical and religious practice. Hinduism was introduced to the mainstream when the Beatles met with the Maharishi Mahesh Yogi in 1967. A trend was set for the Western world to embrace what had once appeared alien.

Art of the region is public, in the sense that it was created for display. However, it has always served a most private function as the focus of intense and devout worship by individuals. In today's global culture, these public and private functions often fuse in Western museums rather than in Asian monasteries: The Dalai Lama himself now encourages the collecting and viewing of Tibetan artifacts in Western museums.

62 *Scenes of the life of the Buddha*

Pakistan or eastern Afghanistan,
Gandhara region
Kushan period, 2nd–3rd century
Schist
H. 19⅜ in. (49.1 cm); w. 42⅝ in. (108.4 cm)
Purchased with funds provided by the
Bessie Timon Endowment Fund
77.956

This panel was probably made to decorate a temple or shrine and conveys key theological elements of the Buddha's life to the faithful who attended services or prayers in its presence. Buddhism first flourished in the Gandharan region, in modern-day Pakistan and eastern Afghanistan, during the reign of Ashoka (273–232 BCE). The Kushan conquest in the first century CE initiated an ambitious program of proselytizing and patronage that led to the founding of many religious establishments. Over the next four centuries, artists from the Gandharan region created a new human-based iconography influenced by Hellenistic styles from the West that helped spread Buddhism across Asia.

The central icon in this piece is Shakyamuni, the historical Buddha, seated in the lotus position. His hands are posed in the "turning the wheel of the law" gesture, which signifies teaching. Surrounding the figure are scenes depicting seminal events in both his secular and his sacred life. The panel in the lower right illustrates his birth. Above, he is shown as an adult prince wearing elaborate jewels. In the upper left panel, he is featured as the enlightened Buddha wearing monastic robes, which he assumed after renouncing his earthly life. In the lower left panel is his *nirvana,* or death.

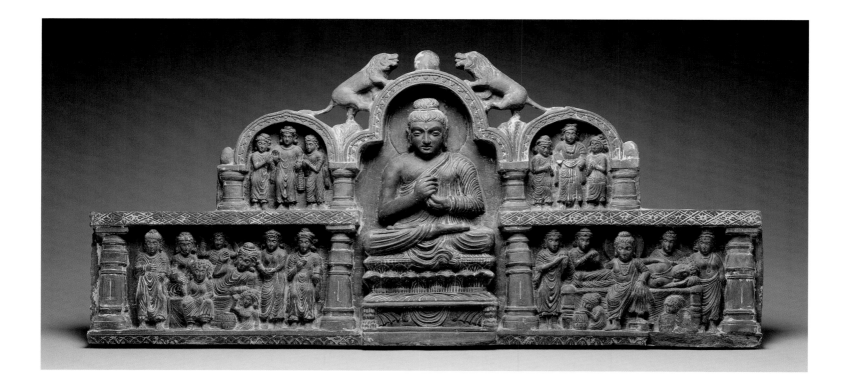

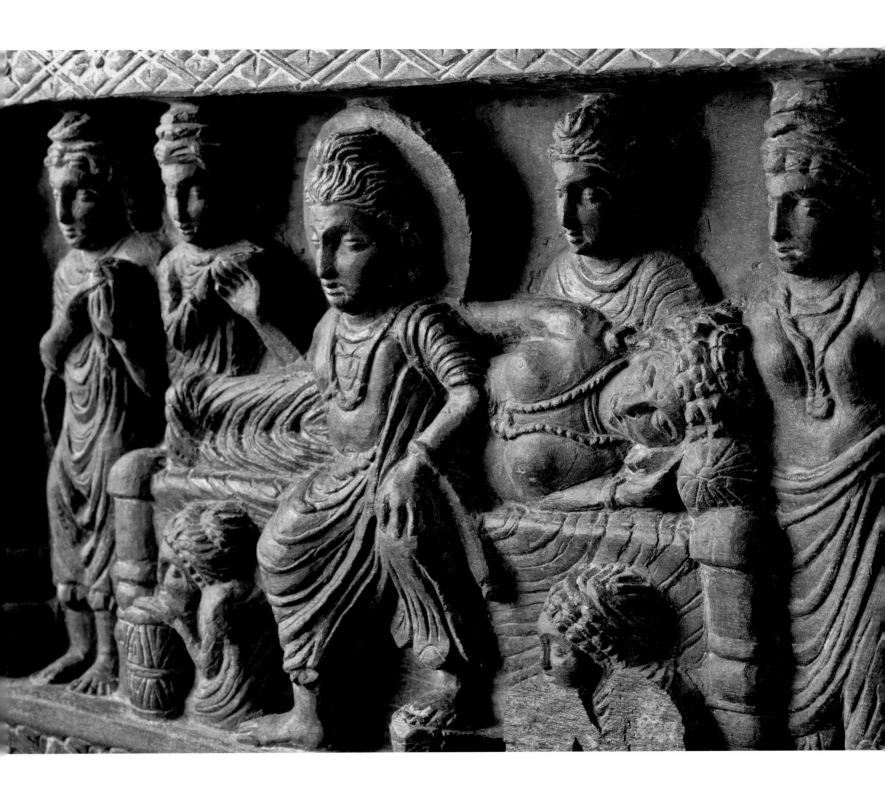

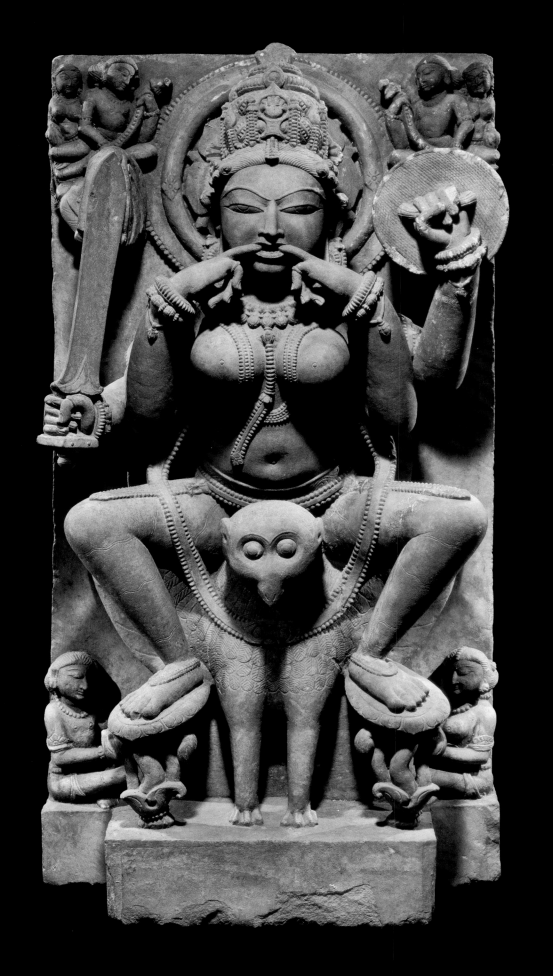

63 *Yogini*

A yogini, a female counterpart of a yogi, represents a yoga practitioner whose meditation culminates in the attainment of perfected stability and inner tranquility. There are sixty-four yogini in the Hindu pantheon. Although worshiped individually, this group of esoteric deities, who were associated with the Shaiva Kaula cult, was believed to emanate from the great goddess Durga. They represent Shakti, or female creative energy.

This image was probably made for a yogini temple, common in northern India. The temples are circular and house images set in niches that face inward to a small shrine, usually devoted to Shiva in his fearsome form as Bhairava.

Yogini are conceived as voluptuous and seductive. Some have human heads, such as this one, while others bear the heads of animals. This four-armed deity sits on an owl. Two hands are held up to a partially open mouth with clearly delineated teeth. Some scholars have suggested this may indicate whistling, while others note the possible association with numerous other yogini with names like "She Who Makes a Loud Noise" and "She Who Utters Loud Sounds." The nocturnal owl and the attributes of sword and shield invest this image with a sense of the occult.

India, Uttar Pradesh or Madhya Pradesh
10th–11th century
Buff sandstone
H. 34 in. (86.4 cm); W. 17¼ in. (44 cm);
D. 9¾ in. (24.8 cm)
Purchased with funds provided by the John and Karen McFarlin Purchase Fund
90.92

64 *Vishnu*

India, Bengal or Bihar
Pala period, 12th century
Chlorite
H. 38 in. (96.5 cm); w. 18½ in. (47.2 cm);
D. 7¼ in. (18.3 cm)
Gift of the Nathan Rubin–Ida Ladd
Foundation in honor of Martha Blackwelder,
Coates-Cowden-Brown Curator of Asian Art
2002.12

This beautifully carved stele presents Vishnu in his role as the kingly ruler. He stands firm and erect with his feet planted together in the *samabhanga* position on a double lotus pedestal. He wears a short dhoti with incised pleats, meditation cord, floral garland, and jewelry. On his head is a crown. In his four hands, he holds weapons emblematic of his power, such as a mace and the *chakra,* or wheel, in his upper two hands and a conch shell in his lower left. His lower right hand is in *varada mudra,* the gesture of charity, and a small lotus bud is carved in his palm. He is flanked by his two consorts, Lakshmi (holding the *chauri,* or fly whisk) and Sarasvati (holding the *vina,* a musical instrument), who stand in *tribhanga,* or triple-bend posture. The elaborate style and deep carving of this stele is typical of the late Pala period.

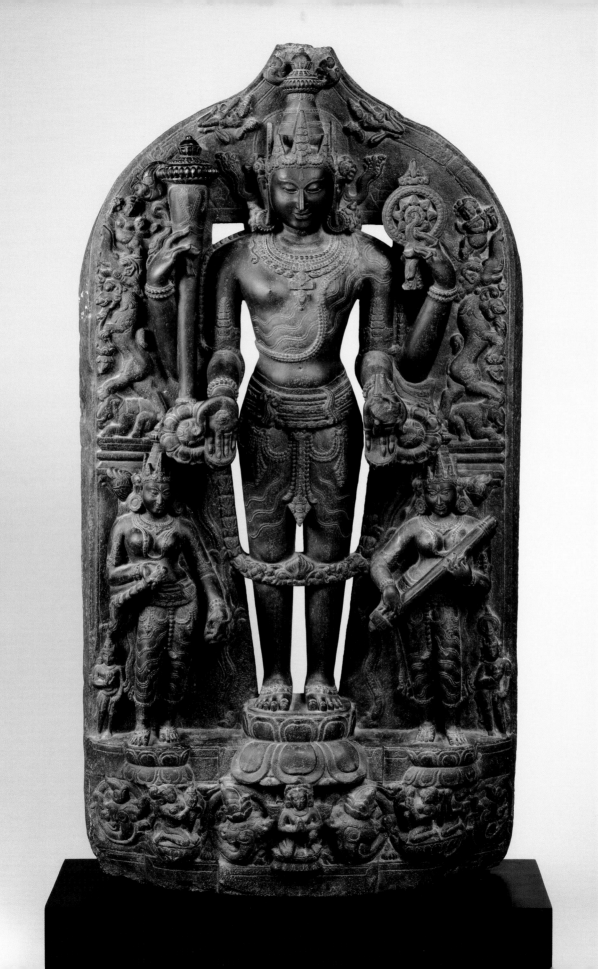

65 Vajrapani

Tibet
Late 12th–13th century
Cast copper alloy
H. 11½ in. (29.2 cm)
Purchased with funds provided by the
Ewing Halsell Foundation
2004.6

This active warrior pose of the Vajrapani, Holder of the Thunderbolt Scepter, is intended to convey his vigor and energy as well as his commitment to defending the faith and its devotees from demons both external and internal. One of the wrathful deities of Tibetan Buddhism, he is dressed in powerful symbols: Tiger skin adorns his waist, and snakes wrap around his ankles, wrists, and chest. He represents the concentrated power of all Buddhas, and his wrath is directed against evil, ignorance, lust, greed, and similar negative attachments. Unlike the elegant and ethereal images of contemplative Lamas and Buddhas that represent knowledge, compassion, or other attributes, Vajrapani is earthy and visceral, endowed with primal power and fierce determination. He holds a double five-pronged *vajra* (Tibetan: *dorje*), a thunderbolt scepter, in his right hand and makes *tarjani mudra,* the gesture of threatening, with his left.

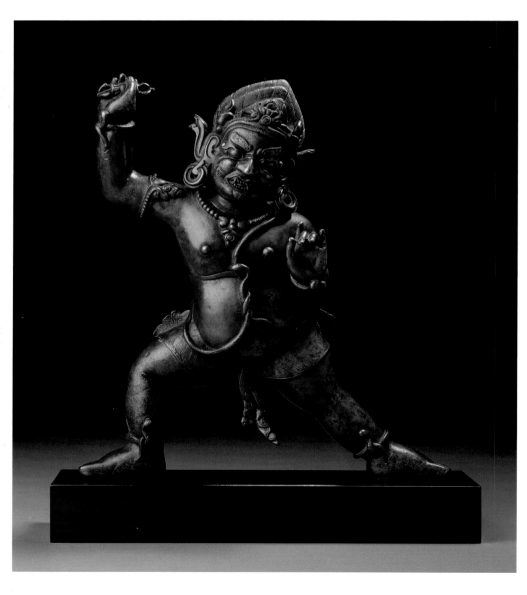

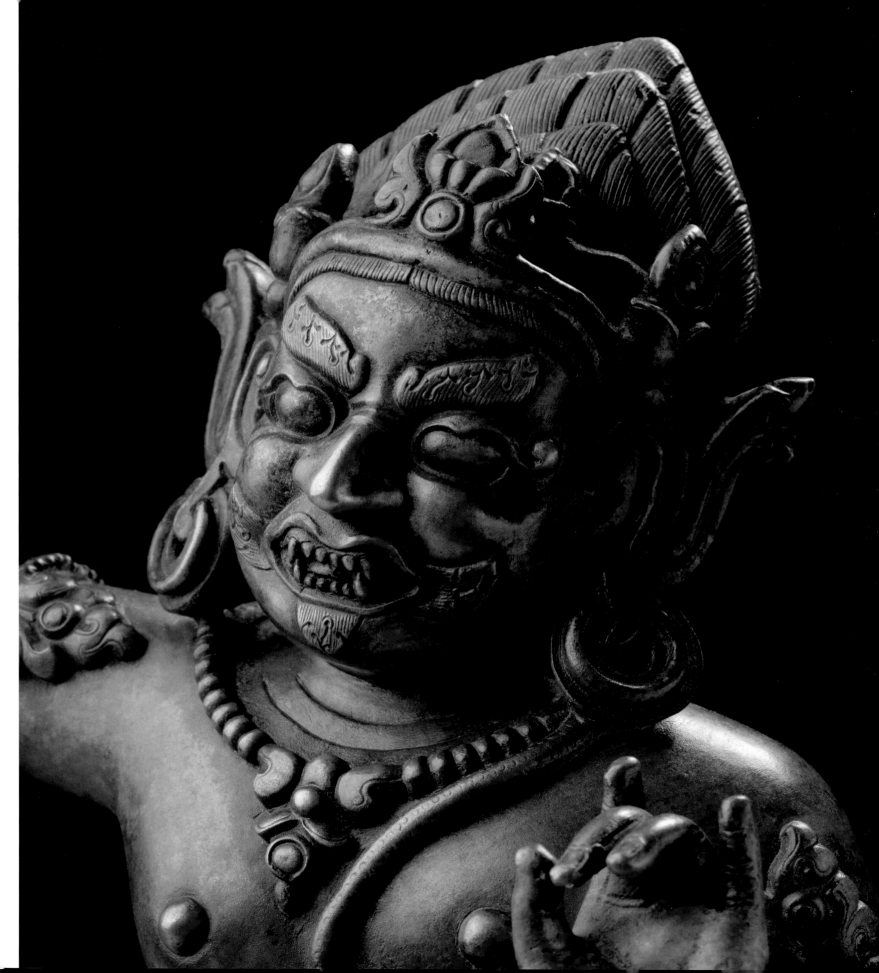

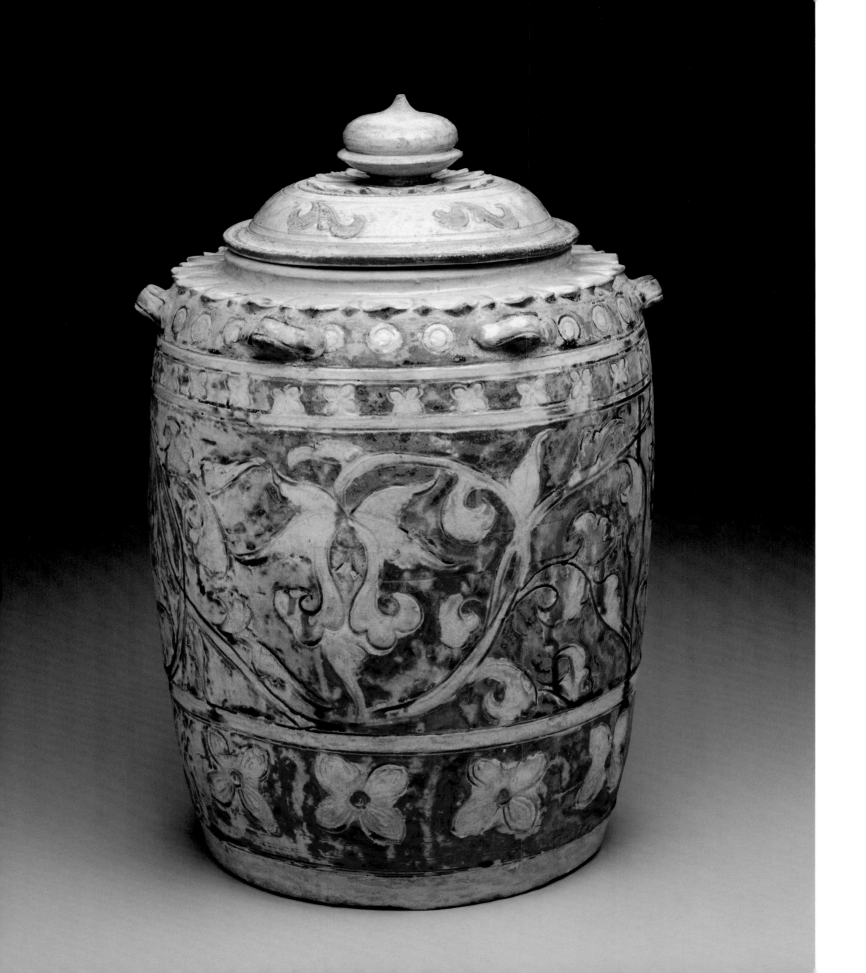

66 *Covered jar*

This cylinder-shaped jar with its nearly vertical walls and decoration organized in a series of horizontal registers reflects Vietnamese tastes and styles of the 13th and 14th century. Large bands of thinly stemmed vine scrolls decorate the central register, while bands of flower heads fill the upper and lower regions. The shoulder is marked with a raised, lotus-petal collar and six lug handles. The shallow domed lid is embellished with a pointed ball, known in Vietnam as the *chintamani,* or "wish granting jewel."

The potter took several steps to create the elegant cream-colored decoration. First the jar was dipped in a viscous ash glaze. Then patterns were incised or scraped through the vessel body. The scraped areas were finally painted with an iron-oxide glaze, which acted as a background to the lighter-toned floral elements.

Jars such as this one have been excavated from tombs, but there is no evidence to suggest they were used as funerary urns. It is commonly believed that these jars held food or wine and probably had a domestic function in homes or temples before they were placed in tombs.

Vietnam, probably Thanh Hoa province
13th–14th century
Earthenware, brown and transparent glaze
H. 16 in. (40.6 cm); DIAM. 10 in. (25.5 cm)
Gift of Lenora and Walter F. Brown
2004.20.3

67 Censer

Vietnam
16th century
Stoneware, cream, green, and brown glazes
H. 14¼ in. (36.2 cm); DIAM. 14 in. (35.5 cm)
Gift of Lenora and Walter F. Brown
2004.20.2

Altars in Vietnamese Buddhist monasteries and temples were furnished with vessels for the five offerings: incense, light, water, flowers, and fruit. A censer and a pair of candlesticks were always present; burning incense and lighting candles were part of daily devotional practice.

The molded and applied ornament mimics metalwork and features parrots and auspicious dragons, emblems of the natural and supernatural worlds. Molded medallions, including animal masks, flaming jewels, lotus, and fantastic beasts, decorate nearly every available surface.

Elaborate censers like this one were used for burning large stick sandalwood incense, which was thought to have the power to purify the surrounding area and ward off evil spirits. Placed at the center of an offering table, it served as the principal altar decoration.

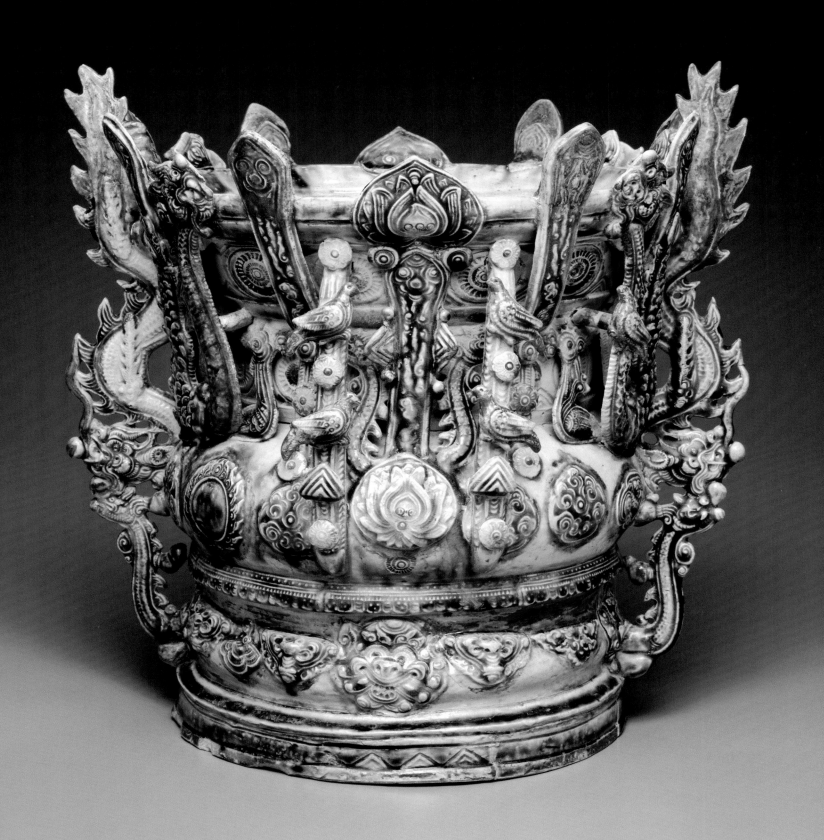

68 *Amitayus Buddha*

China, Sino-Tibetan style
Ming dynasty, 15th–16th century
Cast gilt bronze with lacquer over gesso
H. 27¾ in. (70.5 cm)
Gift of Lenora and Walter F. Brown
2004.20.4

Amitayus, the Buddha of Eternal Life, is a popular form of Amitabha, the Buddha of Boundless Light. Seated in the lotus position with hands in the *dhyana mudra,* or meditation gesture, this figure is crowned and adorned with jewels, exhibiting the qualities of a prince rather than a monk. As the Buddha of Eternal Life, Amitayus is often depicted with an elaborate vase, containing the elixir of immortality, in his upturned palms. It is possible that this sculpture once held a similar vessel.

This robustly modeled, finely cast image was probably made for a temple altar and may originally have been covered with gold leaf.

Based on Tibetan models, but made in China, this image reflects the long and complex interaction between the Chinese imperial court and Tibet. Since the 13th century, Tibetan religious leaders had played a major role in the politics of Mongolia. Early Ming dynasty emperors seeking to exert their authority over the Mongol populations of their empire became leading patrons of Tibetan Buddhism and helped spread tantric Buddhist worship in China.

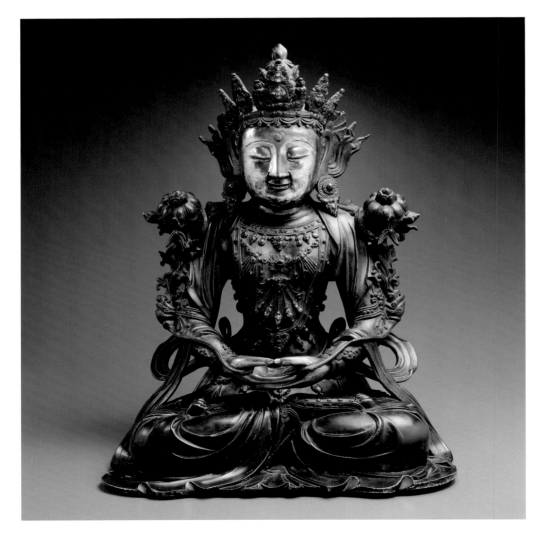

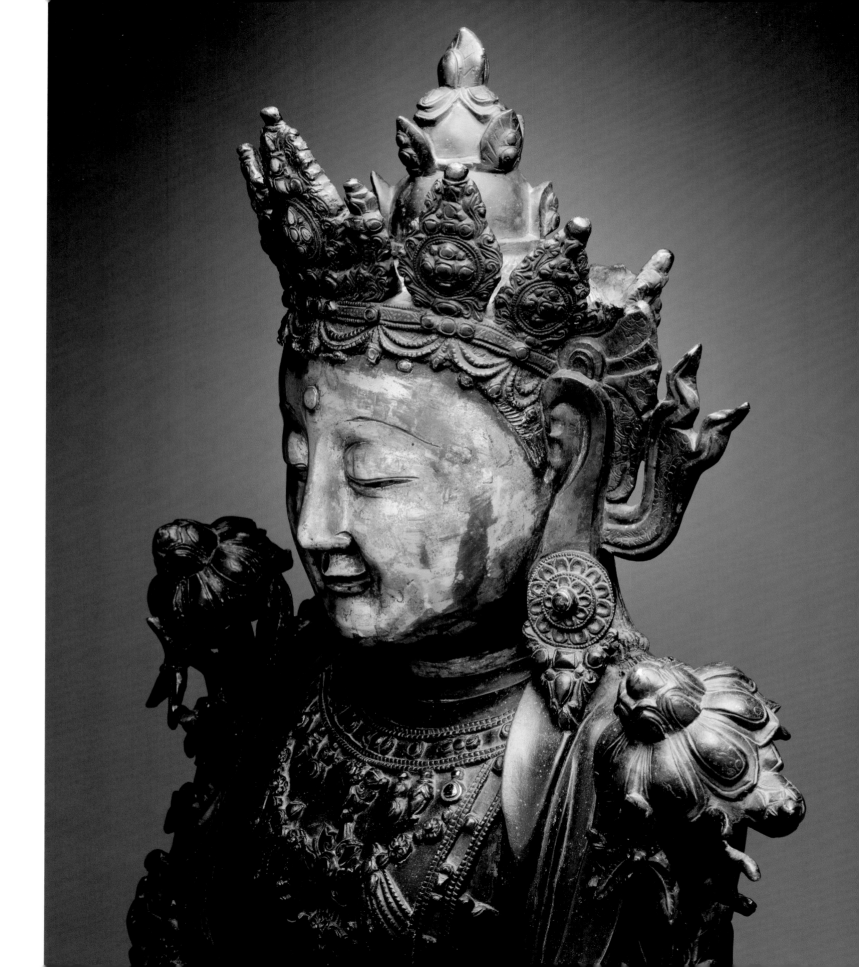

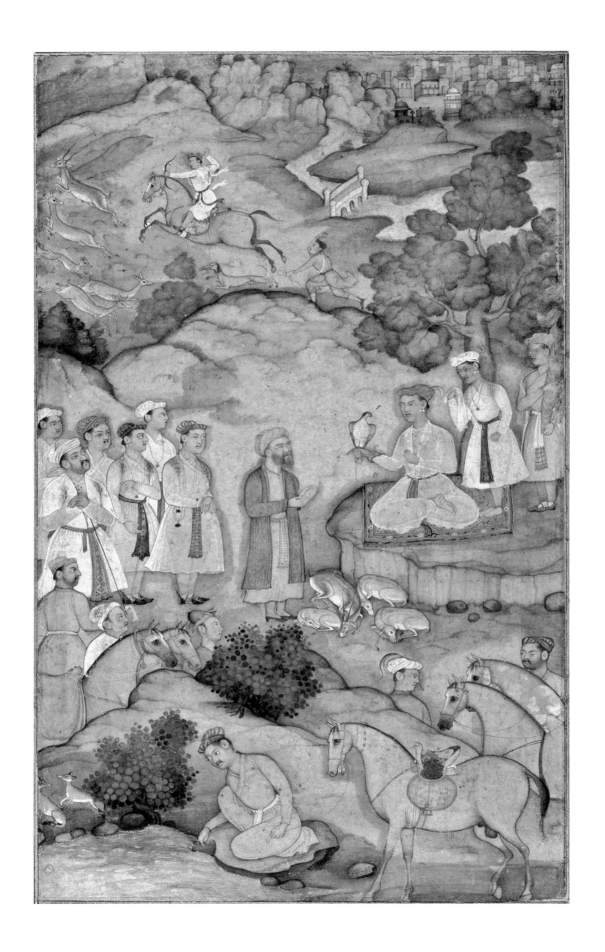

69 A Prince on a Hunting Excursion

The theme of the royal hunt, an ancient motif in the Middle East, was introduced to Indian art by the Mughals, who conquered Northern India in the 16th century. These Muslim rulers also introduced the arts of the Persian court, including manuscript illumination.

This page, removed from a book, shows a seated prince with a falcon receiving his retainers while a mounted gazelle hunt progresses in the distance. This finely drawn, subtly shaded, and delicately tinted painting is typical of early Mughal manuscript illumination.

India, Mughal style
Late 16th century
Pigments on paper
Painting: H. 9¼ in. (23.4 cm); W. 5⅞ in. (15 cm)
Mount: H. 13 in. (33 cm); W. 9¼ in. (23.4 cm)
Purchased with funds provided by
Mr. and Mrs. E. B. McFarland
61.100.1

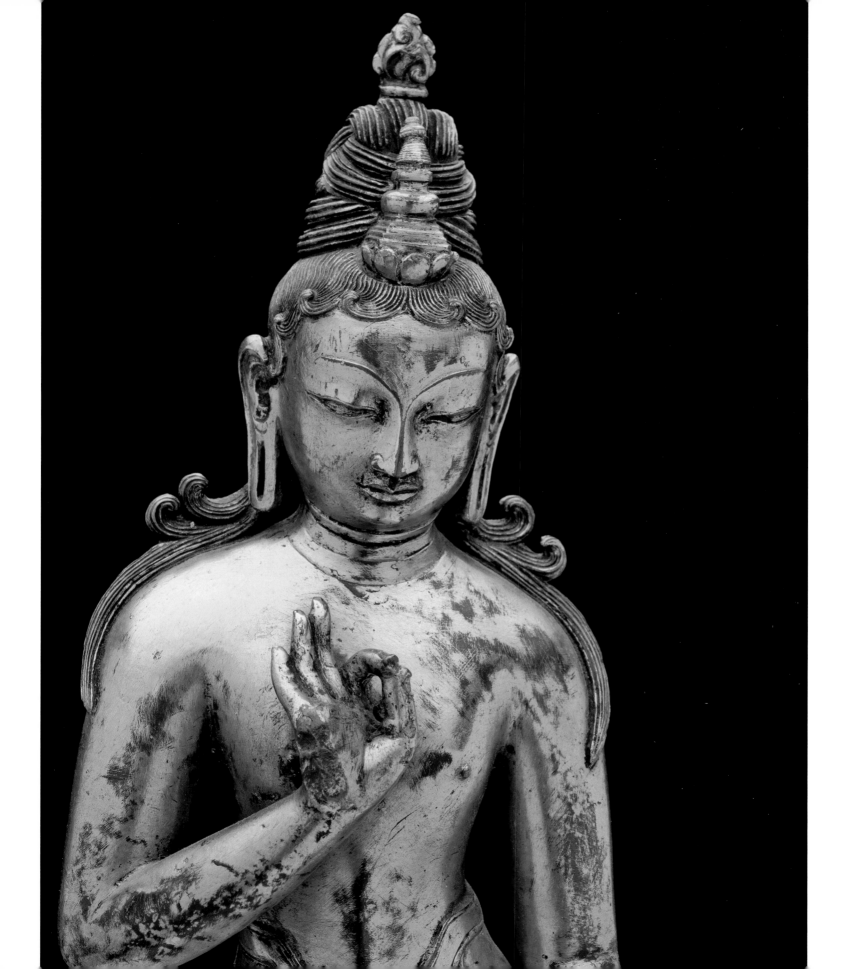

70 *Maitreya, or the Buddha of the Future*

This richly gilded image of Maitreya, the Buddha of the Future, may have been a Tibetan commission in Nepal or the work of a Nepalese artist living in Tibet. Its graceful form and youthful, idealized features reflect the elegance of traditional Nepalese sculpture. The figure stands in a triple-bend posture and wears a long skirt with simple incised decoration and a sash that hangs loosely from his hips. His lower hand holds a vessel carrying the elixir of immortality, and his upper hand, placed at the center of his chest, is in the teaching gesture. The slight downward tilt of his head conveys a spiritual presence that is reinforced by his gently downcast eyes. His hair is coiled in a high-standing bun with a miniature gilt stupa, the primary attribute of Maitreya, resting against it. While the long, slender body and soft fluid shape of the figure illustrate a strong Nepalese influence, the sculpture is larger than most Nepalese or Tibetan works and seems more in character with Buddhist sculpture from Mongolia.

Throughout the Buddhist world, Maitreya achieved a wide following. As he is the Buddha of the next great age, his devotees were inspired to be reborn in his paradise or to be alive when he descended to earth.

The Tibetan inscription carved along the bottom rim reads:

> By the power of erecting this statue of
> Maitreya,
> may Lodro Gyaltshen obtain omniscience.
> May the Reverend Lamas increase their work
> of performing religious services.
> May the patron be flourishing in life, force,
> glory, and wealth.
> Accomplished successfully by the maker
> Chandra.
> May happiness prevail.

—Translation by David Weldon

The inscription states that the sculpture was commissioned by a Tibetan named Lodro Gyaltshen and was made by Chandra, a noted Nepalese artist with a Newari name. The fact that the inscription is written in Tibetan while the style of the sculpture is clearly Nepalese sheds light on the relationship between Tibetan donors and Nepalese artists working in Tibet and Nepal.

Tibet or Nepal
17th century
Gilt bronze
H. 17 in. (43.2 cm)
Gift of Rose Marie and John L. Hendry III
2005.17

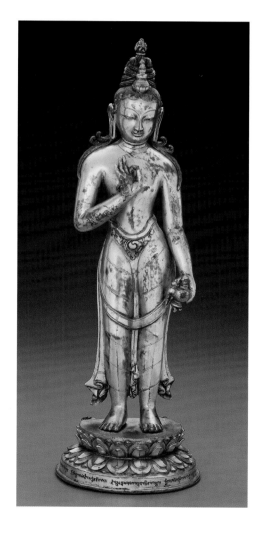

71 *Lama Mipham (1654–1715)*

Tibet
Early 18th century, possibly 1716
Gilt bronze, semiprecious stone inlay
H. 20½ in. (52 cm); W. 15 in. (38.2 cm);
D. 11 in. (27.8 cm)
Purchased with funds provided by the
Ewing Halsell Foundation
2004.7.1

This figure is identified by the inscription on the base as Lama Mipham. According to historical documents Mipham lived in Mustang, located in western Tibet on the border of Nepal, in the late 17th to the early 18th century. He was a lama and preceptor to the king and was revered for his teachings and spiritual accomplishment. In this sculpture, he is depicted seated on a double lotus with his right hand in the *bhumisparsha mudra,* or earth-witnessing gesture, and his left hand holding a vase filled with life-giving water to symbolize immortality.

Lama Mipham is represented not in typical Tibetan lama garb but as a *mahasiddha,* or mystic in the Indian tradition, with matted hair in a prominent topknot and robes exposing his chest. The sash over his right shoulder is a meditation strap used by yoga practitioners.

The inscription on the base reads:

I, Phun tshogs byang chub mtsho mo,
Make homage and take refuge in the noble
 Vajradhara Mipham phun tshogs shes rab.
May this saint's wishes be fulfilled.

—Translation by Amy Heller

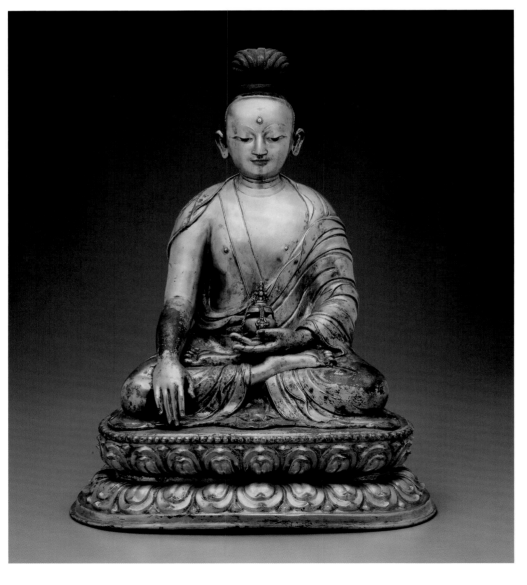

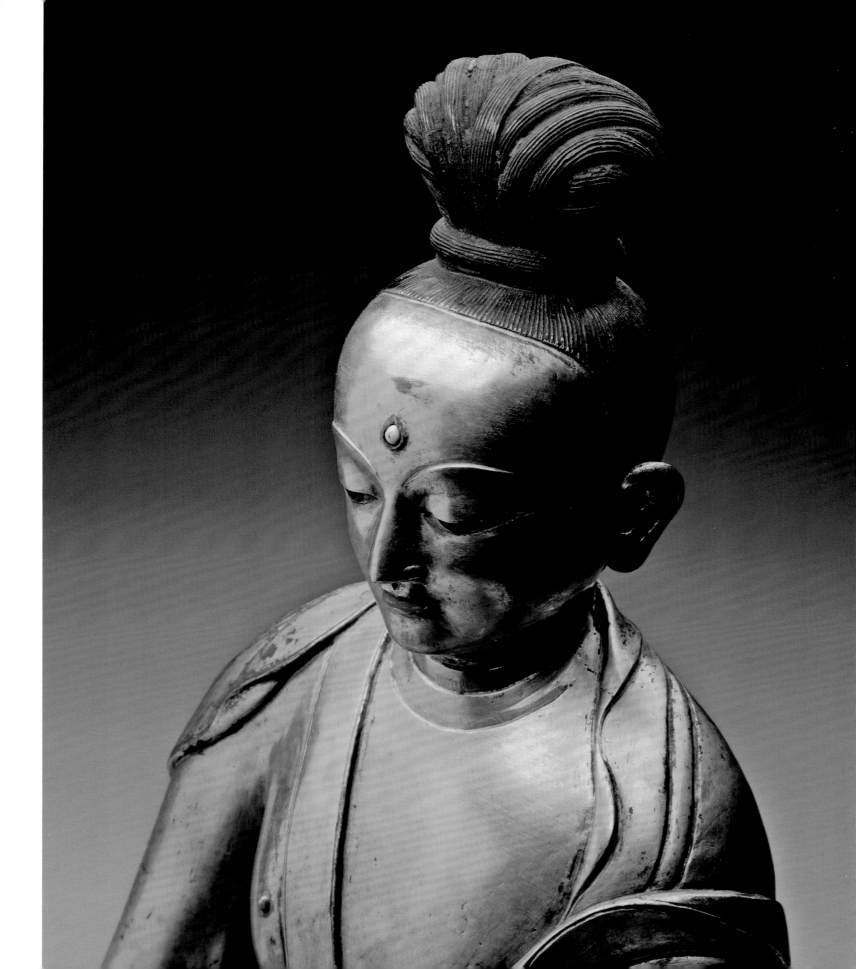

72 Krishna Meeting with King Kamsa, *a leaf from the* Bhagavata Purana

This painting depicts an episode from the *Bhagavata Purana,* one of the best-known and most popular works of Indian religious literature. It was compiled before the ninth century and contains the numerous stories of the Hindu god Vishnu in his multiple manifestations. A lengthy section is devoted to Krishna, Vishnu's eighth incarnation. Krishna remains one of the most popular Hindu deities, and the stories of his adventures recorded in the *Bhagavata Purana* are known to most children.

This scene depicts an episode from the 41st chapter in which Krishna and his brother Balarama visit King Kamsa and his court in the holy city of Mathura. It features the blue-skinned Krishna seated at the far right of the composition with his brother, the light-skinned figure, beside him. They sit in discussion with these secular leaders in a walled garden. The artist has used the palace façade to frame the composition. By overlapping the figures at the edges of the group, he suggests a private space beyond and offers a nuanced, psychologically charged scene that was intended to delight the viewer as well as to illustrate the story.

Miniature painting flourished in the Pahari Hills of the Himalayas in northern India during the late 17th and 18th centuries. The Basohli workshop takes its name from the small independent state of Basohli. It was the principal center for a painting style known for its colorist and decorative exuberance.

India, Himachal Pradesh, Basohli workshop
c. 1765
Pigments on paper
Painting: H. 9⅜ in. (23.8 cm); w. 13 in. (33 cm)
Mount: H. 12 in. (30.5 cm); w. 15¾ in. (40 cm)
Purchased with funds provided by
Mr. and Mrs. E. B. McFarland
61.100.6

73 *Portable shrine, or gau*

Tibet
19th to 20th century
Amber, silver and semi-precious stones
H. 6 in. (15.4 cm); W. 4¹⁄₁₆ in. (10.3 cm);
D. ¾ in. (1.9 cm)
Gift from the collection of Thubten Losel Dawa
in memory of Gilbert M. Denman, Jr.
2004.30

A *gau* is an amulet container or portable shrine. Smaller *gau* were worn as jewelry around the neck; larger ones, such as this example, would have been suspended on a strap worn at the chest. At home, they would have been stored on the household altar. The *gau* functions as a protective device to ward off evil. This example consists of a piece of amber, carved on both sides, encased in a silver frame adorned with turquoise and coral on the front and pairs of suspension loops on the sides.

A protector deity is carved on each side. On one side, the figure stands in a warrior pose holding a dagger in his right hand and a skull cup in his left, implements with which to fight off evil. He has a mask-like face with bulging eyes and fangs and wears a crown with five skulls representing the five delusions: anger, desire, ignorance, jealousy, and pride. On the reverse, the deity appears seated on his haunches and holding a chopper and a skull cup against his chest.

Although the carving is not refined, this large piece of amber represents a significant investment. Amber is rarely encountered in Tibetan decorative arts. It is possible that this piece of amber may have made its way to Tibet in trade from Central Asia or the West.

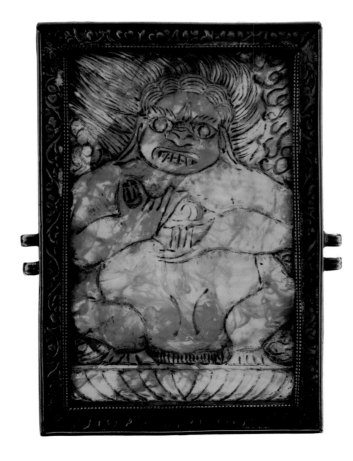

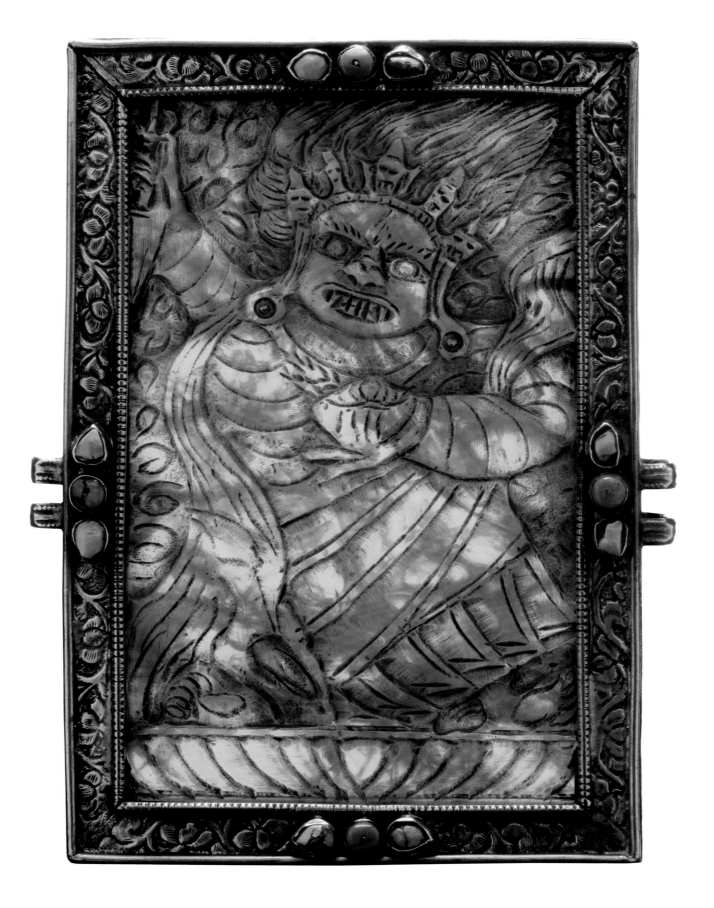

Selected Readings

Cunningham, Michael R. *Buddhist Treasures from Nara. The Cleveland Museum of Art*. New York: Hudson Hills Press, 1998.

Dehejia, Vidya. *Indian Art*. London: Phaidon Press Limited, 1997.

Guth, Christine. *Art of Edo Japan: The Artist and the City 1615–1868*. New York: Harry N. Abrams, Inc., 1996.

Heller, Amy. *Tibetan Art: Tracing the Development of Spiritual Ideals and Art in Tibet*. Milan: Jaca Books, 1999.

Lee, Sherman E. *A History of Far Eastern Art*. Fifth edition. New York: Harry N. Abrams, Inc., 1994.

Leidy, Denise Patry. *Treasures of Asian Art*. New York: The Asia Society Galleries, 1994.

Li, He. *Chinese Ceramics: From the Asian Art Museum of San Francisco*. New York: Rizzoli International Publications, Inc., 1996.

Mason, Penelope. *History of Japanese Art*. New York: Harry N. Abrams, Inc., 1993.

Medly, Margaret. *The Chinese Potter: A Practical History of Chinese Ceramics*. London: Phaidon Press Limited, 1989.

Pal, Pratapaditya. *Tibet: Tradition and Change*. Albuquerque: The Albuquerque Museum, 1997.

———. *Asian Art at the Norton Simon Museum*. Volume 1, *Art from the Indian Subcontinent;* and Volume 2, *Art from the Himalayas and China*. New Haven: Yale University Press, 2003.

Portal, Jane. *The British Museum: Korea: Art and Archaeology*. New York: Thames and Hudson, 2003.

Rawson, Jessica, ed. *The British Museum Book of Chinese Art*. New York: Thames and Hudson, 1992.

Rhie, Marylin M., and Robert A. F. Thurman. *Wisdom and Compassion: The Sacred Art of Tibet*. Expanded edition. New York: Harry N. Abrams, Inc., 1995.

Shimizu, Yokhiaki, ed. *Japan: The Shaping of the Daimyo Culture 1185–1868*. Washington, D.C.: National Gallery of Art, 1988.

Stevenson, John, and John Guy. *Vietnamese Ceramics: A Separate Tradition*. Chicago: Avery Press, 1997.

Sullivan, Michael. *The Arts of China*. Third edition. Berkeley: University of California Press, 1984.

Thorp, Robert L., and Richard Ellis Vinograd. *Chinese Art & Culture*. New York: Harry N. Abrams, Inc., 2001.

Watson, William. *Tang and Liao Ceramics*. London: Thames and Hudson Ltd., 1984.